"This book explores our aversion to scary things, as well as the emotional, physical, cultural, and psychological allure of fear. Keisner examines everything from horror movies to giving birth—and does it fearlessly. This should be a paradox, but it's not. Instead, it's a literary achievement. Yes, soldiers, astronauts, and refugees overcome their fears, but so do the rest of us. To do so with grace is another thing. This book is that thing."
—SUE WILLIAM SILVERMAN, author of *How to Survive Death and Other Inconveniences*

"Keisner courageously maps the dark corners of her psyche, extracting difficult insights without resorting to the saccharine in putting these fears to bed."
—SONYA HUBER, author of *Supremely Tiny Acts: A Memoir of a Day*

"Fear has many faces, and terror knows no single name. From wildfires to haunted houses, horror films to the monster beneath the bed, Jody Keisner grapples deep within this darkness, riding the line between paranoia and pure evil in this journey from the outside world into her own interior. . . . Eerie, elegiac, and empowering most of all. Don't run, don't hide, just read."
—B.J. HOLLARS, author of *This Is Only a Test*

UNDER MY BED AND OTHER ESSAYS

AMERICAN LIVES Series editor: Tobias Wolff

UNDER MY BED
AND OTHER ESSAYS

JODY KEISNER

University of Nebraska Press Lincoln

The University of Nebraska Press is part of a land-
grant institution with campuses and programs on the
past, present, and future homelands of the Pawnee,
Ponca, Otoe-Missouria, Omaha, Dakota, Lakota, Kaw,
Cheyenne, and Arapaho Peoples, as well as those of the
relocated Ho-Chunk, Sac and Fox, and Iowa Peoples.

Library of Congress Cataloging-in-Publication Data
Names: Keisner, Jody, author.
Title: Under my bed and other essays / Jody Keisner.
Description: Lincoln : University of Nebraska
Press, [2022] | Series: American lives |
Includes bibliographical references.
Identifiers: LCCN 2021060222
ISBN 9781496230478 (paperback)
ISBN 9781496232854 (epub)
ISBN 9781496232861 (pdf)
Subjects: LCSH: Keisner, Jody. | Victims of family
violence—Biography. | Women—Psychology. | Fear. |
BISAC: BIOGRAPHY & AUTOBIOGRAPHY / Personal
Memoirs | BIOGRAPHY & AUTOBIOGRAPHY / Women
Classification: LCC HV6626.2 .K44 2022 | DDC
362.82/92092 [B]—dc23/eng/20220421
LC record available at https://lccn.loc.gov/2021060222

Set in Adobe Caslon Pro by Laura Buis.
Designed by L. Auten.

For Lilian Grace

Each female body contains a female brain. Handy. Makes things work. Stick pins in it and you get amazing results. Old popular songs. Short circuits. Bad dreams.

—MARGARET ATWOOD, "The Female Body"

CONTENTS

PREFACE

When I was in my twenties, recently graduated from college and beginning what I viewed as my adult life, a new nighttime ritual took hold of me. At night after waiting tables, I returned to the apartment where I lived alone, my heart pounding and armpits sweating, and—in quick succession—whipped open closet doors and cupboards, yanked back the shower curtain, peered behind the couch and chair, and got down on my hands and knees and looked under my bed. I was half-expecting to find a real boogeyman: an intruder waiting to rape me or chop me up (or both), and though these horrors happened to women—*and still do*—I knew it was statistically unlikely to happen to me in the way I imagined. On the worst nights I woke from nightmares where men darkened my bedroom doorway or chased me through unlit alleys, and I felt compelled to repeat my checks. I viewed my behavior as an embarrassing character flaw, a childlike anxiety, and it remained my secret for sixteen years, until one night when my new husband caught me looking under the bed. "Why do you do it?" he wanted to know. I didn't have an answer then, but I knew my impulse to check for boogeymen represented more than a lingering fear of childhood monsters.

This book began as my quest to uncover the origin stories of my greatest fears and compulsion to "check." I have arranged the chapters thematically and mostly chronologically. In part 1, "Origins," I seek out the familial, cultural, sociological, and spiritual roots of fear afflicting me from early childhood through adulthood, beginning with the family into which I was adopted. I explore the relationship between experiences in childhood and the development of hypervigilant behaviors (i.e., checking under the bed). One of the essays in this section

has me returning to my growing up years, and I move into second-person narration to authentically capture my childhood perspective. Motherhood shape-shifts the literal and metaphorical boogeymen who haunt me, and I delve into both the enormous pressure placed on mothers and the anxieties that frequently result. I consider the protective barriers we place in front of us and our loved ones, hoping they will be enough. In part 2, "Under the Skin," I explore the neurological forces behind the development of both fear and love as they relate to my husband, daughter, and extended family members. I worry that love is not enough to hold families together. A new terror emerges, too: a diagnosis of a hereditary, chronic autoimmune disease. I once feared what an intruder might do to my body (slash, attack, violate), but now I fear what my body does to itself. Because I have limited access to my biological family's medical history, I question what conceals itself under my own skin. I discover that some fears—and pain—are written in the language of the body from birth and wonder what my daughter has inherited from me. In addition to naming the real and imagined boogeymen who have made appearances throughout my life, in part 3, "Risings," I confront them. I also remember the advice of my favorite grandmother, "Don't be afraid," exploring her words in the context of her own pain and suffering. I question what I should teach my daughters so that they can learn to keep themselves safe and without living in fear of the unknown. I learn that despite whatever harm may befall us, most of us continue to choose the greatest vulnerability of all: to care for and love others.

While not all women are under-the-bed checkers or nervous mothers, women are more likely than men to develop anxiety disorders. Further—and as I suspect in my case—the brains of children exposed to chronic stress develop differently from the brains of children who are exposed to mostly positive or moderate stress. Science has shown us that children who have endured trauma are less able to effectively regulate their emotions and are more apt to overrespond to even mildly stressful events. Children whose stress response systems

"turn on" repeatedly and for prolonged periods of time have a higher likelihood of later developing a mental illness (e.g., a general anxiety disorder) or chronic physical conditions (e.g., an autoimmune disease), among other behavioral and relationship issues. Regardless of one's childhood experiences, the things that make women anxious and fearful in these times are similar: experiences of abuse; media coverage of horror and tragedy; the cultural objectification and sexualization of the female body; the expectation of perfection for mothers; and a society that teaches young girls to be outwardly pleasant and accommodating while inwardly denying their anger and rebellion.

The act of naming fears and working to understand them is empowering, and I want this book to empower readers. Above all, I hope to reach readers as they, like me, experience the tension between the illusion of safety, a desire for control, and the struggle to keep our greatest fears from getting closer to us.

UNDER MY BED AND OTHER ESSAYS

PART ONE

Origins

Under My Bed

I know women who enjoy being alone in their homes at night. A single mother at my daughter's preschool, for instance, says she *lives* for uninterrupted hours of André Watts's piano playing when her children are elsewhere. Another, a former student of mine, binge-watches *Breaking Bad* on Netflix while her girlfriend works overnight shifts as a nurse. And a third, whose husband regularly disappears for weekend hunting trips—*not regularly enough*, she says—spends her alone time absorbed by home improvement projects. These women celebrate having the house to themselves. But I don't. At least, not during the hours when the sun goes missing. At the risk of sounding melodramatic, when I'm home alone after sunset and something triggers me, which happens often enough, what I experience is the antithesis of pleasure. It's closer to terror.

Case in point: I'm drinking wine and watching a romantic comedy in my living room, relishing my freedom, when I spot a moth bumping into the only lamp in the room. Who let the moth in? That morning my husband, Jon, rode off on his motorcycle for a four-day guys' trip. The sun has dropped below the horizon, and I can see no farther than the old ash tree in my front yard. Hours earlier, I sang my daughter Lily to sleep in her crib. It isn't the moth I fear, but what I imagine its presence in my home signifies. A gristly lump of anxiety catches in my throat, followed by the slow turn of a key, and the drawer to the filing cabinet in my brain where I lock away my greatest fears—break-ins, sexual assaults, kidnappings, murders—slides open. Memories of every crime TV series I've ever watched where women and girls are regularly and disproportionately brutalized (*Law & Order: Special Victims Unit*), every eighties slasher movie

where young women are terrorized (*A Nightmare on Elm Street*), every movie based on real serial killers (*The Hillside Strangler*), every statistic or true story I've ever read about violence against women (at least one woman is raped every hour in America and about twelve out of every hundred thousand women are victims of homicide)—sprint down neural pathways in my brain. Will the moth become a clue, like those that help csi: *Crime Scene Investigation* detectives determine the victim's (usually a woman) cause of death or the identity of the perp (usually a man)? An image flashes in my mind: the cocoon of the death's-head hawk moth being extracted from a dead woman's throat in *Silence of the Lambs*. My pulse quickens. How *has* the moth gotten inside? I haven't opened a door since I took my daughter for an afternoon walk in her stroller. The windows on the ground floor are closed and latched, a task I feel compelled to carry out when Jon is away, even though we live in a suburban Omaha neighborhood populated by tidy, slow-moving seniors.

I stand and turn off the movie so I can focus. The loudest sound in the house comes from Lily's upstairs bedroom, where her sound machine is set to "rain." I sniff for the smell of a cigarette Jon and I have never smoked, listen for the squeak of a door being opened, and walk into the kitchen to look for shoe prints on the clean kitchen floor. There, I make a discovery. The sliding glass door is unlocked, the screen door behind it slightly open to the deck and backyard. I imagine the moth fluttering against the kitchen door, drawn to the dim light from the living room lamp. I imagine a man stepping from out of the shadows, quietly opening the door, and stepping inside, not noticing the moth on his shoulder. I know a man is hiding inside of my home, just as I know there isn't one. Or is there? If people always knew when intruders had broken into their homes, no one would ever die this way. I think of the thousands of bodies of girls and women, stuffed into garbage sacks, or left naked by a riverbank under a pile of leaves, or left to decompose in a basement. I can hear their cries, their choked-off warnings: *Watch out for him!* I grab a chef's knife,

the knife that slices through a whole chicken, flesh and spine. There's only one way to be sure. I'll have to check.

*

"Why does your mind go down such dark corridors?" Jon, who has never been a worrier, asks. I don't entirely know, but I recognize the logical flaws in the brain pathways I follow. I'm a white woman with a home in the suburbs of eastern Nebraska; my body and my home are safer than many other bodies and many other homes. It's only my femaleness that has ever put me at any risk, however slight, however imagined—or however real. It's the "however real" propelling me down the corridors, and what I find at the end is always the same. A man has broken into my home. I'm alone. He subdues me. Sometimes I suffer humiliations and torments first, but regardless of what happens along the curve of my narrative arc, the ending—*my* ending—never changes. I die.

"Anxiety is the dizziness of freedom," writes Søren Kierkegaard in *The Concept of Anxiety*. Anxiety is worrying over the possibility of an intruder hiding in a hallway closet, while fear is opening the door and seeing a man's muddy boots sticking out from underneath a floor-length coat. At best, my thinking is the result of a mild general anxiety disorder; at worst, it is delusional. I recognize the improbability of my anxiety (an unfocused and ambiguous threat) transforming into a human body (a living, breathing threat) even as I feel the weight of the chef's knife in my hand. How did I—a wife, mother, college professor—get to be this way?

*

I trace one of the origin stories of my fear to the year I was ten. Every week on my family's television set, human-looking aliens plotted how they would steal the earth's water and use it to resuscitate their dying planet. Initially, only the aliens' vermillion uniforms, militaristic and designed for space travel, distinguished them from humans. And then

one evening an alien became agitated. His skin stretched tight across his face as if he were riding on a roller coaster. It tore, split, and pulled apart, revealing the face of a slimy green lizard. The lizard man jumped on a real human and killed him. Disturbing transformations from humanoid into reptile were repeated weekly. The series was called *V*, for Visitors, and it was one of my father's favorite sci-fi shows. He sat in his recliner, glass of Bacardi rum and Coke in hand, while my nine-year-old sister, Debbie, and I sat on the floor, watching from between our fingers. People were never what they seemed on *V*, and neither was my father.

On good nights, he propped his feet on the ottoman, chain-smoking and drinking, rarely leaving his chair, while my mother brought him cookies and potato chips. On bad nights, he transformed from the man who, after hard rains, collected earthworms with us for fishing trips along the Platte River and into the man who punched a hole into the kitchen wall, scolded and screamed, and yanked us around by our scrawny arms and the scruffs of our necks. My father looked like he belonged to the Harley-Davidson culture and for many years had in fact ridden one. He dressed his tall, muscly frame in dark T-shirts and jeans and sported a long, bedraggled beard and bushy eyebrows. He smelled of rail grease, cigarettes, and the woody odor of English Leather. In his youth, he'd dropped out of high school to join the Marines, and out one evening with other recruits, he had a small "13" tattooed in green ink in the crook of his left hand. "I'm not afraid. For me, thirteen is lucky," he'd say. On some of the bad nights, my mother threatened my father with the divorce we all knew she'd never follow through with, and then he cried out in drunken pity and bitterness, throwing his hands into the air: "I might as well leave and live somewhere else if I'm unwanted!"

It was as if the seam holding in who he'd been before ripped, and out stepped another man, one full of venom. Debbie and I never talked about the confusion of loving a father who had two selves. Instead,

we used *V* as our code letter for anything bad. "Did you look behind the couch for V?" we said. "Better say your prayers or V will get you while you sleep." After watching the show every week, we ran down the dark hallway to our bedrooms, too frightened to check under our beds and in our toy chests for the inevitable Lizard Man. My father took advantage of our fright and hid in the laundry room closet, between the living room and our bedrooms. He listened for pattering feet and giggles and then lunged from out of the darkness, his large, hairy arm looking more reptilian than human. When we shrieked, he laughed and slapped his hands together. Everyone knew the game was supposed to be funny, but I hated it. It was the surprise—the scare—that amused my father and made me so mad.

I realize now that my father unwittingly conditioned me to fear bedtime, similar to how Pavlov conditioned a dog to salivate at the sound of a bell. As for the night my father crawled into my bedroom on elbows and knees while I lay in bed, covers pulled up to my chin, he quite possibly conditioned me to fear my own bed. He waited for the perfect moment, when my breathing was beginning to deepen, and wrapped his hand around my skinny leg. I shot up in bed and screamed. It was just a hand, my father's hand, not the claw of a carnivorous reptile. I started to cry angry tears. My father snickered despite himself. He was only playing around. Why was I so sensitive? That was all, but I made a vow that night: I would never be caught by surprise again.

<p style="text-align:center">*</p>

"What is your greatest fear?" I ask the college students I teach. One of the many questions from the Proust Questionnaire, it's a good get-to-know-you activity. I like it for reasons other than its potential to break the ice. It comforts me to know that my students have irrational fears, even if they don't act on them the same way I do. My students' answers are similar and frequently fit into neat categories: bugs (insects with stingers or more than four legs), common

fears (heights, flying in airplanes, dental visits), losing loved ones (self-explanatory), extreme ways to die (being buried alive, drowning, burning to death, epidemics), existential dilemmas (failure, ending up alone, disappointing one's parents), science-fiction fantasies (zombies, robots, mutant bugs), aging (losing one's ability to hear, see, walk, think), broad social, political, environmental, and economic fears (our country will never pay its national debt, women will always be treated like second-class citizens, climate change will doom the planet and the next generation), and fears most of us find humorous (boogers, baldness, being tickled by feathers, becoming lost in a cornfield). Like me, my students fear the dizzying possibilities of what lurks, if not under a bed, then inside of the chain-link fence of an ordinary backyard, deep in the waters of a childhood lake, and even within the cells of our own bodies.

Vanity Fair gives the Proust Questionnaire to celebrities so we can learn that having "gastrointestinal difficulties" was Julia Child's greatest fear (humorous) while snakes are Joan Didion's (common). Meanwhile, Bette Midler's greatest fear is political: "That the greatest days of my country are past." Some refuse to answer the question, one assumes because their fears are too great. When asked, Matt Damon said, "I don't want to give it a voice."

I, too, worry that voicing my fear might summon it, turning it into a self-fulfilling prophecy. Or perhaps when you name your fears, they can't get you. The only time I told a classroom of students about my nighttime checks, they laughed. I saw myself through their eyes: the thirtysomething college writing teacher, in her matching Ann Taylor skirt and blouse, lecturing about narrative authority by day and jerking back shower curtains by night. I laughed, too. It—*I*—was ridiculous. That evening, though, when Jon was working late and I was doing just the thing that when spoken about in daylight had seemed so silly—*so obsessive compulsive*, as one student put it—I couldn't find the humor in it. I had something in common with the type of men I feared; like them, I understood that who someone is in public is not

the same person someone is in private. We shape-shift according to the environment. We never truly know the person we're talking to.

*

A year before *V* exposed its yellow eyes and vertical-slit pupils in our living room, my father suddenly forbade Debbie and me to ride our bicycles in Bellevue, the southern suburb of Omaha where we lived. He also banned us from playing unsupervised at the park across the street. Both of my parents kept a watchful eye on us—she from the kitchen window, he from the garage—while Debbie and I played tag, stuck in our own fenced-in yard. Ordinarily supportive of our kid-only adventures to the point of obliviousness, the abrupt change in my parents' behavior surprised me. Even without explanation, I understood they believed my sister and me to be in some sort of danger, something so horrible that it couldn't be named. But what? Soon after, we moved from Bellevue to a home in the country outside of Louisville, Nebraska, and just as mysteriously, my father returned our freedoms to us. I promptly forgot about the whole thing.

What my parents were afraid to tell us then was that it was the fall of the Nebraska Boy Snatcher. John Joubert was stationed at Offutt Air Force Base in Bellevue—a mere ten minutes from our home—when he snatched and stabbed one Nebraska boy and then another in 1983. One of the boys was found nearly decapitated. (Over a year before these killings, he had murdered a first boy, in Maine.)

I finally put two and two together in high school, having read about Joubert in one of the books stacked on the steps leading upstairs to my bedroom. *Buried Dreams: Inside the Mind of a Serial Killer, Edward Gein: America's Most Bizarre Murderer, Confessions of Son of Sam,* and so on. The books belonged to my sister and were part of her criminal psychology school project, which had been both teacher- and parent-sanctioned.

As if I were still in morning marching band practice, wielding my flute and cummerbund, I high-stepped over the books when going up

the stairs. I hated when they were open to the pictures of the killers inside, since I felt like they could see me from wherever they were (earth or hell), and I kicked them shut or down to the landing. Too frequently, though, my curiosity got the better of me. When that happened, I brought one to my bedroom, reading random paragraphs until my idealistic worldview was sullied. Clever nicknames were given for each serial killer's preference of weapons, methods and places of killing, and sexual turn-ons. Hammer Killer. Railroad Killer. Monster of the Rivers. The Shoe Fetish Slayer. Half of the murder cases hadn't been solved and so couldn't be attributed to anyone, yet these men had enough gore-spattered murders pinned on them to earn their nicknames. The books made it clear most serial killers were male and most victims were female: Arthur Shawcross (thirteen women dead), Robert Hansen (seventeen women dead), Earle Nelson (twenty-two women dead). There was the rare survivor, too, whose testimonies I gulped down like air, like this one from *The Stranger beside Me*, about notorious rapist and serial killer Ted Bundy: "When I woke up about four, I saw him standing in the doorway. I saw his profile. There was a light shining through from the living room where he'd left his flashlight on. He came over and sat on my bed and told me to relax, that he wouldn't hurt me." Bundy was a liar and hurt the woman—taping her eyes shut and raping her—though unlike at least thirty others, she lived to tell her tale.

Serial killers were a fact of life, Debbie said. They didn't frighten her, they captivated her. (My sister now works as a psychotherapist. Perhaps my father's nighttime pranks conditioned a fear response in her, too, but instead of fearing killers, she wanted to analyze and treat them.) She read her books, she said, because they made her feel prepared. Prepared for what? I wondered. An encounter with the Schoolgirl Killer? There were too many man-monsters. Some were serving life in prison. How many walked the streets, or worse yet, walked my street? I could think of at least one. I took a small amount of guilty comfort in knowing Joubert targeted boys, the same

way I took comfort when a serial killer only went after landladies (the Dark Strangler; twenty-two dead) or prostitutes (the Riverside Prostitute Killer; nineteen dead)—groupings I didn't belong to. But Joubert frightened me because he had been so close at a time when I had been so naive.

Initially my sister's research was limited to library books, but due to her persistence, she eventually met Pat Thomas, the Sarpy County sheriff in the Joubert case. "When I asked John what he would do if we released him today," Pat told my sister, "He said, 'Well, I'd go out and find another boy and kill him.' He said it just the same way I might say, 'I'm headed to the grocery store to buy some peas.'" Pat told Debbie she should pray to never meet a man so evil. Debbie was unafraid of the possibility. I, on the other hand, feared what would happen if one of the Lady Killers described in my sister's books wandered into our own boring backyard.

*

The first time I lived alone was the spring after I graduated college. My job at a restaurant and bar meant I typically worked until 2 a.m. After my waitressing shifts, I came home to my cat and an empty one-bedroom apartment in southwest Omaha. I had a new bedtime routine. Before I took off my jacket or undressed from my uniform, I opened the coat closet and made a mental note. *Check!* Next, I went into the bathroom and yanked back the shower curtain. *Check!* Now, with blood roaring in my ears, I ran into the living room and would look behind the couch and then the chair. *Check, check!* Now the furnace closet. *Check!* The deck, the kitchen, inside the kitchen cabinets—too cramped for even the scrawniest homicidal maniac, but still I had to look—and into the bedroom to check the closet. *Check, check, check, check!* I saved the bed for last, getting down on my hands and knees to peer underneath. Again: *Check!* I was searching for a man—a Lizard Man?—who was waiting to rape me or murder me, or both.

When the apartment complex manager refused to install extra locks on my door, my parents brought over a contraption called a Master Lock Security Bar. It looked like a long robotic arm, and its job was to keep others—"What others?" my mother asked. "You live alone with your cat!"—from opening my bedroom door while I was sleeping. My cat behaved as cowardly as I had become, and the sound of a creaking floorboard sent us both scrambling to our feet. I was only satisfied after my father attempted to shove my door open with the mechanism in place, panting and cursing from the exertion.

I let my parents believe I wanted the extra security because I lived in an apartment complex notorious for its parties. My nightly ritual remained my secret because I didn't want to be confronted about it. My fear of male intruders contradicted the feminist writers I had fallen in love with during college. In the words of a Margaret Atwood character, "This above all, to refuse to be a victim. Unless I can do that I can do nothing." I perceived my fear as my character flaw, yet my behavior seemed reasonable to me. I was a young woman, living alone on the first floor of an apartment building with an unsecured front door. Other women were likely not engaging in similar nighttime rituals, but I didn't care. Weren't women who found themselves alone at dusk, thousands of them, typing in an office after dark, clicking heels on the concrete floor of an empty parking garage, fumbling for keys in an apartment complex hallway, merely unaware that someone was watching?

*

Men have invaded my sleep since I was a young girl. I dream about a man chasing me through unlit parking lots and deserted homes. The man is a dark shape in an alley, a monster at the bottom of the stairs, a volcano of evil in a flannel shirt and grease-stained jeans, always faceless. "Why do you think some man is out to get *you*?" Debbie asks when I call her following a night of unrest. Ignoring the emphasis she places on *you*, as if I think I'm hot stuff to be the chosen victim,

I confess I don't know. "Try to get a good look at him," she suggests. "Imagine he's a figure in a wax museum." He turns his head before I can see. I hide in a closet and bury myself in clothing belonging to a young girl. Sometimes I fly out of a window, but I can't outrun him; the ground is black tar, the stairs too many to climb, the doors bolted shut. I wake in a sweat, switch on a light. I look around the room to see if everything is in its place. I get out of bed and do my checks. In the aftermath of these dreams—and even though I'm a lapsed Catholic—I squeeze tight the ring rosary I keep under my pillow. I pray.

*

I want to be clear: I don't fear all men. I have always loved men. I enjoy and seek out their company. What I fear is one specific man. A nomad who knows how to cover his tracks, one who meets a woman and thinks about snuffing the life out of her. Such a man reaches mythological proportions in my mind, howling at full moons, except the man I fear prunes hedges, bags groceries, and pumps gas into his truck, folding into the crowd. He is ordinary only in how predictably his heart forces blood through his veins. Unlike the rest of us, who struggle with our inner spiritual conflicts between the potential for good and evil we all bear, who feel remorse when we kill a living thing without ritual or reason, this man transcends our fear of mortality by seeing a human not as "living" but as "thing." This man has become his shadow self. I draw a line under his name in a newspaper article or book, hoping this act of identifying empowers me—instead of making me neurotic. I bear witness to how he—the abuser, rapist, the serial killer—is parodied, studied, documented, made into T-shirt designs and sold on trading cards, written into song lyrics, personified in movie characters, glamorized and fetishized. Hiding behind this kitsch cultural obsession is a fear and loathing that is universally human: fear of the body's defenselessness against violation and death.

*

I understand statistics. The probability of a serial killer breaking into my home and murdering me is exceptionally low, currently 0.00039 percent. Former chief of the FBI's Elite Serial Crime Unit John Douglas once said, "A very conservative estimate is that there are between thirty-five to fifty active serial killers in the United States." Serial killers, though, are cagey. According to the algorithms produced by members of the Murder Accountability Project (MAP), the number of serial killers walking around the nation on any given day is likely in the thousands (if a serial killer is defined as someone who murders two or more people in "separate events").

When I was in my early thirties, an eleven-year-old boy and his family's housekeeper were slain in the small historic neighborhood in Omaha where I had recently moved. The police had a sketch of the man they suspected in the double homicide, which had occurred in a home I routinely passed on my morning walks. Two days later, a rapist surfaced (resurfaced, actually, but the police didn't know it yet) in my neighborhood. I had a teaching career I loved but no roommate. Even when leaving my apartment for a quick trip to the basement to use the communal laundry room—especially then—I secured my windows, front door, and the rickety back door that led from my kitchen to the fire escape. I did my checks. What would I do if my eyes ever met someone else's during those checks? Go bat-shit crazy. I knew where to locate the knives and scissors in my apartment. I imagined myself kicking a groin and scratching an eyeball. But I had no other weapons; I had no other plans. Meanwhile, the Midtown Rapist or Midtown Molester—as he was nicknamed—assaulted another woman. And then another. One woman was molested in an apartment a block away from mine, and like the other victims (and like me) she was young and lived alone. A newspaper blurb read, "He's a patient man who watches and waits for his victims late at night." *A Patient Man*, I thought: sounds like the overly ironic title of a *Lifetime* movie.

My paranoia reached a fever pitch. I never stayed on campus after dark. I never left my then-fiancé's house without an escort to my car. I never parked next to a white van when I shopped. (Incidentally, Jon drives a white van for his construction job; he calls it "the Kidnapper.") I lived with a lot of "I nevers." *I never felt safe.* A tree branch scratching my window or my cat plopping onto the wood floors from a chair sent me darting out of bed, ready to face the improbable. I had long ago crossed a line into unhealthy fearing and there was no turning back. I stopped sleeping through the night. I wanted to see him coming, whoever he was. I surrendered to over-the-counter sleeping pills, and when they failed, I sought a prescription to knock me out. When nothing else reassured me, I slept with a knife under my pillow (next to the ring rosary). I became a woman who behaved like she was next.

But I wasn't next. In the midst of my internal calamity, my fiancé and I bought a house in a neighborhood farther west, a solid thirty-minute drive from my apartment, where we still live today. I knew that I had escaped, and the first night, worn out from carrying boxes and furniture up and down stairs, I fell asleep without doing my checks. It was that simple and that complicated. Soon after, Jon and I married. We were newly in love, and during those first few months, I was never by myself at night. Even my dreams empowered me.

I feel my way along an endless white hallway, palms out. A man is shouting. No, now he is laughing. I look outside of the house through the only window. I see him standing in a sandlot nearby. I run to the roof and lift my arms. I fly. The man pursues me, running below me on the ground. I fly around a cul-de-sac, a neighborhood of pastel homes. In each yard, a different woman in a flowered housedress plays with a small child. I call out to each duo; I scream for help. The children hear something. They look away from their mothers and up at the sky, but they see nothing. The man is closer. He is running and he has grown King-Kong size. Before he grabs me, I am back in the house. I look out the window and see the man in the

sandlot. He shrinks to normal size. There is a gray truck in the sandlot. I will it to move with my mind. It runs over the man and kills him.

For nearly a year my fear disappeared, and my public and private persona lived in something close to harmony. Other women were not so lucky. The Midtown Rapist created his legend. He had sexually assaulted at least five women by the time the police caught up to him. (The man who had committed the double homicide would reemerge five years later, in 2013, to murder a husband and wife living in Omaha. In 2017 *Dateline NBC* featured a story on the serial killings, which they titled "Haunting.") That it had been a hard time in my life but an even harder time for those other women was not lost on me.

I wish I lived in a world where women and girls aren't abused and murdered. But, of course, I don't. So, when I'm alone and triggered, I do my checks. As with the evening when my fear returns in the shape of a moth. I leave the living room and pass by the closet in the den, a closet with room for hide-and-seek, a space I would normally check, but my intuition drives me downstairs toward the spare room Jon has converted into his office. *Kick the shins, knees, or groin,* I think. A gym trainer once told me I have powerful legs, and I'm foolishly counting on them. From the bottom of the stairs, I see the desk Jon has fashioned from an old metal door and two filing cabinets. Things are in their places. And then in the unlit space behind the door to my husband's office, I see something: an outline of a body wearing a green, hooded sweatshirt. I gasp. My knees buckle. It's him. I feel it. The Lizard Man, the Midtown Rapist, and my father, too. I have to satisfy the urge. I have to scratch. I push the door with an arm weak with panic and someone pushes back. Electricity travels from my head to my stomach. I might throw up. I force myself into the room, whipping the door toward me, where I'm confronted by a housecoat and a green sweatshirt, hanging on a new hook on the wall. No body, no man, no monster. Only me, shuddering and wondering: If there had been someone, would I have run up the stairs and out the front door, screaming into the street like a true coward, my only child left

behind? Or would I have fought until I finally reached the end of this story, his and mine?

Later that night, with my daughter asleep in her crib in the room across the hall from mine, my husband hundreds of miles away, and the moth beating its wings close by, I enter my bedroom. Before I can begin the descent into the dark, swirling tunnels of sleep, I get down on my hands and knees and look under my bed. It's a hard habit to break.

Recreationally Terrified

An unconscious man, hairy chest exposed, lay flat on a medical table. Another man, with the kind of horseshoe pattern balding that recalled my least favorite grandfather, stood over him, forcing two round paddles onto his body—defibrillating, a word I didn't know as a young girl. Already agitated, a feeling heightened by the sound of howling wind and the sight of another man holding a gun, I couldn't stop watching even as the unconscious man's chest ruptured, splitting open to reveal a gaping mouth, fanged teeth, and a whole lot of gunk within. The balding man's arms disappeared elbow-deep, reappeared as bloody stumps. Parts of the dismembered arms jutted out of the stomach-mouth. My heart twitched in my chest. My breathing quickened. My limbs vibrated.

Just then a screen door banged shut and I jumped, finally able to look away from the room on the TV and into the living room of my real life. It would be many years before I would stop jumping when doors banged closed. And it would be many more years before I would stop fixating on the scene I had just watched, dubbed by fans of John Carpenter's *The Thing* (1982) as the "chest chomp."

My mother, returning from where she'd been chatting up a neighbor on our lawn, flicked off the TV and sat beside me on the couch. At least, she looked and smelled like my mother, with her lit cigarette, salt-and-pepper hair (prematurely gray) cropped boy-short and sprayed with Aqua Net, and congenial smile, but she was different now. So was I. I placed my hands flat on her soft stomach, pushed into warm flesh, feeling for whatever hid within her, because I was never going to be the type of kid who sees a scene of body horror and recognizes the fantasy elements. Destined to be described by

the caregivers in my life—sometimes affectionately and other times testily—as a sensitive girl who takes things in, as *overly imaginative*, I refused to recognize the boundary separating what was possible and what was not. Instead of rejecting those on-screen images for the gory fiction that they were, my brain accepted them, my fear finding a logic and neural pathway all its own. *Terror* has never been a strong enough word for how I felt then.

Over three decades later, my memory of this afternoon stops precisely when I'm administering the stomach test to my mother—I assume she passed—and when I ask her about it now, *no*, she shakes her head, *I don't remember. I wouldn't have allowed you to watch that!* Overcome with emotion while watching reruns of *Little House on the Prairie*, she'd never wittingly watch a horror movie because she's sensitive, too. (*Jaws* is the only horror movie my mother has seen in a theater or at home and only because my father convinced her to do so.) She's also offended at the insinuation that I could have been terrorized this way in her care. My partial memory of this afternoon, though, remains intact, unnervingly graphic, and easily retrievable from the filing cabinet in my brain where I tuck away the origin stories of my greatest fears. And besides, mothers can't be everywhere at once.

My parents and grandparents, then in their thirties and fifties, respectively, had collectively never suffered so much as a broken bone since I'd been alive. People died, I understood this elusively in the way most middle-class children raised in suburban neighborhoods do, but I'd never seen a corpse on-screen or in real life. (I hadn't seen *Jaws*.) Bodies were whole and strong, like the muscles in my father's back rippling while he worked—shirtless and in grease-stained jeans—on his 1935 five-window Dodge coupe in the garage, but during *The Thing*'s "chest chomp" scene, I saw that they were easily halved. Weak and fragile. The discovery terrified me, and though the method of halving was farce, there is truth at its core: it doesn't take many tools or much force to perforate a human body. The space between *remaining* and *remains* wasn't as vast as I'd once believed.

We all make this same discovery at some point during our child-hoods, albeit through many diverse experiences, some more traumatic than others. These days my elementary school-aged daughter Lily, anticipating a visit to her pediatric doctor or dentist, asks: *What are they going to do? Will it hurt, Mommy?* The sight of a needle—the first bodily penetration most infants experience and in the tender seconds following their birth—sends her into hysterics, but she eventually acquiesces and accepts her shot or blood-draw, quivering and with tears streaking her cheeks. We carry on with true grit in the face of the knowledge that our bodies are predisposed to both wound and pain, for what choice do we have? Or maybe we become obsessed and anxious with our own delicateness, our mortality, with some of us unable to leave our homes, our beds.

Eventually, the memory of the "chest chomp" lost some of its hold on me, my sleep no longer disrupted by the nightmares that followed, and I almost forgot. Almost. But I would never be able to stop watching horror, and I admit a part of me has never wanted to. And the question this begs—*Why watch?*—perplexes me most.

Isabel Cristina Pinedo, writer and professor of media and cultural studies, writes that when watching horror movies, audiences experience "recreational terror," a term she coins in *Recreational Terror: Women and the Pleasures of Horror Film Viewing*. I first learned about Pinedo's book over a decade ago when I was a graduate student, recently given an opportunity to pursue an interdisciplinary study of the horror films of my youth while still earning credit for my degree in English. Women's reactions particularly intrigued Pinedo, who argues that horror movies offer women a safe and socially acceptable place to experience danger and violence and express inhibited emotions like terror and rage. Viewers react to simulated events in horror movies as if experiencing them firsthand: excitement, a fight or flight response, and an accelerating heartbeat—all indicative of the body's physical and emotional reaction before the brain can communicate a

rational one. The rational one being: *This horror you are witnessing is just a simulation! You need not carry these images with you as a possibility of what could happen to you tomorrow. Have fun and enjoy the thrill!*

Unfortunately, my childhood brain had limits to its rationality, and I bore those limitations well into adulthood; many people do, since the frontal lobe is still in development until sometime in our twenties. Movies and TV shows influence our understanding of reality, shape our social norms and mores, and stoke or calm our anxieties and fears. This influence is strongest when the viewer is young, though researchers don't yet seem to know if the impact lasts months, years, decades, or a lifetime.

Before writing her book, Pinedo viewed approximately six hundred movies, among them *The Thing*, which engages the cumulative paranoia experienced by a group of male American scientists who face off against an alien capable of both metamorphosing into and exterminating any other life-form. Pinedo writes that it's the Thing's ability to pass as first dog and then human that contributes to the mounting paranoia of the characters on screen and by proxy, those viewing the film. One character after another expresses something to the effect of "I don't know who to trust anymore." The Thing never shows its original form, a true "face," but only mimics an amalgamation of those it has previously killed, which makes it ultimately unidentifiable. It could be anyone, or as Pinedo quips, "any*body*." Pinedo writes, "The film throws into question the distinction between reality and appearance, human and alien, by contrasting the apparent normality of the crew with the knowledge that some are not human."

The distinction between reality and appearance consumed me those first few months after I witnessed the "chest chomp" as a girl. Any of the men around me (or my mother!) could have the Thing inside of them and not know it, similar to how we are unaware when a parasite or virus has taken up residence inside of us until our bodies expel the threat. In those instances—after the expelling and the knowing—we usually return to our previous healthy selves. Except in *The Thing*, the

knowing happens when a body splits open, new eyeballs sprout, or a few crimson-coated tentacles shoot out, making obsolete any hope of returning to a previous self.

Somewhere in all this gooey mess is a woman's viewing pleasure, according to Pinedo, ostensibly amplified by the absence of female characters-cum-victims. (The only female "character" in the movie is the feminine voice of a computer.) Academics, critics, and fans alike have since developed a wide range of theories about the meaning behind *The Thing*. It's possible the alien is female, its presence forcing the men to confront their own shaky statuses within the crew's hierarchy—or their homoerotic and homophobic impulses. Some believe it expresses the widespread cultural paranoia characteristic of the AIDS epidemic. Others believe the movie offers a spectacularly gross allegory for childbirth. Or, as one fan suggested on a message board, it just as likely presents "a hideous metaphor" for evolution and our inability to accept a changing universe. The film could even serve as a metaphor for autoimmune diseases—like rheumatoid arthritis, multiple sclerosis, or lupus—where the immune system attacks its own body (its host). Regardless of one's theoretical stance, *The Thing* offers viewers a safe space to experience the blurring boundaries between reality (rationality) and appearance (fiction), human and alien. A safe way to witness pain, experience violence, and control our fears. Or at least, *mostly* safe.

As a graduate student in my late twenties, I was old enough to both understand and experience recreational terror while finally watching *The Thing* in its entirety, the death/rebirth at the end of the "chest chomp" revealed to me only then: the disfigured head of the man who still lay on the medical table detaching itself from the dying body and growing insectoid stalks to walk with. There, in my then-boyfriend's apartment, my own head resting safely against his broad chest, I laughed out loud at the gruesome absurdity of the reanimation of what should have been a carcass and at the suddenly obvious limitations of eighties special effects—though critics agreed

that they were astounding at the time—and then drove home to my own apartment and slept with the lights on.

I slept this way for a solid month (unless my boyfriend or a friend slept over, in which case I experienced no fear at all since my fear was tied to my being alone), until my irrational fear of finding an oozing head-spider-thing clinging to my shower ceiling, crouching inside a kitchen cupboard, or worse yet scuttling out from under my bed, finally disappeared. But it wasn't the physical appearance (fiction) of the Thing that most frightened me—as repulsive as it was in its alarming misappropriation of life (just Google "Dog-man-thing Carpenter") and its drab colors suggesting filth, decay, and bowels—but what contact with it represented: *pain. So much pain.* A pain that can't be anticipated or imagined because to know it is to transmute into the living dead. The kind of pain that contorted and devastated a human body until it was unrecognizable, an abomination. To encounter it was to lose all control over what made one human, the self turning into something utterly and unforgivably grotesque, refusing to die even though the contortions rendered the body unlivable, devoid of dignity or soul—a thing. A Pain-Thing.

It's an interesting observation of contradictory human behavior, then, to admit that more than a small part of me enjoyed being frightened at my boyfriend's apartment, welcoming the drama of it all, the now-familiar bodily stress reaction. No longer a stranger to horror movies, I'd lost many hours in the basements of high-school parties watching *The Nightmare on Elm Street* series, *Friday the 13th*, and the first *Halloween*, the latter also directed by John Carpenter. Perhaps I should've been taking advantage of the chaperone-free home to pair off behind a couch or swig alcohol upstairs in the kitchen as my classmates were doing, but I was irresistibly drawn to the carnage on screen. Also, like the only young women who survived the slashing—dubbed Final Girls—I, too, was a Goody Two-Shoes, book smart, drug-free, and virginal, though not as edgy or brave or instinct-driven in the face of monstrosity and violence. (I would learn

about the Final Girl trope in horror movies from Carol J. Clover in *Men, Women, and Chain Saws: Gender in the Modern Horror Film*.) As the bodies piled up, I knew what to expect from my own: My heart thumped in my throat. Adrenaline coursed through my bloodstream. My body trembled. My fingertips—which partly blocked my view of the screen—tingled.

Less predictable was what I should expect from my mind. Would my teenage brain logically reject that the gruesome images on-screen belonged to the world I inhabited even as my nervous system reacted as if they were real and true? Or would I check under my car or in the backseat before I drove home to meet curfew, certain that if I didn't check, a man-monster would grab my shoulder as I sped down unlit, country dirt roads, the cornfields flashing by? (While I drove, I continued to recheck my backseat in the rearview mirror.) "Trust is a tough thing to come by these days," says R. J. MacReady, a helicopter pilot and *The Thing*'s protagonist. Played by Kurt Russell, MacReady specifically references the mounting paranoia afflicting the men in the film, but he speaks a universal truth: some people—and things— aren't what they seem, and they will bring us physical and emotional pain. This is what our worst fears remind us. We can't trust *everyone*.

Yet the push-pull between body and brain and between fear and logic invigorated me. In *Nightmare on Main Street: Angels, Sadomasochism, and the Culture of Gothic*—another book I went looking for during my obsessional graduate years of studying horror movies—Mark Edmundson writes that movies test a viewer's sense of superiority and control over plot and character. A movie with defining elements of horror "in effect gathers up the anxiety that is free-floating in the reader or viewer and binds it to a narrative. Thus the anxiety is displaced and brought under temporary, tenuous control." The idea that we have control over our lives and our own fear is seductive, though dangerously deceitful. After watching horror movies with my high school friends, at home and unable to sleep, I controlled this unsettled and unsettling energy to clean my cluttered bedroom, run miles on

my mother's treadmill, or madly type stories at the family computer. When I became recreationally terrified by the images of suffering and dying, I also never felt so alive. As much as the on-screen pain troubled me, I also reveled in the bodily consequences of, more or less, safely experiencing violence and rage—emotions girls are taught to suppress from a young age.

Sometimes the brain of our collective consciousness says *too much*. When it premiered, adult audiences were as appalled by the violence and gore of *The Thing* as I was as a child. Movie critics responded with what sounded like pure hatred and hostility. Roger Ebert famously called it "a great barf-bag movie." In a review for the *New York Times*, Vincent Canby wrote that the movie might amuse viewers who enjoyed "such sights as those of a head walking around on spiderlike legs; autopsies on dogs and humans in which the innards explode to take on other, not easily identifiable forms; hand severings, immolations, wormlike tentacles that emerge from the mouth of a severed head, or two or more burned bodies fused together to look like spareribs covered with barbecue sauce." In the science-fiction magazine *Starlog*, critic Alan Spencer wrote, "Here's some things [John Carpenter would] be better suited to direct: traffic accidents, train wrecks and public floggings." Revulsion, though notably not evasion, of *The Thing* became a communal experience. If *The Thing* was meant to provide recreational terror, it had plainly missed the mark.

Carpenter, who had already enjoyed box office successes with movies like *Halloween* (1978) and *The Fog* (1980), was hurt by the film's critical and commercial failure: "I was pretty stunned by it," he reflected seventeen years later. "I made a really grueling, dark film, and I just don't think audiences in 1982 wanted to see that." But Carpenter had had good reason to assume audiences would enjoy his creation; his Thing was a remake and revisioning of *The Thing from Another World* (1951), which was itself a remaking of John W. Campbell's novella *Who Goes There?* (1938), and now serves as a sequel to the 2011 film of the same

name as Carpenter's. Subsequent to the film's release, Carpenter lost his next job, which had been to direct Stephen King's *Firestarter*. In a 2013 interview at the Cape Town Film Festival, Carpenter said, "It was hated, *hated* by fans. I lost a job, people hated me, they thought I was . . . horrible, violent—and I was . . ."

Though my viewing of "the chest chomp" felt distinctly unique and oddly personal, I now wonder: how many adult under-the-bed-checkers exist because of this exact scene (a side effect of our viewing pleasure)? Of course, *The Thing* was rated R, and I was a child and didn't represent the audience Carpenter was hoping to reach. Though even his intended audience didn't respond as he'd hoped; Carpenter recalled a man fleeing the theater to vomit. So, I wonder, at what age is one old enough to enjoy being recreationally terrified? It wasn't until 1984 when the Motion Picture Association of America added a PG-13 rating, nestled between the grandmotherly, open arms of G and the putrefying corpses of R, alerting parents to content that "may be inappropriate for children under 13 years old." Steven Spielberg's 1984 *Indiana Jones and the Temple of Doom*, another movie I had seen, this time while under the care of an easygoing babysitter, had inspired the new rating with its scenes of human sacrifice, among other moments. I was twelve when it was released to video, apparently old enough to handle an Indiana Jones movie, and since I cannot recall a single scene from the movie with any specificity now (and only vaguely—and with awe—remember the heart-plucking scene), I conjecture that whatever impression it made on me was short-lived, unlike my viewing of the "chest chomp."

Research has long shown that children exposed to scary images and scenes like those found in horror movies suffer long-lasting aftereffects, whether jumpiness, sleep disturbances, or avoidance behavior, like checking under one's bed at night. A child's stress response network, made up of the brain, the immune system, and the endocrine system, is remarkably "sensitive," writes Paul Tough in the *Atlantic*.

"Sensitive" suggests a weakness in the contexts in which it is frequently used, but really means *an opening, an allowing in, a caring for an other*. Sensitivity is a characteristic we should cultivate in humankind, but also one that makes it tougher to survive being human. While Tough doesn't address horror movies, he does explain how the stress response network "is constantly looking for signals from a child's surroundings that might tell it what to expect in the days and years ahead." It isn't hard to figure out that repeated exposure to horror movies, just like repeated exposure to real violence and the negative childhood experiences Tough writes about, will eventually amp up a "sensitive" child's stress response, potentially altering the way a child views their world and responds to stressful situations. What is harder to figure out is where and at what age to draw the line.

Even my mother's trusted litmus test of what constituted family-friendly TV failed once or twice. A 1991 study later republished in the book *Media Effects: Advances in Theory and Research* found that sixth graders who watched a house-burning scene from *Little House on the Prairie* were later frightened about a fire happening in their homes and "less interested in learning how to build a fire in a fireplace than were children who were not shown the episode." The brain says *too much. Too much.* We flee the theater. But isn't the moment of fleeing a moment too late?

What we once believed surpassed the norms of culturally acceptable recreational terror—Carpenter was called a "pornographer of violence"—has become commonplace in movies (for example, *The Saw* franchise). Like the offensively adaptable Thing itself, Carpenter's movie refused to *just die already* and ranks as the director's eighth highest grossing film, raking in 19.6 million dollars. Many websites, published articles, and books tell the story of Carpenter's downfall and later return to horror grace; many more continue to analyze the thematic meanings of *The Thing*. Retrospectively, critics and scholars alike recognize its profound influence on the horror genre and pop

culture (even upon its disastrous release it found a smaller group of "its people"). Horror movie directors like Stephen King count *The Thing* among their Top Ten favorites. A horror classic. Averaging original negative reviews like Ebert's with reviews following its Collector's Edition Blu-ray release in 2016 and at the time of this writing, the aggregator Rotten Tomatoes scores it as "fresh," at 85 percent, with audiences scoring it at 92 percent. In more than one recent review, a movie critic calls the film "beloved"—a baffling descriptor. In 2018 *The Collider* listed *The Thing* as the best movie Carpenter ever made: "There have been several films that tried and failed to capture the same tight, intensely uncomfortable level of paranoia and mistrust that *The Thing* managed to conjure up in the early 1980s, but alas, none have come close to the ultimate master work that this snowbound thriller achieved." On May 15, 2019, Carpenter received the French Directors' Guild's Carrosse d'Or award for creative achievement in filmmaking—following a screening of *The Thing*, obviously. What has happened between the film's original release and the present day? Have we simply become desensitized to violence? Or in the face of real horror—school shootings, climate change, acts of racism and terrorism, sexual assault, global pandemics—do we now more than ever need movies like *The Thing* so we can temporarily feel in control of our fears, as Edmundson wrote? Likely, it's both things and more. But there's little doubt that at least some of us simply celebrate "entertainment gore."

Touting itself as *The Thing's* number one fan website and named after the research base in Antarctica where the movie takes place, Outpost #31 publishes fan fiction that fills in characters' backstories, organizes expeditions to the original set location, and shares deleted scenes and film trivia, whereby I discovered that the "total human body count" for the Thing is twenty-eight (including the deaths at the Norwegian Outpost that occurred in the prequel). At Outpost #31, a fan can also learn the names of characters before and after they encounter the Thing, though some names are too ambiguous to

easily link to a specific character. Split-Face Thing. Dog-Thing. Arm-Thing. And Norris-Thing, the first *thing* taking ugly hold in my mind, named after the man who lay unconscious—and condemned—on the medical table. All these years later, I'm still fixated on that scene, that body-rupturing, that appearance-reality dichotomy, that Pain-Thing.

Recently I spoke with my preteen niece about her long and growing list of horror movie favorites. Unless a horror movie is sexually explicit, if it's come out in the last decade or so, she's seen it: *The Conjuring*, *Lights Out*, *Hush*, six *Saw* movies, and *Annabelle*, for instance. My niece has the pale complexion and plump cheeks of a white cherub, her eyes are ice blue and wide, but oh, what those eyes have seen. Decapitating, disemboweling, hacking, slashing, dismembering, exploding, popping, and *blood, so much blood*: spurting, leaking, pooling, dripping, and congealing. Blood can do so many things. Maybe the pleasure I derive from thinking and writing the action words of body-maiming and subsequent blood activity provides further evidence of avenues to being recreationally terrified. Then again, images are more powerful than words, having the ability to bypass the thinking part of our brains and head straight for our emotions, filling us with adrenaline, causing us to react (or freeze, or blank out).

When I asked my niece if she'd seen Carpenter's *The Thing*, she smiled wide enough for me to see her braces and turned to fist bump her father—who had been standing nearby, drawn to our conversation about gross-out movie moments. They share a proclivity for the horror genre, though her mother and older brother have no interest, and the brother—an exceedingly well-mannered, husky high-school athlete—used to avoid the costume area of stores during Halloween season. Quickly claiming *The Thing* as one of her Top Ten favorites, my niece would later confess she'd watched the film a few times—she liked it *so* much—but left the room midmovie during the first viewing, the blood-testing scene at which point a character undergoes a gruesome transformation into thingness (Palmer-Thing), because it was "so gross. Almost too much." *Almost.*

Masterful as it turns out to be, *The Thing* affected and infected my brain, building neural pathways that contributed to what I'd most fear in my life as a child, teenager, and adult—and especially as a mother: people weren't what they seemed and couldn't be trusted, the human body was easy to break down, and danger was everywhere and close on its heels was pain, unpredictable and overpowering. I wonder now if this is what all fear boils down to. Unlike my niece, I am a person who has, over the course of forty-some years, feared the various permutations of a metaphorical boogeyman. I wish I could stop watching horror, and it would be inaccurate for me to claim I can't. (It's not as if a paranormal force drags me to the screen, clamping my eyelids open like the "Ludovico technique" scene in the 1971 movie *A Clockwork Orange*.) The fact is I don't want to stop watching because, on an intellectual level, I enjoy and am fascinated by the subversion of reality, the total collapse of logic, and the simulation of a near-death moment. Horror movies satisfy my curiosity, my craving to safely consume eerie and psychologically bizarre stories. They respond to my need to understand humanity's greatest fears and the ways we survive them. (Or don't, as with the nihilistic ending of *The Thing*.) Horror movies send my nervous system and mind into overdrive and offer me my recreational terror, the pleasure of my fears, just as Pinedo predicts.

Still, I've been cautious about what Lily is exposed to. For better or worse, she's already displayed signs that she's inherited my sensitivity and overly imaginative mind: weeping during a family-friendly movie where a truly "beloved" dog is injured, for instance, and refusing for two years to look at the page in *Snow White and the Seven Dwarfs* where the wicked stepmother disguises herself as a crone. The latter story, like most fairytales, expresses its own version of *Trust is a tough thing to come by these days*. Though I think "empathy" might be a truer word than "sensitivity" for what she and I experience. We both occasionally ache even for G-rated cartoon characters in peril.

Unable to shield my daughter forever from the R-rated world, I wonder: should I want to? Of course not. A certain amount of horror

belongs to the human experience. What if she enjoys the horror genre, like my niece, and is untroubled by its fictitious, bloody, disembodied, still beating heart? It's too late for me, but my daughter may grow up feeling empowered by today's modern Final Girls (who can embrace both their femininity and sexuality without being slashed into pieces; they can embrace their anger and violence, too), connecting not with the on-screen victims but instead finding herself elated and victorious, standing there among the survivors.

As I've gotten older, the things I fear have taken on a more realistic and frightening shape: the sheer number of sexual assaults against women and the ever-rising number of school shootings, as just two examples. The real world is horrifying, but as Pinedo writes, most of us can repress this knowledge and live our ordinary lives. Yet I've always feared horror movie fodder becoming new realities. And so the horror movie provides me with an illusion of control over my fears, management of pain, and pleasure in viewing, however brief and fleeting, while also paradoxically adding to my repertoire of things to fear. *Will it hurt, Mommy?* Yes. Some days it will. Even if we mothers could be everywhere at once, we can't stop pain.

During the restless nights that followed my first viewing of the "chest chomp," a dense ring of blackness visited me. I'd sit up wide awake in bed, my eyes settling on a large glob of black in the corner of my bedroom that seemed to pulse, larger then smaller. Larger then smaller. Larger. Smaller. When I slept, my head filled with images of things, but not all the things frightened me. I dreamt the Things I feared—like thin, hairless boogeymen with long fingernails—but also the Things I wanted, like a new bike with a bell and a basket; and the Things I loved, like the sensation of floating in inner tubes at my grandparents' lake. More often than not, sleep wouldn't come and the pulsing-thing pulsed, and anyway, my dreams of running away from the Things I feared ended in dead ends: endless hallways without doors and roads that fell away in

Road Runner–esque cliffs, like those from my supposedly benign, daytime cartoon viewing.

When I cried out, my mother came to me, pressed her hand to my feverish forehead and held me close to her, and though I welcomed her soft body and found it comforting, I didn't trust that she could keep me safe because I didn't have the language to tell her what I saw or felt. The embodiment of fear had manifested itself in the corner of my room, and I already understood that words alone would never be enough to make it go away.

Fracture

A bone is the squirrel skull that you find in the untouched big blue-stem grass near your home in the country, the elongated snout and sharp teeth crawling with the black bugs that your father calls "skin beetles" (a nickname they earn for eating flesh from carcasses). And it's a picture in a Louisville Elementary School textbook, thin arrows pointing to a dun-colored femur and mandible, words you memorize to please your teacher but soon forget. And a bone is the child-size skeleton hanging from a metal stand in your pediatrician's office, hollowed eye sockets, empty pelvis, and ribs that unnerve but also excite you. As a child, you don't think of your own bones as alive or learn until you are older that underneath the smooth, hard outer surface grows soft, vulnerable tissue that needs protection. But you do know that with the right amount of pressure, living things—like dead things—break.

Every Thanksgiving, while the women in your family bang around dirty dishes in the kitchen and the men smoke and watch football in the living room, you suck the warm meat from the forked bone found between the neck and breast of the turkey, two clavicles fused together. Your younger sister and you each grab a side and pull because whoever gets the longer piece wins. The wishbone easily snaps in two, sending a shiver of revulsion through your limbs. Perhaps the bone cracking represents an exercise in wish fulfillment (though your madcap wishes never will come true), or more likely, it's an exercise in violence. Before beginning, you must first consider which spot is most vulnerable. Which spot appears weakest? Which part of a bone will bend and then give?

*

You have no first memory of learning you are adopted, as if you were born with the knowledge in your marrow. But your adoptive mother remembers telling you about your closed adoption when you were two years old. "You," she said in a narrative that was encouraged at the time, "are my gift from God. You are special. Chosen." After three miscarriages, something deep inside of her had shattered, something a little like hope, but then you came along and her recovery began. Adoption agencies initially preferred closed adoptions because it was widely believed the closedness allowed the adoptive family to begin anew while protecting the identity (and shame) of the unmarried birth mother. The court sealed identifying information about an adoptee's biological family along with the original birth certificate. Contact among the triangle—adoptive parents, birth mother, and infant—was not encouraged, and due to the sealed documents, virtually impossible. Birth mothers didn't know who had adopted their babies. Adoptive parents didn't know the names of their babies' birth mothers. Agencies occasionally referred to closed adoptions as "secret adoptions" and left the level of disclosure up to the judgment of the adopted family, which meant some adoptees would grow up unaware of their biological origins and history, unaware of from whom their bones had grown.

*

You and Debbie sit unbuckled on the passenger side of your father's gray pickup truck (predating Click It or Ticket). When the truck and the dump trailer attached to it hit a patch of sand and gravel and the truck starts to skid and spin out, your father says, "Hold on girls. We're going in!" He reaches out a muscular arm to try and hold you both in place. The dump trailer slides into the ditch first, the truck follows, rear end leading, then flips and lands on its side. The air knocked out of your lungs, you lie on the dogpile bottom. Your father climbs out onto the side of the truck, pulls Debbie free from

your entangled arms, legs, and tennis shoes, but you can't grab your father's outstretched hand because your right shoulder and arm burn, as if you're pressed up against your favorite grandmother's wood-burning stove. Movement flames the fire. Gas has spilled down the side of the truck—you can't see it, but you smell it and your father stammers *something gas*—and he climbs halfway back into the cab to drag you out by your good arm and the belt loops on your jeans, with you suppressing a howl the entire time. Only then do you notice the blood dripping from his nose.

Your father and sister stand in the grass alongside the rural road waiting for help, while you crumple onto the ground. It hurts to breathe—*oh, God, oh, God, your shoulder, your arm*—but you won't cry, you won't break. You've heard your father say before, "You have to be stronger than the average," when talking about the fistfights he used to get into during his high-school years and when describing his work as a laborer at the railroad, but you think maybe he's also talking about you. You can't be average. And you can't be weak. You're special.

*

Your best friend from school, whom your father nicknames Louisville Lips because she chases after boys on the school blacktop with her puckered mouth, asks, "But who is your *real* mother?" and this confuses you. If one mother is real, what does that make the other? A fake? A copy of *mother*? You wonder about the real mother, the one who grew your teeth and nails and lungs in her womb and then labored through your welcome to planet Earth. The one who gave you away: a gift from God or a burden? Can you be both, one mother's start, the other mother's finish? Special to one, not so special to the other? What about her? Where is she? *Why didn't the other lady want me?* You first asked your mother this question when you were three years old. You now know better because when you do ask, she cries, holds you to her chest, and sobs, "I just think of you as my own!" You don't want to make your mother cry because you have come to think

of yourself as the soother of the broken dead-baby place inside of her. It's a lot of pressure, being responsible for her dead-baby recovery in this way. Can you withstand it?

*

You believe a fracture is maybe just a tiny crack in the outer bone shell, and thus, simple to mend and make whole. A break, on the other hand, splits clean through, like when you press your thumbs and pointer fingers together, flexing your forearms, and *snap*: a stick in half. Duct tape from your father's garage does the trick, with you clumsily realigning the broken pieces, and you think, *Good. Good enough.* After the truck accident, in the emergency room, nurses appear with a gurney to wheel you to radiology. When your mother arrives from her job as a credit union teller wearing a navy pantsuit and her single strand of imitation pearls, blubbering up above you—she who devotedly clips your toenails and braids your wet hair so it will look crimped when it dries—you finally break down. Tears and snot (and fear) run down your face, and you weep, *Mommy. Mommy.* An hour later and calm again, almost cheerful at the sight of your new sling for your fractured collarbone (your friends will sign it!), you think: *Well, at least it's just a fracture and not broken, like Dad's nose.* Because you still believe some breaks are easier to repair than others, some fractured things can be made whole again, like a stick duct-taped to a family tree.

*

You are a preteen when your mother hands you a thin manila envelope marked in her cursive in pencil: *adoption papers.* (You fuss over the pencil, so easily erased! Why didn't she use a pen?) You take the envelope to your bedroom to read privately, so your mother won't witness facial expressions betraying anything but curiosity toward your adoption. (It will be years before you identify the roiling gut-thing you also feel as grief, and years after that before you allow yourself to

talk about it.) Though there are only a few, not nearly enough to fill your need, you read and reread the documents, two of them printed on yellowing onionskin paper: your health statistics at the time of birth (*satisfactory*), a couple of lines about the medical conditions of your extended birth family (*Glasses were worn for correction*; of course! you've worn glasses since third grade), and four sentences each about your birth parents. She is German and *her interests are artistically inclined* (from here on out, you will wonder, *Could that be her?* about every female substitute art teacher). He is English, *with interest in medicine* (you won't wonder about doctors, though, because it's your other mother you're most fascinated by, the one whose womb you lived in). They were college students when you were conceived—not the wayward, unruly high school students you had every so often imagined, like the Criminal or the Basket Case from *The Breakfast Club*—and you begin to think of yourself as a love child. Not bastard. Not illegitimate. Not someone's unwanted, out-of-wedlock mistake. Instead, a child made from hand-holding and neck kisses and wishes made true from wishbones.

*

What does it take to break a bone? Perhaps a sweaty grip, a slip from the monkey bars and the arid dirt below, hard as metal. Or, maybe flying over bicycle handlebars, hands outstretched, palms out and fingers splayed to prevent a jaw from crashing into concrete. Or imagine a shoulder slamming into the window of a pickup truck, the truck upended, the clouds where earth should be. Within a few hours of the collision, the restoration process begins. Blood clots form around the injury, white blood cells arrive to carry off microscopic fragments and new blood vessels grow. Muscles around the break spasm, holding the broken pieces together. A few days later, a soft callus forms around the injury to prevent further damage. Within two weeks or maybe longer, cells arrive to regenerate bone and connect the alive but broken pieces. Bone remodeling occurs lastly, when cells break

down any extra bits that grew, and the broken bone finally returns to its previous strength and shape, a skeleton made whole again.

Occasionally, because of the nature of the bone trauma, a break doesn't reunite. Surgery may be in order, or metal screws, rods, and plates. Or a bone graft from a cadaver. When the fractured bone pieces don't mend and grow back together, it's called a nonunion. Invisible to the naked eye, symptoms include further bone deterioration, a feeling of not belonging anywhere or to anyone, and a deep, aching sense of loss that can take years to heal, if healing occurs at all.

*

From your adoption papers, you learn you were a month old the very day your parents met you and, less than two hours later, brought you home in a crude bassinet made from a cardboard box. (Later, you also learn your mother did not "choose" you as if from a display of babies, like at a pet store or flower shop; you were her only option.) Where were you for the first thirty days? "I don't know," your mother exhales, either flustered or exasperated—you aren't sure. And since you were adopted through a Catholic adoption agency, she says, "With nuns? I'm sure you were well cared for." But she doesn't know for certain who bathed, fed, or soothed you during your first month, and it becomes another piece broken off, misplaced, gone from your story. Did you mistake the nun for your mother? Was the separation from the nun confusing or painful? Or were there too many babies, not enough nuns to go around? Is this why your mother says, "You were such a good baby. You never cried!" Did you learn early on that no one would answer your wailing? More likely, nuns held and loved you—and if not in precisely the full-bodied, sun-filled way a mother would, then a close second or third or fourth—but you still agonize over those thirty days.

You read all the adoption books in your small rural town's school library, many of which theorize that babies removed from their "natural" mothers never learn how to bond with anyone else. You learn

that in the mid-1970s, shortly after your own adoption, adoption agencies began to change their approach to confidentiality when they discovered that infants separated from their birth mothers were traumatized. One book informs you that the first moment of separation sets into motion an adoptee's lifelong fears of abandonment. A second discusses the adoptee's predictable self-destructive patterns of behavior. Another book claims adoptees have a well-known increased risk for anxiety and are twice as likely to suffer from mood disorders than children raised with their biological parents. And yet another says adoptees will always fear the possibility of their loved ones being taken away from them. (One day when you are a mother, you will return to this theory again and again. Your daughter will be the first biological family member you live and make memories with. And you will fear too often that she will be torn from you. You hover too much, parent her too tightly. Because who would you be without her?)

Suddenly, every psychological affliction in the books seems like it's describing you, although your mother is usually nearby to assure you how special you are. Your mother's love for you is tender and tinged with a sorrow you don't understand, so you don't tell her you worry over the meaning of *special*, which also means *different* and *unlike the others*. A little over a year after you were adopted, your mother gave birth to Debbie. "My miracle baby!" your mother says.

Is *special* different from *miracle*? Which is better? You aren't sure. What you want is to be *ordinary, normal, part of a set*. If you are unlike the others in your family—your maternal grandmother says of Debbie's fine black hair, knock knees, heart-shaped face, and thin-lipped grin, "You are your mother's spitting image, child!"—then whose image were you made in? Who are you like? Your tangly dishwater-blonde hair, square face, bad eyes, and underbite. Who? Who?

*

When you return to an orthopedic surgeon for a check-up, he shows you and your mother an X-ray of your shoulder. He points. "Here,"

he says. "This is where you fractured your clavicle." You exclaim: "At least I didn't break it!" but he says he's using the word fracture interchangeably with break and they mean the same thing, just as clavicle is the medical term for collarbone. Adults are always telling you different words mean the same thing. *Real mother. Adoptive mother. Birth mother. Fracture. Child. Adoptee. Break. Mother. Mother. Mother.* "When broken bones heal, do they leave behind scars?" you ask. You imagine a ridged scar on your collarbone and are disappointed when the doctor tells you they don't. Sometimes, he says, bulges appear at the surface from the callouses forming around the break. Months or even years later, the body absorbs them. He adds, "When a fracture doesn't heal, the chance of future complications is high."

Later when you are alone in your room during the predusk hours, the rest of the household asleep, you rub the small, rubbery lump on your collarbone. In a few months, it will disappear. But for now, it's the scar you've always wanted. Proof of your body working to heal itself, the marvel of your flesh and blood, and your longing for reconnection.

The Secret of Water

1. Once home, I was afraid to give Lily a bath.

Two days after Lily was born, a nurse had walked into our hospital room and demonstrated how to maneuver her small arms and legs, wiping a washcloth around the raw stump of umbilical cord. "She's the size of a shoe," my sister-in-law said later, during her visit, peering into the plastic bassinet. Her comment startled me. Shoes could be dropped, kicked, tripped over, misplaced, and replaced. A pair of grungy tennis shoes were strung up on a telephone wire in our neighborhood. Never before had I felt as vulnerable as I did while gazing at my days-old daughter. Right then a new fear was born in me: my baby could be hurt because of something I did wrong, something easily prevented, something as simple as tripping over a pair of shoes.

Swaddled in a cotton blanket decorated with ducks, a virtual stranger blinked at me from where she lay in the plastic infant tub at our home. I struggled to recall anything from the past three days other than the actual birth. One image came to me: Jon's face when the top of the baby's head crowned, his eyes and mouth wide with surprise as if he wasn't sure a baby had been inside of me after all. I'd never seen that look on Jon's face in the five years we'd known each other, and it pleased me. Lily was her own coiled mixture of chromosomes and DNA, but the nurse who'd given my daughter her first bath described the complicated biological mechanisms through which any human being's conception could occur as a "miracle." Miracle meant intervention by divine agency, an idea I wasn't sure I believed in.

"Clip her fingernails so that she won't scratch her face," I remembered the nurse saying during the bath demonstration. I opened a clenched fist and, looking at the pink, miniature half-moons and skin

attached to her nails, shuddered. Moving bits of the blanket exposed her skin, yellow with jaundice. Her eyes, the corners dark with blood, stared cross-eyed at her nose. I said, "Welcome to planet Earth." She stuck out her tongue. I dabbed a warm washcloth around her nose, flattened from labor, and then with trembling hands, dabbed at her torso. She was a pupating caterpillar without a chrysalis.

2. My mother's middle sister, Carole Ann, waded at a public sandpit lake at age twelve with two other girls, one of them my mother's eldest sister, when she stepped into water up to her eyes. She panicked, swallowing water, and lost her footing on the sandy bottom. None of the girls knew how to swim. The other two left the water and ran for help. A man treading water nearby saw Carole Ann coughing and flailing her arms. He grabbed her long yellow hair and tried to keep her head above water, but whatever it was that had her pulled her harder and threatened to pull him in, too. He let her go and she sank.

Help arrived twenty-five minutes after Carole Ann had taken her last breath. Divers searching for her said the pressure in the deep water hurt their ears. They couldn't stay down for long. Not even the men on the boat, dragging the lake bottom with hooks, could find what was now "the body"—Carole Ann presumably no longer in it, already somewhere else. But where? The body was found by a lifeguard wearing an Aqua-Lung. Two hours had passed. Her drowning was the third so far in the county that season. Afterward, police speculated Carole Ann had stepped in a sand hole that trapped her, the lake dragging her down over twenty feet.

My mother, age ten, was home during the drowning. Two months later, my mother, asleep in bed, suddenly sat straight up, wide awake. "Something had scared me. I opened my eyes and saw Carole Ann standing next to my bed," she told me. She offered this story when I was growing up, seeking to plant the seed of faith, proof of an afterlife. Instead, another seed was planted in my mind: Bad things happened to good people. God wouldn't—or couldn't—prevent it.

"She wore her favorite dress, brown with yellow and white flowers and a fancy hem," my mother continued. "I was too scared to look at her face, so I closed my eyes. When I opened them again, Carole Ann was gone. I think she wanted me to know it was going to be okay."

It wasn't okay. Throughout the rest of her childhood and into her adult life, my mother rarely went into the water, except to shower—never to bathe. When she did it was a treat for my sister and me. In Hanson Lake, which was near my father's parents' home, I would grab her slick shoulders above the orange, plastic foam life jacket she wore, while she sputtered and giggled and tried to keep her head above water. "Don't hang onto me," she'd say. "You know I can't swim."

Thanks to the swimming lessons my father's mother, Grandma Grace, drove me and my younger sister Debbie to every summer, I swam like a fish: with grace and purpose, without fear. In summer months when the hot Nebraska air limped like a three-legged dog, Hanson Lake was the only place I wanted to be.

I relished the sensation of sliding from my inner tube and plunging to the bottom, squeezing the muddy sand with my toes. I would open my eyes and a bluegill would swim by. I imagined I was seeing Purgatory, a place where caught souls held their breath until enough of the living's suffering and prayers released them to swim up toward eternal joy. Carole Ann had been baptized, but what if she hadn't been pure enough to enter Heaven? She drowned at the same age as I was then, and I knew that I wasn't pure enough for Heaven, with my "sass mouth" (I talked too much during class), my U for Unsatisfactory that sometimes appeared on teachers' reports, and the thoughts I had about boys in my catechism classes, which my teachers—had I ever told them—would have certainly described as impure.

Whenever I was in pain—an upset stomach, a stubbed toe, or a fierce blow from a red rubber ball during a dodgeball game—I would think, "I offer this up for you, Carole Ann." I wished I could be like my mother's favorite saint, St. Margaret, who, as a young girl, tied ropes around her waist until her sides bled and offered

up her self-inflicted sufferings to those who waited in Purgatory. But I wasn't like St. Margaret; my pain made me angry, not pious, and I would yell or cry out, wanting my hurt to be acknowledged. I imagined I saw Carole Ann spinning in the murky water with me at Hanson Lake, hair like vines reaching out from her head, caught in an otherworldly current, until enough of my offerings would free her. Then I pushed off from the muddy bottom of the lake, resurfacing, gasping for air.

3. An eleven-month-old in Germantown, Maryland, drowned in the bathtub after being left alone for a few minutes. *So sad*, I would think when I heard these kinds of stories before Lily was born, and then turn my attention to another news factoid. I never thought such a thing could have relevance in my own life. I didn't understand the bottom-of-the-lake coldness of the word "tragedy" when paired with "child." But after Lily was born, I would snap off the TV or radio midstory, afraid I might cry at the cosmic unfairness of it all, afraid of feeling the pain of the Maryland mother, who would surely spend the rest of her nights dreaming about her child sinking underwater, eyes open, stubby arms reaching.

When Jon went back to work a week after she was born, Lily's baths were my domain, as well as round-the-clock rocking, nursing, singing, and diapering. I had to be vigilant. Without windows, the bathroom was the most isolated room in the house. The bathtub, with its hard, slippery, porcelain-enameled steel, upset me. I understood bathtub drownings to be very rare. To calm—or inadvertently stoke—my fears, I researched the numbers online. The statistical likelihood of Lily drowning during her bath wasn't much higher than the likelihood of her being struck dead by lightning, yet I was anxious. When lightning struck, folks often considered it worthy of legend, a mythological moment, statistically a "miracle," even when resulting in death. This was not the case for a bathtub drowning, which took more than one life when it happened, the responsible caregiver deadened by the

guilt and the *should haves*. The drowning should have been prevented, she should have taken necessary precautions, she should have made different choices.

Some say the very moment women transform into mothers, their maternal instincts kick in; the role of woman-turned-mother becomes unambiguous: protect, feed, love—three essentials to a newborn's survival. Sometimes infants die, but mothers are supposed to know better. Put them to sleep on their backs, choose breast milk for the antibodies, keep the house at a comfortable temperature, lock up the household cleaners, install baby gates near stairs, use a car seat, avoid the mall during flu season, chop up hot dogs into smaller bites, and don't ever leave a baby unattended, especially in the water.

On the phone, my mother tried to reassure me: "You can't control everything, Jody. Trust that God has a plan." I had once found comfort in those words, during mandatory catechism classes when I was young, but not anymore, not when illness, disease, natural death, earthly catastrophes, or even slight, unpreventable injuries intruded upon the people I cared for. I had grown into a religious mutt and believed in a mix of science, Eastern philosophy, Unitarianism, and the leftover Catholic teachings of my youth that I could never completely shake. What was God? A giant celestial hand guiding me toward a predetermined plan, holding me in bed at night while I lay awake, needlessly worrying about things I couldn't control? My belief in human agency both liberated and terrified me. Any mistake I made was mine and couldn't be soothed by the idea that it was God's plan. I preferred the terms *omnipresent deity* or *Higher Power* to embody my hope that someone or something greater than humanity would one day show itself, that my life had purpose beyond my years spent on earth, though I had no idea how or what. For now, my infant daughter depended on me for her every life need. I was responsible. We mothers were supposed to be little gods, guiding our children toward our—or God's or society's—predetermined plans. But we didn't always know how.

4. Jon knelt on the bathroom floor holding Lily on his lap, his hands under her armpits, ready to lift her and plop her into the two-inch-high water. I watched from the doorway. Her head lolled forward, and I stopped myself from reminding him to support her neck. Parenthood ushered our new selves into sharp focus: I was Uptight Mom and Jon was Laid-Back Dad, and in my sleep-deprived mind, laid-back translated into danger. We were still the couple who once took long bicycle rides through Chalco Hills, a recreation area near a reservoir, and, on dinner dates, liked to pretend what kind of businesses we'd open in abandoned buildings. But I wasn't sure who to be when I was with him now.

"Did you check the water?" I blurted, standing in the hallway just outside of the bathroom. "Lily's skin is more tender than ours," I said. He already knew this, of course. I stepped into the room and dipped my hand into the infant tub. "It's too hot!" I said. "You would have burned her."

Jon's body went rigid with anger. He wrapped Lily in a green towel with a frog hood and laid her on the carpet in the hallway. We were both so tired. We stood in the hallway glaring at each other while Lily studied her hands, cooing. "Don't you think I would have checked the water? Do you think I would hurt our baby?" he said. His nostrils flared. My mother-self was wearying to us both.

"I didn't have time to be polite and spare your feelings." It didn't help that we were in the middle of a midwestern winter; my hours were spent sealed indoors without the benefit of sunlight or adult conversation.

"Are you serious?" Jon said. "When are you going to trust me with her?"

I trusted him. It was the universe I didn't trust, the uncontrollable everything "out there." Bad things happened to good people all the time—to people in my family, to Carole Ann. Especially after something good, at the moment when you let your guard down, when you forgot that the hardest part of being a human was anticipating and experiencing loss, sometimes as a result of human error. During my

early years, my father lost his job, twice; my parents separated; a cousin shot drugs into his veins; my grandfather's alcoholism killed him; a schoolmate died in a head-on collision with another schoolmate; an old high-school classmate put a gun in his mouth; and on and on. My grandma Rose had buried a daughter and then heaped her grief onto my mother's dinner plate. I felt my dead aunt's presence when Lily's fingertips turned to mush in the bathtub. If God had a plan—like my mother told me—then His plan included bad things happening to good people.

But not yet to me. I felt due. What bad thing would follow to balance my good fortune? Unlike me, Jon trusted that everything would be all right.

"I'm sorry. I didn't think. I just reacted," I said. In the unflattering hallway light, he must have seen a new mother coming undone— glasses slipping down a greasy nose, a sweatshirt wet with breast milk, and hair that hadn't seen the inside of a shower in a few days. Why hadn't I bothered to shower? Water was one of the only things I interacted with that had such potential to ride the line between people living well and dying quickly.

In the end, Jon gave Lily her bath while I sat on our bed in the next room, eavesdropping. Jon talked to her in soft tones, and she squealed, his words indecipherable to us both.

5. The infant tub was crammed into a nook of our storage room. Lily no longer fit. I assumed my new bath time position: back resting up against the cabinet, feet pressed against the cold enameled steel of the outside of the tub, my butt cushioned by the rug. She washed her elbows, popped some soap bubbles, flopped onto her belly, and stretched out her toes to the outer limits of the tub. She said, "Mommy kiss," and then made a fish face with her lips. We grinned at each other like lunatics.

Evidence of the past year had disappeared into Lily's baths; red dust on her arms from the zoo's Desert Dome, mud caked on her

toes from barefoot walks through Chalco Hills, dirt underneath her fingernails from the neighborhood park, dried blood on her knees from a fall onto the sidewalk. But not all things could be so easily washed away.

Each month Lily's body had grown sturdier, the soft spots on her skull eventually closing, ossifying. She was more "kid" and less "baby," and my mother-fear that she would be hurt began to fade. Just months before she could only say "Mama," her arms and legs haphazardly darting here and there. Now she was holding a plastic fish and saying, "Blue," trapping the tip of her tongue between her teeth on the *l*. And *l*'s were not easy. When it was time to shampoo her hair, I sat up on my knees, leaned over the tub, and used a washcloth to wet her head. I sang "Baby Bumblebee." The heat radiating from her body surprised me. Water droplets collected in her eyelashes and on the tip of her nose. "Face dry," Lily said. She didn't like getting her face and ears wet. She never went under the water.

6. I left her alone in the tub: a quick trip—seconds, really—to the linen closet in the hallway. In that moment I felt above the danger, as if only I, her mother, her own little god, would sense if she were in trouble. I rummaged around in the closet, looking for the pink hand towel with the embroidered heart. It was Valentine's Day, just a few weeks after Lily's second birthday. Born with a dive reflex, babies hold their breath and open their eyes when submerged under water, but they still can't swim. I hurried back to the bathroom. Lily had not drowned. With her hair slicked back, I saw her baby face. She was wet, all ribs and backbone. Why had I let my guard down? Because I resisted the idea that it could happen to her and, if it did, that a spiritual awakening awaited me on the other side of the loss. I thought, *She's not going to die before old age. She could—the possibility exists—but she won't. I won't let her.* I raised my middle finger to the universe. *Don't even think about it, I'll combust right here and now, scatter into a million particles. And I'll take everything with me.*

48

I liked to think those babies who drowned weren't scared when they opened their eyes and that it felt like all the other firsts—first breath, first touch, first word—this one a return to the womb, a sliding in and letting go, an enveloping. I sat on the closed toilet lid and watched Lily. "Yucky," I said. "Don't drink the soapy water." In utter defiance, she dipped her hand in and brought it to her mouth. At times I thought I saw it happening, like a premonition—a vision of God's predetermined plan?—her trying to climb out of the tub, slipping and cracking her head, and then I knew where to put my hand and how to hold her so that she wouldn't be hurt.

I did it again—left her alone in the tub—to travel to her bedroom across the hall for footed pajamas, and once or twice, shamefully, downstairs to check food boiling on the stove, my heart thumping loudly, the bathroom door left open so I could hear Lily babbling. I remembered another news story. A Wellington, New Zealand, mother called out to her thirteen-month-old son from another room. He babbled in reply. Until he stopped.

Later, when Lily was asleep in her crib in her room and Jon watched TV in the living room, I scolded him lest he ever forget: "Don't ever leave Lily alone in the tub! Ever. It's not safe. A child can drown in three minutes."

He looked at me intently before responding, "Of course not." He furrowed his eyebrows as if solving complicated equations.

How did I fit into this equation? I was trying to prevent something, trying to control the variables. Was *I* the errant variable? How stupid of me. I promised myself that I wouldn't leave her alone in the tub anymore. *I wouldn't.*

7. During my childhood, baths were not a priority for my father's mother—Grandma Grace. Neither were traditional baptisms. Grandma Grace read books about reincarnation, opportunities to be born again physically because of the soul's urgent desire to correct past mistakes, to evolve. She told me, "Never be afraid to try new

things." A person could try anything if she believed in reincarnation. Her two sons had grown to maturity to have children of their own. She liked the smell and look of natural human bodies: hairy limbs and armpits, body odor, and yellowing teeth. When, during summers, I would spend the night at the small one-bedroom home she shared with my grandfather near Hanson Lake, I fell asleep on the couch she called a "davenport" wearing my damp swimsuit. "You're just going to jump in the lake when you wake up in the morning, anyway," she reasoned. My time in the lake marked the only washing up I did for an entire week.

Before I became afraid of being pinched by crawdads making their homes in the rocks, I would float in the ankle-deep water near the bank and run my hands over the green algae-covered surface feeling for smooth pebbles. I would try to walk on the rocks, despite my grandfather scolding, "You'll fall and break your head open." No, I wouldn't. I'd make my toes monkey-like, the silky algae squeezing between them, gripping onto the sides of the rock. Some days I would fall stiff-as-a-board backward into the water—we called it the Nestea Plunge after a popular commercial—unharmed. Other times, I'd scrape against the rocks with my elbow, knee or head, a bloody scratch as a warning. The rocks were too slippery to hold onto for long.

8. Lily slid around—hadn't I been saying to Jon that we needed to buy those sticky treads for the bottom of the tub?—until she was on her back. She strained so that her neck and head were out of the water. She looked at me expectantly. These were the moments I wanted to climb into and stay forever. I would protect her. If only it could always be so. Why did I feel now like everything presented a risk? My own childhood was spent diving from a dock, my body slicing through lake water turned green from algae. Undeveloped neighborhood farmlands, woods, and lakes were my preferred playgrounds. My kid-world had been a giant cartoon where nobody was seriously hurt. Even if Wile E. Coyote fell from a cliff during a high chase

pursuit with the Road Runner, he'd reappear in the next episode or be rescued by two doves, dangling him upside down by his ankles in the sky. All children should be so lucky to enjoy a feeling of invincibility. I wished for Lily a feeling of unbridled freedom, too—that feeling that the world would unfurl its hidden treasures just for her.

How do I temper that feeling with everything I now know? In grown-up world, Coyote doesn't reappear at the bottom of the canyon in a puff of smoke, unhurt except for the cartoon stars and squiggles surrounding his scruffy head, signifying his comically scrambled brains. In grown-up world, Coyote would get hit by a car in a grocery store parking lot, choke on a hot dog, or drown in a tub. He would struggle in a sandpit lake while nearby swimmers continued their game of Marco Polo. He wouldn't hover on clouds with smiling cartoon coyote-angels. He'd disappear.

Carole Ann disappeared. Her death wasn't fate, or part of a master plan. It was an accident, a mistake—an interstellar *should have*. God should have planned for Grandma Rose to be there the day of the drowning, to plow into the water and pull her still-alive daughter to shore before she began to struggle. But I didn't believe in God in this way, so there was no one to do any planning except for my grandmother. At home the day of the drowning, she tended to domestic duties, sorting and folding my grandfather's work shirts, cooking the dinnertime meal of meat and potatoes, sweeping up after her six children, who ranged in age from sixteen to nine, who once a week took turns, oldest to youngest, climbing into the cast iron tub. Cleanliness was "next to Godliness" in her house, but heating water was expensive. Holman's Beach, where Carole Ann drowned, was less expensive than Merritt's Beach—the one with a lifeguard, the one that cost an entire week's allowance, the one where my grandmother had told her children to swim. Grandma Rose survived the death of Carole Ann and then five years later, the death of her middle son, nineteen, killed in a car wreck. She couldn't be everywhere at once. No mother can.

I had to trust that the universe would take care of my child, of all its children, and at the same time, I knew that it wouldn't. It would be easier for my family if I believed that *what was meant to be, would be*, and that I couldn't control (or prevent) any of the variables. Instead, I believed in each moment. Where had Carole Ann gone? Heaven? The eternal darkness of lost consciousness? An inky black night pulsing with atoms? A celestial galaxy birthing stars, one of them Carole Ann? Where was Carole Ann before she was born? Where was Lily? I didn't know the answers to any of the questions I fretted over.

Lily, at age three, was forming her own early ideas. Lying in the bathtub, she said, "When you were a baby, you were small, and you were in my tummy and I was the mommy."

Strangers had trouble with the way Lily's mouth warped consonants, but I understood. I cradled my daughter's head in the bathwater.

She said, "When I grow up, I'm going to be a mommy. I will have a baby in my tummy, and it will be you and then Daddy."

Her ears were underwater now—a sensation that she had never enjoyed before—her eyes and nose above the water. We were both quiet, her staring up at the ceiling, the lukewarm water lapping at the sides of the tub as her body settled, me holding her dark head.

"Let me go under," Lily said.

I moved my hand, and her body and most of her head, still rounded out with baby fat, went under. Her eyes, above water, were wide open, her gaze steadily holding mine until I felt myself slip into their black and white Milky Way center. Then both of us were floating.

Firebreaks

Wildfires burn throughout eastern Washington on the day that my plane touches down in Spokane. One count has fifteen active fires, igniting in coniferous forests, on rolling hills, in grasslands, near state parks and in a handful of backyards. A few of the fires jump rivers and roads; others cross human-made firebreaks. Bone-dry grasses and unusually hot temperatures are to blame. So are people. It's early July, and even in counties that have banned fireworks, residents continue to shoot them skyward for their Independence Day celebrations. The largest fire this year, the Rail Canyon Fire, spreads across 880 acres of timber, brush, and homesteads only forty miles northwest of my parents' new home. A woman on the news recalls watching the fire from her living room window: "I got into a state of panic because you never know what's going to happen." What she feared happening, I imagine, is that the fire would engulf her house (it did) and burn her family (it didn't). Families evacuate homes. An emergency shelter opens at Mary Walker High School. Farmers and ranch hands move cattle, chickens, and pigs to rodeo grounds. Several families are left homeless. Nobody has died yet.

I ask my parents if they're afraid.

"Washington burns every summer," my mother says matter-of-factly. She sits in the passenger seat of a diesel pickup truck, next to my father. Her short hair has been white for nearly twenty years, but it's thinner now, showing patches of her pale scalp. My father, sixty-eight, an intimidating figure with his scraggly, long zz Top beard, black motorcycle T-shirt and jeans, looks more solid, younger than my mother though he's older by a year. They've picked us up— my daughter and me—at the airport, my mother blubbering at the sight of Lily, whom she last saw nearly a year ago, right before they

moved from Nebraska to the West Coast. I tried not to scowl at my mother's airport tears. Hadn't I begged her to stay? Hadn't I told her how hard this would be?

"Washington burns every summer?" I repeat. I sit in the back next to Lily, who dozes in her car seat. Jon will join us in two days.

"Oh, you know what I mean." She sniffs and looks out the passenger side window.

I do know what she means: fires are common in the West. The Rail Canyon Fire would have to blaze through thousands of acres to be considered a major fire. Its presence is not entirely unexpected for this region, though global warming accounts for the uptick in fire frequency.

"June was unusually dry. We hardly had any rain," my mother adds.

We? Already my mother sounds like she's from Washington. I remember the summer day she and my father surprised us on our suburban lawn with the news that they had sold their farmhouse in Fremont, a forty-five-minute drive from the prickly square of grass where we stood. They hadn't told us they were thinking about moving, a two days' drive at that. I was stunned. During their brief visit I kept my composure, but as soon as their truck disappeared around the corner of our street, I left Lily with Jon and took off in my car for an empty parking lot behind a nearby elementary school, rolled down the windows, and bawled with my whole body, like a baby—or like an abandoned child. I raged at the deserted lot. *How can my mother do this to me? To Lily? Doesn't she understand how this will change things?* My father and his only brother and his brother's family were estranged at the time and there weren't any other living family with our surname. Now Lily wouldn't know any. *Mom.* I sobbed in my car. *Don't leave me. Don't go.*

"Besides, the fires aren't near us," my mother says, drawing me out of my memory. "There's nothing to be afraid of."

Maybe she's right. I don't see any evidence of fires. We leave downtown Spokane and drive past a neighborhood of two-bedroom starter

homes. Several of the lawns are as patchy as my mother's hair, toys and trash litter the grass and broken sidewalks, screen doors and blinds are ragged, every flaw illuminated by the bright Spokane sun. We lived in a similar home when I was an infant. "A cracker box house," my father described it: a small box-shaped house with poor white people living a hardscrabble existence inside. We sail right by these homes without my father saying anything, and I wonder whether it's a good or bad sign of the distance between us and our past.

Twenty minutes later and outside of town, I spot the first fire through the windshield of the truck. There, on the east side of the highway, among the pine trees and native grasses on the rolling hills of Riverside State Park, is a smoke as thick as fog. I don't see any flames, just smoke. A helicopter makes an aerial drop, carrying water retrieved from the Nine Mile Falls dam on the Spokane River in a helicopter bucket, a giant red container that hangs from a cable several feet below.

As we round the bend and draw nearer, I barely make out the orange-tipped, yellow dancing flames of a minor fire, par for the course for people living in Spokane. Spokane means "children of the sun," named after the eponymous tribe who first settled the area over eight thousand years ago.

"I've never seen a forest fire before," I say.

"It's a brush fire," my father corrects. A retired railroad electrician, he prides himself on his knowledge of concrete things.

A forest, grass, wildland, vegetation, hill, home, or brush fire—does it matter? If they're not contained, they're all wild. My heart beats faster in response, not from fear but from witnessing the beauty in its wildness.

*

I'm not afraid of the brush fire I see in the rolling hills a mere fifteen-minute drive from my parents' new home because I wouldn't know

how to be afraid of it. I've never seen a wildfire in Nebraska, original home to the Omaha tribe, the "flat water" people, where I was born and where I've lived for most of my life. We prepare for tornado season instead of fire season by building storm cellars and concrete basements that we stock with canned goods and battery-operated radios. Jon once said it's hard to be afraid of something that you have no context for. When he said this, he was holding infant-Lily in his arms as he reclined in a chair and watched Tony Montana's infamous machine gun scene in *Scarface*. *Say hello to my little friend.* He wasn't concerned that the senseless violence and blood spatter on TV would affect her developing brain; her face was aglow in the light from the screen. I took her from his arms and fled upstairs. I'm not one to take any chances with what fears her brain can or cannot absorb. If it's true, as my husband also says, that to be brave one must understand the risk, then I'm not fire-brave, I'm just unaware. The fires of my youth—flaming in a burn barrel, fireplace, campsite, or smoke pit—have always behaved, snuffed out easily by a few handfuls of sand and dirt.

There are other things I fear, things my mother knows about but refuses to discuss, but wildfires aren't among them. When I was growing up, my parents sold one home after another. To be more precise, they gutted bathrooms, knocked down walls, tore out kitchen cabinets and flooring, repaired, remodeled, and *then* sold the six houses I grew up in and the five houses they've lived in since I moved out. They had their reasons: my father's lay-offs from the railroad, disagreeable neighborhood politics, neglected neighboring yards, boredom or, as was the case with our cracker box house, a longing for more space and a better life. With each new house purchased we had a renewed chance at happiness. But my father's job loss, laid-off not once but twice from working on the Union Pacific Railroad trains he loved, and my parents' escalating arguments and empty threats of divorce made happiness difficult for any of us to achieve. When my father felt he was losing control over his job and all of us—my mother, younger

sister, and me—he lost his temper. He yelled in our faces and struck walls. He said cruel things to us he'd later regret. He beat the dog, his fingers entwined in fistfuls of dog hair as he shoved its nose into the dirt. He slapped my sister's face. His jabbed us too hard with his finger. Over the years I've learned that ingrained in his fury was his fear of not being able to provide for his family, and to a working-class man, providing was everything. He worried he wasn't good enough for us. He was also terrified my mother would leave him, though he put on an angry front. I remember feeling afraid of him, his unpredictability, his wrath, and of what he might do—a fear that has never entirely left me and, as a young woman, made me mistrustful of most men.

When you live in the same house long enough, bad memories can be replaced with good memories happening around the same cluttered dining room table, near the same artificial Christmas tree, or on the same square of prickly suburban grass. But when you move frequently, as we did, sometimes the only memory you carry with you to the next house is the bad one. And everyone knows that if your new house isn't strong enough, the wolf will blow it down. "Is he outside of *our* house?" Lily asks when I read fairytales to her at night. "Show me the wolf." I don't tell her that in some stories the wolf is already inside.

I fear that the widening geographical distance between us will widen the emotional distance that's been there for most of my life. I thought of their Fremont farmhouse as a place of healing—a place for us to replace bad memories with good. We'd only just begun the work when they told us they'd sold it.

*

I once read that fear's purpose is to teach us how to handle situations that we identify as physically or psychologically unsafe. For my father, this psychologically unsafe situation is flying on an airplane. He won't step foot on one now, though he flew several times as a young Marine. That was before he learned about "metal fatigue"—the normal wear and tear on a plane—and began to suspect that some airplane

mechanics were sloppy at their jobs. "You can do things to avoid a car accident," he says, "but in a plane you have surrendered control to the pilot." With my father, it's always about his fear of losing control. Does he worry about the fate of Lily, Jon, or me in the air? Or does he trust whichever plane we board to eventually land soundly on the ground? I don't ask.

My father handles his fear by traveling only by truck, car, or boat. I figured out the consequences of this during my parents' farewell dinner at Brother Sebastian's, a dimly lit steakhouse and winery in Omaha decorated in the spirit of an "old world" monastery. We were all there, my parents, me with my family, and my sister with her husband, when my mother began talking about the heavy snow along the three mountain passes they would have to drive through to get from Spokane to the Midwest.

"Crossing Montana and South Dakota in the winter months is too risky because of the snow and ice storms," my mother said. "You never know when the interstate will close."

I thought of winter holidays and my winter-born child. "You'll miss Christmases *and* Lily's birthdays, then?" I didn't care if I sounded insolent. I had been feeling resentful since they first told us they were moving, and I wanted them to know it. My mother looked at me sharply, sniffed, and then concentrated on cutting the fat from her prime rib. My father crossed his arms and leaned back in his chair, sighing deeply. Hadn't my mother already told me they were moving to Spokane because she wanted to be closer to her two brothers and their families? They wanted to spend their last years with people who they loved and who were closer to their own age. Why wouldn't I accept this rationale? There was an awkward silence. I wanted to know why Lily or I wasn't enough to make them stay. Were they running away from the hard work of repairing our relationship? It felt like it. I wouldn't offer any gesture or phrase to ease the tension though I understood then as I do now that some fears are illogical. My father was more likely to die driving his truck along the sharp bends of

Highway 291 than in a fiery explosion in the sky. If I wanted to see them, I'd have to be the one to make the effort. So I did, planning a ten-day trip where we'd stay with my parents and begin anew the process of making happy memories.

*

My mother's brothers—my uncles, both retired Spokane firefighters—counsel my parents on what's known in fire science as a "home ignition zone." To prevent or slow flame progression, my mother and father trim low-hanging limbs of the evergreens near their two-story home. They plant blue spruce trees and whiteberry bushes around the perimeter of their backyard. The home's previous owners laid sod around the periphery of the house and installed an underground sprinkler system, and the combination of this carefully plotted out landscape will reduce the risk of a fire spreading from the rolling hills in their backyard to an evergreen tree planted right by their bedroom window. A fire can jump easily from a tree to a rooftop. My parents create firebreaks on a miniature scale, reducing or halting the advancement of flames, limiting the violence of a future fire, controlling what they can.

Roads, canyons, cliffs, quarries, green vegetation, rivers, lakes, and other wetlands are natural firebreaks. People create firebreaks by plowing, stripping, and bulldozing land, plants, and trees, replanting with fire-resistant vegetation to slow the progression of flames. One of the Spokane fire departments has a bulldozer that will become so popular in the coming months—it's so big! so loud!—that it will become a recognizable character in local newspaper headlines: *Spokane dozer digs fire lines this summer.*

Only once have we practiced a tornado drill with Lily at home. We grabbed blankets, pillows, and stuffed animals and moved calmly from her bedroom and down three small flights of stairs in our multilevel home. We brought a bag of potato chips and three juice boxes. Jon and I had located the safest spot in our basement laundry room,

under the stairs. My parents utilized a similar space in their Fremont farmhouse, except their level of preparedness was better: a roomy concrete basement cellar filled with a variety of canned goods, blankets, a battery-operated radio, books, and a portable electric generator. In comparison, Jon and I were preparing for a minor tornado inconvenience. Tornadoes had not yet made it inside the locked cabinet of fears in my brain, so I didn't prepare for a worst-case scenario.

One evening, after a pleasant meal in Spokane with my parents and my mother's two retired firefighting brothers and their families, I discover long metallic bars propped against the doorknob in my parent's bedroom and on the door leading to the deck. I recognize the Master Lock Security Bar as soon as I see it because I used one when I was in my twenties and living alone for the first time. Then, I feared a man would break into my apartment with its unsecured front entrance and attack me (even though the door to my apartment was locked). It was a mostly unjustified fear. I no longer bar doors with the Master Lock Security Bar. Instead, when I'm home alone and have seen or heard something alarming on the news—Gunshots in Northwest Omaha! Attempted robbery at the Kum & Go!—I double-check locks on doors and latches on windows. I look under my bed. I've always understood my fear of intruders as my character flaw, one I didn't think my parents and I shared.

"Why do you have those?" I point to the metallic bar propped up against my parents' bedroom door.

"To give us an edge on any burglar," my mother says. She stops folding the shorts and T-shirts that she's dumped from a laundry basket onto her bed and turns to face me. She tells me it would take some heavy hits to the door to break it down, giving my father enough time to wake and grab his gun.

"I don't remember you using them in Fremont," I say.

"Burglars aren't as uncommon out here," she says. She tells me a story about a man who lived in a home not unlike theirs, on several acres of land, some of it extending into hundreds of untouched acres

of native grasses and coniferous trees, who came home after a long vacation to find squatters living inside. The squatters shot him dead. To listen to her explanation, one would think her fear is logical. Is it? I reconsider my lock and latch checking. No, it's still statistically improbable. We fear what hasn't happened yet, what we perceive as a terrible possibility for tomorrow—or the next hour. I remember the woman on the news. *I got into a state of panic because you never know what's going to happen.* Anything is possible.

*

If the opposite of fear is curiosity, then we're most curious in our childhood, reaching out to touch the red hourglass on the black widow, the burning exhaust pipe of a just-parked motorcycle in the driveway, the man at the grocery store with the "Any Hole Is a Goal" T-shirt. Or maybe closing our fingers around the striped, flying insect that's landed on our palm because it tickles. Which is exactly what Lily does when Jon and I dismount and pull our bicycles off the Route of the Hiawatha, a fifteen-mile-long rail-trail along the Bitterroot Mountains. Jon arrived in Spokane the day before, and with my parents' encouragement, the three of us are enjoying two days along the Idaho-Montana border before we'll return to their home. The trail passes over seven trestles and through ten train tunnels in the Bitterroot Mountains. Jon and I wear helmets with blinking lights and Lily holds her own light, but the visibility in the train tunnels is poor. I like adventures if they are primarily safe for our daughter. Lily has been riding behind Jon, tethered to his bike in a rented bike trailer. I ride behind her. We've pulled our bicycles over to the side of the dirt road for a water break when she's stung.

She howls. I scoop Lily into my arms. "I saw it fly into her hand," I say. I press her close to me. "Let me see." She holds her left hand at the wrist with her right one. I see the area on her palm where the blood is rushing, swelling.

"Was she stung by a bee?" Jon asks.

Another bicyclist, resting nearby, has witnessed the incident. "It's a yellow jacket," he says. "A wasp." He opens the first aid kit that he's been carrying in his backpack and speaks to Lily in soothing tones. Jon and I look at each other. We didn't think to bring one. We're unprepared for what we did not know to fear. What if she's allergic to the venom? How far away is help? An EpiPen? I see her, in my mind's eye, red-faced and unable to breathe: anaphylactic shock. Later, Jon, normally unfazed, will confess he worried through a similar scenario— but Lily's breathing resumes its normal pattern as soon as she stops crying. She wants me to put her down so that she can explore. She's perhaps a little wary, but she's not afraid. Curiosity wins.

"Where are you from?" the bicyclist asks and when we tell him, he replies, "I lived in Nebraska once, for about three weeks, and then I got the hell out of there. Too small. Nothing to see or do. I live in Seattle now." He's helped our daughter, and so I let it go, his misunderstanding of a place I love. His comment stings more because my mother recently said something similar. Her rejection of Nebraska felt like a rejection of me and my childhood. I wondered: was it so easy to leave one's past behind?

After we've finished the bike ride, while we're waiting in line with thirty-plus other bicyclists for the bus that will deposit us at our cars, Lily is stung a second time, by another yellow jacket on the wrist of her same hand. My stomach sinks with dread. Two stings on the same day will increase the likelihood of an allergic reaction. Jon picks her up. She cries, "Get me out of this place of bees!" Strangers approach us with kind words and anesthetic wipes to numb the pain. "The wasps are very aggressive here," says a white-haired woman in red spandex shorts. The woman waits in line with her grown son and his two children. She touches me on the shoulder, mother to mother, and I feel less panicked, though not less angry. On the bus the windows are open, and I swat at the yellow jackets flying in and out of them and the small ventilation window overhead. I hate the yellow jackets, and in the moment, I hate that we've come to Spokane, too. Lily sits

on my lap and closes her eyes. She's worn out from the drama of the encounters with the yellow jackets, but she's not allergic to their venom.

When we return to Nebraska the following week, Lily will be afraid of the bumblebees that pollinate the rhododendron bush by our backyard deck. She will scream and run away from them, toward the kitchen door, even when Jon or I assure her these bees are gentle. Children learn *what* and *how* to fear through experience, when associations are formed between a stimulus and an unpleasant outcome. Will she now have a lifetime fear of anything resembling a bee or wasp?

Yet, Lily's ability to run away from the bees gives her hope. She hopes she will escape pain. All fear is ultimately related to a fear of pain: physical or psychological. Pain, like fear and like death, is a universal and profound truth. We hope it away.

*

We want our children to have a healthy fear. But what or who should they fear? Will fear protect them or make them weak? What artificial barriers should we build to protect them? What natural barriers should we put between us and our fears? Are heavy snow and three mountain passes enough? I've been thinking more about this as Lily becomes more observant, more intuitive of my actions. I worry about raising a daughter in a world where violence against women and girls is common—violence that frequently has its inception in one's own home. One day she will learn this fact, but not yet.

During our Spokane mornings, after the two of us have climbed the steps from the downstairs guest bedroom to my parents' living room, I watch Lily clamber onto my father's lap. He tickles her cheeks with his long, coarse beard. He reads her books where a family of raccoons make discoveries narrated in large block letters. He shows her how to carefully place a biscuit on the tip of his sitting black Labrador's nose—a test of patience and love for both the dog and

Lily. Lily adores her grandfather. When he walks outside to tinker in his work shed, she follows, just as my sister and I did when we were children. I follow, too.

One morning my mother serves breakfast on the back deck: scrambled eggs, last night's baked potatoes now sliced and fried, and hot-to-the-touch bacon. Jon has gone into town to gas up my mother's car, so it's just my parents, Lily, and me. My mother wears a floral, snap-down-the-front housecoat and hasn't yet stuck her dentures to her bare gums. I try not to notice how much older she looks in the mornings and how many pills she swallows, while my father has managed to keep all his teeth and brawn and has grown hairier.

We have a view of the rolling hills extending from their backyard, where my father says he heard a coyote howling the night before. He was afraid to let the dog go outside to pee. "The coyotes around here will rip a dog to shreds," he says. It's a near-perfect morning, except for the smell of the smoke from the fires that we cannot see and the fact that Lily is cranky from the two-hour time zone difference. She interrupts whoever is talking. She whines. I try redirecting her and my father scowls and stands, slams his open hand down hard on the table, rattling our plates and silverware, tipping over a glass of orange juice. "Be quiet!" he shouts. "Enough! Stop it!" His face is red, his cheeks puffed out. It's not his words that bother me—though he has yelled them—but the look on his face. It's a forewarning of fury-to-come that I know and remember well. If my childhood or teenage self were sitting here, I wouldn't say anything. I would retreat into silence and my own resentment, wanting him to leave me alone, even if what followed was worse, and it often was. It took little to provoke him then, and I feared setting him off the way someone hiking these rolling hills fears upsetting an underground nest of yellow jackets. I trod carefully.

Now someone else's perception of the moment is at stake. Lily has never had her grandfather's anger directed at her. She starts to whimper. My father has stung her, but it won't cause the same fear response

as the yellow jackets. She will forgive him, as I used to do. "Everyone calm down," I say, standing up—though I don't mean *everyone*, I mean only my father. "Don't yell at her." I speak firmly though I'm shaking. My mother looks uncomfortable. Quietly, she says, "Now. Now. Now." It isn't like me to stand up to my father, though it is like my mother to accept his behavior. I scoop Lily out of her chair and carry her downstairs to our guest bedroom. I sit next to her on the bed and look directly into her eyes. "Grandpa shouldn't have yelled at you," I say to her. "It's not okay. Adults make mistakes, too. He loves you." These are words that I wish someone would have spoken to me when I was young. I wonder why I don't confront my mother with her complacency. Am I a coward? No, but I know what my mother's reaction will be if I ask her, and I don't want her to move any further away from our past than she already has.

<p style="text-align:center">*</p>

The month after my parents sold their Fremont farmhouse but before they moved to Spokane, my mother confessed to me over the phone, "We're lonely in Nebraska. There's not enough to do." I didn't understand. I ran through a list of self-centered questions: Didn't we see them every week? Couldn't they visit whenever they wanted? Why didn't they move closer to us, not farther away, if they were lonely? Didn't she want to see Lily?

Now, on the morning that we make plans around the kitchen table to travel to Priest Lake, Idaho, for a boating day—to gaze at lake water "clear-blue-to-the-bottom," unlike the murky lake water my mother remembers in Nebraska—she says something new, something I haven't thought of: "Who will take care of me if something happens to your father? You? Your sister?" She sniffs. "What if I'm unable to live on my own?" I imagine the question hanging in the air between us, along with the smoke particles described on the radio in the Smoke Advisory. The Air Quality Index ranges from Good to Hazardous, with four levels in between. Spokane is two levels away from Hazard-

ous this morning, at Unhealthy for Sensitive Groups, but my mother has opened the windows "to let in fresh air" and probably to save on the air conditioning bill. Deep in the lungs these particles do their damage, alongside the carbon monoxide found in smoke, making breathing more difficult. But whatever danger exists is invisible to our eyes, and so this morning my mother characteristically ignores it while I silently fret.

My mother has a point. Neither Jon nor I are cut out to provide in-home care for an elderly mother while both of us work fulltime and raise our child. My younger sister suffers from chronic migraines that often make it difficult for her to care for herself. But I would visit my mother at an old-folks' home. Every day. Well, at least every week. My intentions would be good, but. . . . We've had this talk before and my mother reads my mind: "I'd rather you take me out back and shoot me in the head than put me in a nursing home." My mother feels safer in Spokane. She has family who will look out for her if my father dies first. She has family who would provide her with daily caregiving. "I hope we'll be happy here," she says. I hope, too. I hope my mother knows that, deep down, my bitterness toward their move is about my fear of our relationship changing in ways I'm not ready for. *She* is changing in ways I'm not ready for; no child is ready for her mother to age. No child wants her mother to leave her.

*

We all try to halt the progression of something we perceive as dangerous, setting our firebreaks. My mother moves closer to her brothers. My father refuses to step foot on a plane. My parents bar their doorknobs. My husband checks his cholesterol levels. My daughter runs away from the bees in our backyard. I tell my father to "stay calm." I stand between him and Lily: I won't let him hurt her.

My father won't lose his temper during the remainder of our visit, no matter how badly Lily behaves. He'll laugh at her antics. He'll tell me how smart she is. When she does normal kid stuff, he says,

"Isn't that amazing?" This is how I'll know he's trying to be a gentler person, his hard edges worn away by disappointment and loss. The frequency and quality of his anger has subsided; he's four levels away from Hazardous, instead of his usual one or two. Maybe he is learning that he can't control everything. Maybe he is learning to let go of his fear. I'm trying to let go of mine. The landscape, the wildfires, the wildlife, and my parents are all different here from what I'm used to: me, the stranger. Perhaps we're all being reinvented, another new home, another new beginning, with the geographical distance between us preventing our past from becoming our present. My parents' bodies are changing and softening from aging, of course, but something else is different, something harder to pin down. But I wonder if it's something akin to happiness.

*

One month after Jon, Lily, and I fly home to Omaha, five fires join in Central Washington to burn over 256,000 acres over several weeks. One of the five is the Nine Mile Fire, named for the community my parents live in. Three firefighters die while trying to outrun the flames in their firetruck, and several others are injured. President Barack Obama declares a state of emergency. Active-duty military land from a base in Tacoma. Seventy firefighters from Australia and New Zealand arrive to help. Many of the natural and human-made firebreaks prove useless. Bulldozers create new firebreaks as what's dubbed the Okanogan Complex Fire grows, but sixty-mile-per-hour winds help the flames blast through them. One report concludes that together the fires spread over an area larger than Seattle, Portland, San Francisco, and Los Angeles combined, making it the largest in Washington's history. Dozens of homes are burning to the ground, more than five thousand others are threatened. It's still burning, already covering three times the amount of total land covered in 2014. And not done yet.

I ask my mother, over the phone, if she's afraid.

"I'd rather take my chances with a fire than a tornado!" my mother says.

She reminds me of the 1975 tornado that swept through eastern Nebraska, killing three people and injuring over a hundred others, when we lived in our cracker box home in Bellevue. It's a story I've heard before. "I had you in a playpen in the basement. I was six months pregnant with your sister. Upstairs, your dad and uncle were watching for a funnel cloud from the living room window," she says. "A tornado can drop out of the sky and—poof!—everything you work for is gone. I could've lost all of you!" I hear what I think is fear in my mother's voice, but it isn't the end and it isn't even a beginning. It's dangerous work to love another human being. But we love anyway, knowing that we will fear for our children, parents, loved ones, and for ourselves. Knowing that, as it is with all fears, this one too, burns.

Haunted

There are houses in which bad things have been stored in the
basement or the attic—each of which is a metaphor for the
subconscious, a place to put away the dark memories of the past.

—EDWIN HEATHCOTE, "House of Horror: The Role
of Domestic Settings in Scary Movies"

The living room windows of strangers have always been alluring to me,
though the desire to look is the strongest when I'm feeling anxious,
out on a nighttime stroll through a neighborhood, walking off my
worry before I return to Jon and Lily and the only home we've ever
had. I imagine the stories of the women and children inside the dimly
lit rooms—always I imagine the children as happier versions of my
younger self, having easier relationships to home and family than I
did while growing up. I think about children being read to. Being fed
warm, buttered bread. Being hugged and carried half-asleep to bed-
rooms with heavy blankets and nightlights to fend off the boogeyman.
But in this scenario, I wonder if I'm the boogeyman, the one peering
into windows, yearning for someone else's experiences, my eyes and
thoughts going where they aren't welcome. I imagine a woman open-
ing the front door and inviting me inside for coffee, where we'd talk
about her day or about nothing at all. It doesn't matter. It's the illusion
of security and safety that I'm after. Maybe I'm wrong about what I'd
find inside. Troubled homes don't always reveal themselves so readily.

The Earth Home, 1983

The earth home had a living roof of dirt and grass, rooms for eating
and sleeping buried underground, brain-like within its skull of rein-

forced concrete. From the outside, it was odd and ugly, an eccentric site of domesticity. A brown brick garage and a solarium rose from one side of a hill. On the other side, a south wall of windows looked out from underneath the grassy roof and onto a front yard, where a tire swing hung from a tree on a braided rope. In one of only four pictures I can find of the earth home, it's nearly winter, the sky gray and leaden, and the deciduous trees have dropped their leaves, reduced to trunk and bark. I wonder who took the pictures—probably my father. But what was the purpose if not to capture an ephemeral moment of joy for our family? The only signs of us in the pictures: two abandoned children's bicycles propped on kickstands on a concrete slab in front of the house. And in another, a dull-yellow Subaru hatchback parked by the garage, where a gravel road dead-ends.

"It looks like a bunker," Jon, who once worked as an architect, says of the pictures. He stands behind me at our kitchen table, looking over my shoulder. "And it's too brown."

"You have no idea," I say. Inside, from carpet to cabinet to wall, it was decorated and painted in brown.

The earth home was our fourth home, in Louisville, a town of about a thousand people we moved to in the early eighties when I was nine and Debbie eight. We had left behind three other homes and neighborhoods, my parents always in search of a step up, always fleeing feelings of unrest and inadequacy. They didn't know it yet, but they wouldn't be able to outrun those feelings. (My parents' first home, before my adoption, was a rental.) Our first family home was what my father calls a "cracker box": a small, dilapidated home for poor, working-class white people like us. The basement walls and floors were made of concrete, which my mother loathed for its stark utility and then was grateful for when she rode out the "1975 Omaha tornado" with me in her arms and Debbie in her belly, my father and his brother watching the smoke-colored funnel cloud from an upstairs window. In between we lived for a short while in California, where my parents attempted and failed to buy a fumigation business. Our

third home's most curious feature was a wall of gold-veined, paste-up mirrors, which I stood in front of as a toddler practicing facial expressions. I have no memories of those earlier two houses—my father says in our first home we could hear the neighbor beating his wife—but from the third I remember my sister, a toddler, falling on the porch, the skin on her chin tearing open. For weeks afterward, drops of her blood stained the steps.

Pasture and a few cows bordered the west of our earth home, the farmland separated from our five acres with barbed wire. Beyond our front yard were the sun-freckled woods. Even if aided with binoculars, our two closest neighbors couldn't see inside of our earth home, and this was what my parents wanted. They were fed up with other neighbors and other people, and other than my father's childhood best friend and his wife, they socialized only with each other. "If someone pulls up in the driveway, I'm not a real nice person," my father once said. They desired the isolation, but they also desired a more contented family life, and isn't this what every new home promises?

After we moved in, Debbie and I discovered a lethargic cat in a tall clump of native grass in the woods, its belly hugely distended from eating a squirrel or rabbit corpse. We bent down close to it. We stroked its fur. Flies gathered in the corners of its still-seeing eyes. We raced back home and stole my father away from his work in the garage, bringing him to the sickly cat. "Not everything can be saved," he told us somberly, sending us home to our mother so he could end the animal's suffering privately. (I've never asked him what he did.) My father wanted to save things. He wanted to be a good husband and father, too—I can see that now—but he was insecure and, we soon learned, easily provoked. And when he was unexpectedly laid-off from his job at the railroad, he began to change. He was once a protective, caring father. Now he punched walls. He spanked us with his belt. He beat the dogs when they disobeyed or dug up the yard (we always had one or two, usually strays he brought home from the rail yards). He yelled and threatened. Grabbing Debbie by the fake fur on her

winter coat, he dangled her in the air in our kitchen, his face inches from hers, screaming at her, spittle flying from his mouth. Like a wounded animal, he howled, "I'll leave if I'm not wanted or needed!"

One afternoon my sister and I played a card game on my bedroom floor while my parents planned their divorce outside at a wooden picnic table, but not out of our earshot, dividing up the property. *Who will get the kitchen table, the yellow hatchback, the dog? Us?* I wanted my mother, who was gentle and softhearted, to take us with her, but she was only bluffing. He's the only man she's ever slept with, the only man she's ever made a home with, and making a home with someone counts for something, doesn't it? Instead of divorcing, they made plans to sell the earth home. We couldn't afford it.

As if infected by the misery we were trying to leave inside of it, the earth home began to decay and rot, moisture leaking in through cracks in its skull, dripping inside the walls. My sister and I discovered green and brown spots growing in the backs of our closets. The spots spread in the insulation and drywall, too. Our underground home was alive in other ways we hadn't foreseen: millipedes, sow bugs, and spiders found their way in through the cracks and clung to walls and crawled across ceilings. At night I slept with my bedcovers over my head, dreaming of baths where insects rained down on my naked body and filled the tub.

"A real health hazard," my mother says now. "We had no idea what was going on inside of those walls."

Frances Street, 2008

Already, I knew how the house spoke, every groaning door hinge, every attic-rasp, every sigh and moaning floorboard and wind-shriek. I memorized the sounds of Jon's and my first home together on Frances Street because I'd grown into a woman who dreaded being alone in homes. Hyperalert was a natural state for me. The house was my eighteenth home if I included two college dormitories and a few apartments, and the third state I'd lived in. Finding contentment

with a home and place had proven as elusive for me as it had for my parents, who were living in their tenth home, sixth city, and second state (and this number didn't include my mother's eight childhood homes and my father's seven, where neither of them ever had their own bedroom). Why did they move so much? Why did I? Perhaps we sought the one final home to sever us from the faults of our pasts; the one home to make us better people, where our ghosts wouldn't follow.

A choppy multilevel, my home on Frances Street had three small sets of stairs leading from basement to garage to kitchen to bedrooms. When the real estate agent had shown us the house, I'd fallen in love with the den, a small room that opened from the garage, with white bookshelves and walls painted "autumn moon." I'd pictured myself in that room, reading storybooks to our future babies. I hadn't pictured myself afraid. One evening when Jon was out late, a couple of years before our daughter Lily was born, I sat reading in the den when the basement made a new noise, like someone dropping my plastic storage bin filled with old high-school yearbooks. I couldn't steady my heartbeat or trembling hands, so I locked myself in the upstairs bathroom. I listened for footfalls on the three flights of stairs and breaths that didn't belong to the house. Was I sensing real danger in my home or only following the dark corridors of my own mind—where I watched a faceless man remove the screen from an egress window in our basement and then climb inside? It was the not knowing, the uncertainty, that paralyzed me. I called my sister on my cell phone.

"Why do you think there's an intruder in your home?" Debbie asked, unperturbed. She'd grown up to be the more practical of the two of us.

"I just feel in my body like this is how I'm supposed to die. I dream it. I see it," I said. On more than one occasion, when I'd gone downstairs for a glass of water during the darkest hours of the night, a sensation overtook me: A man steps out from the blackness and covers my eyes and mouth with his hands, pulling me backward onto the floor. I panic, choking on my own dread, before I realize what I'm feeling isn't happening. There was no stranger's hand at my throat.

Why did it always feel so real? Could it be a forewarning? A vision of myself from the future?

"I know you dream about it," Debbie said because we'd been here so many times already. Me, calling her from some room in an apartment or home when night falls and I'm alone and afraid; and her, the psychotherapist, coolly pushing me toward reality and self-awareness.

I ignored her impatience and continued, "I mean, I know there isn't anyone here . . ." My voice trailed off. "I don't want to open the door."

"You do know that you have a general anxiety disorder, right?"

My irritation with her smugness surpassed my anxiety. "I'm ready to leave the bathroom. I'm fine."

After we hung up, I raised myself up from the bathroom rug and flung open the door. No one was there. Of course, no one was ever there who was not supposed to be. We lived in the suburbs, surrounded by retirees and young families, and still I fought the impulse to check. Yes, I recognized I struggled to control what WebMD called the "excessive, unrealistic worry" characterizing a general anxiety disorder that was never officially diagnosed other than by my sister and the internet, but I didn't fully understand where my agitation and obsessive-compulsive behavior came from.

The Brain House

When Lily draws a home, she remakes it into a face: two windows as eyes, a door as nose, the sidewalk as tongue, a gable roof and chimney as hair. I wonder: Does she already sense that her body's true home is within her own mind? Does her rendering represent her perception of her subconscious? Or does she merely see a resemblance between a face and a traditional two-story home? Likely, it's a combination of all three. Dr. Hazel Harrison, a clinical psychologist, uses the analogy of the Brain House to teach children about emotion regulation. Dr. Harrison says, "I tell them stories about the characters who live upstairs, and the ones who live downstairs. Really, what I'm talking about are the functions of the neocortex (our thinking brain—the

upstairs), and the limbic system (our feeling brain—the downstairs)."
I'd told Lily about Harrison's Brain House because she was often
overwhelmed with emotion that led to tantrums and crying jags.
When children encounter stressful situations, the characters in the
Brain House forget to talk to each other, the feeling brain overrides
the thinking brain, and children erupt with uncontrolled emotional
reactions and erratic behavior. It was a useful analogy for her father
and me, too, as using Harrison's saccharine nicknames calmed us when
we grew frustrated with her outbursts: *"Lily, what would Problem
Solving Pete do?" "Would he throw his shoe across the room or would he
try the laces again?"*

The brains of children exposed to "toxic," chronic stress, such as in
an unstable household and with an emotionally unpredictable parent,
develop differently than the brains of children who are exposed to
mostly positive or moderate stress. "While we are less sure how these
early-life experiences change the brain, we do know that the brain
responds by changing its structure, gene expression, and function,"
write Dr. Regina Sullivan, a developmental behavioral neuroscientist,
and Elizabeth Norton Lasley, a science writer. I feel confident Lily's
brain has not had to endure toxic stress, though Jon and I have cer-
tainly made poor parenting choices at times, equating to moderate
stress. Science has shown us that children who have survived trauma
(toxic stress) are less able to effectively regulate their emotions and
more apt to overrespond to even mildly stressful events.

Moreover, children whose brains "turn on" the autonomic nervous
system (located in the feeling brain) repeatedly and for prolonged
periods of time have a higher likelihood of later developing a mental
illness (like a general anxiety disorder) or chronic physical conditions
(like an autoimmune disease), among other behavioral and relation-
ship issues. These children's brains are always on high alert, ready
to detect a threat and engage in a fight, flight, or fright response:
pounding heart and quickening of breath, blood rushing to muscles,
etc. Oftentimes, the event that triggers the stress response network is

perceived as being frightening. "We have learned that fear plays tricks with our memory and our perception of reality; we have also learned that the fear systems in the brain have their own perceptual channels and their own dedicated circuitry for storing traumatic memories," writes Steven Johnson in an article for *Discover Magazine*. No, I'm not thinking about Lily here. I'm thinking about me and my Brain House with its own special filing cabinet of fears. I wonder, where is the line between moderate and toxic stress? At what point does our reality become polluted, the Brain House haunted?

Inside the Closet, 1984

Gail is renting a room on the third floor of a professor's mansion when, one night, she hears scratching on the other side of a locked, three-foot-high closet door. The professor has lost the key, he says. Gail suspects a rat, but Debbie and I, watching an episode of *Tales from the Darkside* on my grandmother's small TV set, could see it is someone or something, and one evening a creature with glowing eyes hides under her bed, pulling Gail's luggage with it.

We watched the series at my favorite grandmother's home on Hanson Lake, a one-bedroom house originally built as a summer cabin. While Grandma Grace drank coffee late into the evening or fell asleep in her chair, her dentures whistling with each breath—our grandfather asleep in one of two twin beds—we watched stories about souls being bought and traded or living in computers and the shadowy recesses of homes; devils, phantoms, aliens, and witches; robots and stuffed animals coming to life in front of unsuspecting people. The characters were often driven by animosity or vengeance, the tales ending with a twist or a moment of reckoning.

When Gail tells the professor about the strange occurrences in her room, he gaslights her. Another evening the creature reaches for her feet with clawed hands, seconds before Gail draws her legs up into bed: a near miss. As many of the episodes did, this one, too, eventually ends in death and ambiguity, as the small creature—hairless and skel-

etal, with razor-sharp teeth—breaks Gail's neck and wrests her into the closet (a moment of reckoning). The next morning, the creature finds the professor downstairs and bites his leg. He coos at it like one would at a daughter (a twist). Is the creature his daughter? Why did he lock her into the closet? Did he wish for Gail to die? And what does it all mean? Or, as I believed, did Gail die because she naively remained in a home that was slowly revealing to her its threats?

Unlike with my grandmother's other favorite series, *The Twilight Zone*, moral truths or ethical dilemmas were not always at the center of *Tales from the Darkside*. They were simply as the title suggested: dark tales. An alternate reality from what I saw during daylight. And I both loved and dreaded them. In no small way, the darkness on the screen comforted me—it was someone else's eventuality. From the floor of my grandmother's worn living room carpet, a bowl of salted popcorn on my lap, I watched as my own fear of someone lurking under my bed was validated on the screen. I wasn't so unusual. Why didn't Gail look under her bed? Perhaps if she had, she'd still be alive. These were lessons in survival.

"Inside the Closet" became one of the series' most popular episodes, now considered by fans as unparalleled. It's easy to see why: what child doesn't harbor fears of what lies in wait at sundown? Scientists theorize it's an inborn, primal fear in the Brain House, left over from when our ancestors slept on the ground or in a cave, wary of predators. As Peter Gray, a psychology professor, explains in an article for *Fatherly*, "the dark placed us in acute danger for thousands of years. It follows that a healthy fear of the dark, and the monsters that prowl at night, is deeply ingrained in the human psyche." Even surrounded by the relative protection of their own homes, children are afraid.

If not the actual source of horror in *Tales from the Darkside*, the homes hid something malevolent inside places like dusty crawl spaces and unfinished basements with pipes exposed like metal innards. As a young girl, I already knew there was a moment in the life of every home where its natural settling—foundations sinking into clay

and soil, concrete or brick cracking—mirrored that of its residents' unsettling.

The Lake House, 1987

The home on Hanson Lake was my sixth since my birth, a gray two-story with a screened-in patio, where I spent hours outdoors and in solitude, swimming or sitting on the dock, listening to the lake water lapping onto the shore. Upstairs, the two bedrooms where Debbie and I slept didn't lock; the doors slid into the wall. An important detail to teenage girls. Across the hall was one long connected closet, also with doors that disappeared into the wall. We moved here after my father was rehired at the Union Pacific Railroad, leaving the rundown rental property on Cherry Street, where we'd lived after the earth home and where my father ripped out carpet stained with cat urine. How I hated moving—"You attached freely and fiercely," my mother says now—leaving behind the places of my childhood, memories I would need to make sense of who I was as an adult. Diving into the lukewarm water freed me from whatever sadness I felt in again being the new kid at school, and now I lived across the lake from my grandmother's home.

My father was happy at first, content with work and routine, his sense of self intact, his role as the breadwinner once again secure. The rest of us could breathe more easily. Our new home—our new life—had the potential to be happy, too. During the summer, family gatherings were held on the beach in front of our home. Debbie and I spent hours waterskiing behind my grandparents' boat. After school, we played beach volleyball as a family, laughing at my mother's wild swings at the ball. My father told anyone who would listen about our school grades. During the colder months he came with our mother to our volleyball and basketball games, even if Debbie and I spent more time on the bench than on the court (which we both did), and cleared a spot on the frozen lake so we could play ice hockey with our friends. I let my guard down. I let the joy of being in a stable family seep in, believing that it could last.

A year after moving into the lake house, my father was laid off a second time. For working-class men like my father, having a job was everything. Without one, he wasn't a real man. He was nothing. I didn't believe this and neither did my mother, but my father did. Ultimately, that was all that mattered. I knew, by then, how to make myself go missing. I found *home* at my grandmother's or friends' houses and at high school, staying after class to run extra laps around the track or write articles for the school newspaper. But when I was at the lake house, I was too big to hide, and anyway there was nowhere to hide from my father. As we grew, his rage grew, too: it was his face and the gristle of his ears flushing, sweat pooling in pockmarks left over from teenage acne, his mouth a snarl, his eyes hard and hateful—a look that, to a young girl, says *I could hurt you*. Him sneaking into our bedrooms and reading our diaries—hoping for answers as to why it was all going so wrong—and then the confrontations after he read about our teenage rebellions, drinking beer at parties in the cornfields and fooling around with boys. It was the open-handed slap across a daughter's face for her sharp tongue. Telling a daughter to "choose the man who is better for you!" when he didn't approve of a boyfriend. And it was him cornering us in the only bathroom, using his wide frame to block the door while he complained about some infraction or another. "Get out of here!" he'd scream when I'd aggravated him. Sometimes, while he scolded me as I sat at the kitchen table, I forgot the relative protection of my stony silence and started to cry, and then he used a girly voice and mocked me. "Get out of my face!" he'd order. I ran upstairs to my bedroom, but there were no locks on the door. By the time my mother arrived home from work, we weren't talking to each other. "Why do you girls upset him?" my mother, ever loyal, asked. My father never apologized for what he said or did to Debbie or me, nor did we ever talk about our fights afterward. Our feelings were left unspoken, rotting like mold inside of our throats.

The brains of children are hardwired to bond with and forgive their parents, a fierce attachment guaranteeing survival of the species.

Sullivan and Lasley write, "The ability to bond with a caregiver is such a strong biological imperative that once a bond is formed—even with an abuser—it is difficult to break." The bonds with home proved equally hard to break, and I declared my affinity to each house we left. When my parents told my sister and me they had sold the lake house, nearly eight years after we'd moved in (the longest we'd stayed anywhere), I refused to learn our new address. By then, I was in college. My mother cited the politics that would raise their taxes, but I knew better. They were fleeing the pain we'd created there, absorbed into the structure of the home forevermore.

I sat on the dock, my feet dangling in the water. When I swam, I imagined the lake was mine, as if a life force inhabiting the water understood me. I felt protected—"at home"—when I was underwater, in my own world and out of my father's reach, waiting until I was dizzy to re-emerge. Where would I find this feeling now?

"You better follow us, or you won't know where we're going to live," my mother said. Defeated, I left with her, openly crying. My parents were accustomed to moving without asking my sister and me what we thought, which left me feeling unmoored, powerless. I wouldn't be uprooted again, hauled away without any control. I wouldn't. I decided then I would return to the home near campus I shared with five other women, and not just for the fall and spring semesters, as usual, but for the summers, too. I wondered about the next residents of the lake house: would they sense our presence, the ways we'd each poisoned the home with our resentment, our grief over the lost mirage of ourselves as a happy family? We'd never all live under the same roof again.

The Dream Home, 1997

As it approached the witching hour on Friday the thirteenth, Debbie and I flew down the interstate toward our parents' new home in Gretna, a raised ranch out in the country overlooking a small valley. They'd built the home themselves in six months while living in a rental

home. Several years from now, after my parents have moved again, my mother will say "the dream home" is the only house she misses. "There is so much of us in that house," my mother will say. Then, as if correcting a rare, vulnerable moment of attachment, she will add, "Never love something that can't love you back."

The midsummer's night was full of stars winking on and off in the black sky. My 1995 Chevy Cavalier trembled and shook at sixty mph, so I drove it at ninety. Our windows were down, our hair whipping around our faces, the radio blaring classic rock. Twenty minutes earlier we had left a party full of twentysomethings, barbeque ribs, beer, and the best pot either one of us had ever smoked. It was the first time my sister and I'd smoked pot together. My sister, now in her early twenties, had been married and divorced already—to an abusive man with a criminal record, including motor vehicle theft—and was sleeping in my parents' guest room while finishing her college degree. She struggled with depression and suicidal ideation. I planned to stay the night at the dream home because I feared sleeping alone in my apartment, having recently kicked out the man I'd been living with, who was the cocaine-snorting manager of the restaurant where I worked. I had earned my college degree but hadn't done anything with it, preferring the blistering pace of the restaurant industry and after-hours party scene. Every night before bed, I did my "checks."

"Hey, didn't we pass the Harrison Street exit already?" Debbie asked.

My hands gripped the steering wheel tightly, since I knew I shouldn't be driving. Hours seemed to pass while I thought about her question.

"That's like the third time we've seen that sign," I said.

Debbie leaned forward to turn the radio down. "And this strip of road. Haven't we been driving this same piece of road for an hour?"

We let out surprised yelps when we passed the Harrison Street exit again.

"What if we're dead?" I said. Outside the car window, lights from businesses flashed by us like spaceships.

"What? You're talking crazy."

"I mean, what if we died in a car accident, only our brains won't let us remember. Like we died in an accident on this stretch of interstate and now we're going to be stuck in this car, driving past this Harrison exit for an eternity, reliving this moment in time forever. Never going home." I looked at Debbie and our eyes met for one serious, prolonged panicky moment. We were starring in our own episode of *Tales from the Darkside.*

"For infinity, us together. Here in the car," Debbie said.

We burst into laughter and the Gretna exit miraculously appeared.

"I'm so high," Debbie said. "Wouldn't Dad be so proud of us if he could see us now?"

We'd been honor roll students in high school, and now we were stoned and drunk. We both struggled with our mental health. We dated hotheaded, domineering men like our father because during childhood our self-esteems had been pummeled. Who would want us? (Eventually we'd both right ourselves, but it would take several more years.) We still went home to wherever our parents were, but we had to numb ourselves first. We were just beginning to remember and talk. Did those things really happen? My mother's defense would always be the same: "Your father and I don't remember those years the same way the two of you do."

We were emotionally stuck, there on the strip of road and in our own Brain Houses, stuck inside of "those years"—our dark tale. We needed a moment of reckoning. If only the walls of our childhood homes could talk. I wanted them to scream.

The Forever Home, 2000

My mother didn't want anything to do with the Fremont farmhouse my father had dragged her out to look at, so he promised to remodel it. "I'll give you the kitchen you've always longed for. Your French doors." After several return visits, he talked her into buying it, though they'd have to clean out buildings full of sheep poop and rewire the

1889 farmhouse with modern electricity. They bought the house from Daisy, a ninety-six-year-old woman whose husband, Ernie, had died of a heart attack twenty years earlier. All their married life, Daisy and Ernie had lived in the farmhouse, raising sheep on the land that been in their family for over one hundred years. Their grown children weren't interested, and Daisy was in the throes of dementia, so their family legacy would end with my parents.

Soon after moving in, my parents began to suspect they were not alone. At first, it was the acrid, woody stink of lit cigarettes, as if my mother's sixteen-year-old self was hiding from her parents in the bedroom closet, dragging on a Winston. But this was impossible: neither of my parents had smoked since the early nineties, and they lived in isolation on forty-six acres of land in Fremont, Nebraska, their tenth home since my birth. The smoking intensified at night when they undressed for bed. One afternoon, my father felt a tug on his screw gun while he stood precariously on a ladder, installing drywall. He steadied himself so he wouldn't fall. The dog growled, his eyes tracking something as it crossed the room. And another afternoon my mother felt a push while climbing down the uneven basement steps with a laundry basket in her hands. She tumbled to the bottom and knocked her head on the concrete floor, unconscious for a few minutes, shaken but otherwise unharmed.

Spooked, my parents visited Daisy's daughter and learned Ernie had been a smoker, but he'd never been allowed to smoke inside. ("Well," my mother later quipped to me, "he's smoking inside now.") Ernie was a jokester, the daughter said, but he wasn't mean. "He just needed us to know he's here," my mother said. Soon after, Daisy died and the haunting stopped. Why? Was Ernie's spirit trapped in the home until Daisy could accompany him or he made amends or said proper goodbyes—or accepted his own death? I think of the imprint homes make on us and us on them, how even if we leave, more than our memories stay behind. Or maybe the spirit wasn't Ernie's at all, but was instead a past childhood self of mine, seeking revenge for the

ways I'd been hurt. The other versions of ourselves that have lived in a home but have vanished with the years can't be disappeared entirely. Ernie offered proof. But my father has tried.

After my sister and I confronted him about the abuse we endured—my sister used the word "abuse" first—he denied it. It had been my sister's idea. He needed to know why neither one of us could stand to hug or be touched by him, she said. The conversation ended with surprise and denial, followed by his characteristic anger, Debbie and I leaving the farmhouse in our separate cars to drive toward our separate lives (which were still on shaky ground). Afterward, he removed pictures of us from photo albums. Debbie and her prom date, standing together in front of the lake house, her blue sequined dress reflected in her blue eyes, her date's matching blue tie. Me standing in front of the lake house with one eye purple and swollen shut after I'd totaled my car on the way to school (my father took the picture). Debbie and I each cradling a white rabbit in our tan arms, standing near the woods at the earth home, the pine trees behind us, tall and protective, like ancestors. Us as toddlers, cross-legged in the dirt near our third home, the one with the blood-stained porch, holding mud pies up to someone who has the camera. Dozens more of them, proof of who we were, of where we'd once been.

My mother said he did it while she was at work. "Don't ask him about it," she said, her mouth tight. "Look in my Bible. The one in the curio cabinet." There, tucked among the pages of First Corinthians, my mother had taken a firm but silent stand, squirreling away pictures of us before my father could throw them out.

"Our forever home," my mother said of the farmhouse. But our ghost-child selves weren't welcome there.

Frances Street, 2013

Why did I check inside of a coat closet or behind a chair—any space I imagined an intruder could hide—when Jon was away? Why did I believe the privacy of homes was so dangerous? Because I knew that

all homes hold secrets. I was like the terrified teenager in my dreams who hid in an endless closet with doors that slid into the walls, covering herself in mounds of clothing fitting a little girl. Who was she hiding from? I never saw a face in my nightmares.

"Do you think the intruder in your dreams is Dad?" my sister asked, over the phone. This time I sat calmly on the living room couch, unafraid in the daylight.

I exhaled. It was the moment of clarity my sister had been pushing me toward for years, though on some level, I'd long suspected my fears were, at least in part, a consequence of my father's parenting. The faceless man chasing me in my dreams sometimes wore a flannel shirt like the ones hanging in my father's closet. On another level, I'd been living in denial. Once I'd dreamt the man was run over by a gray truck, the same color of truck my father drove. My own fury in the dream terrified me.

"You've never learned how to trust men because of him," Debbie said.

It irritated me when she slipped into her psychotherapist's talk. But more than that, it was painful to admit my father had had so much influence over who I had become. I wanted to free myself from his psychological embrace, but to do so, I had to be honest with myself.

"I think it's Dad in my nightmares," I said. In the precise moment I finally gave voice to it, I felt only the absence of fear. In fear's place, hope stirred.

Home

When my parents show up unannounced on my lawn on Frances Street and tell Jon and me, unceremoniously, that they have a "Sold" sign on the road in front of their forever home, I shouldn't be surprised. But I am. Recently they purchased plots at a local cemetery and had a tombstone etched with a picture of them with their new motorcycle. They've made new friends for the first time in many years and found a church they like. We've been, finally, all of us, making

pleasant memories at the farmhouse. And while there are large pieces of our family history we avoid talking about, our pictures have been returned to photo albums. I didn't know they were thinking about moving.

Standing bare footed in the summer grass, my young daughter hanging onto my leg, I ask, "To where?"

"Spokane," my mother says.

I haven't showered. I'm dressed in gym shorts and a T-shirt. Somehow these details matter: I'm unprepared for another move—another loss. How does one dress for loss? Feeling suddenly ill and unsteady, I ask my mother to reconsider but she says they've already placed an offer on another house. Their visit lasts less than fifteen minutes.

Later, when I've stopped crying and called to ask my mother for more details, she says, "Why should we stay when you won't let us have Lily for overnights?" She knows why I won't allow it: I don't trust my father's temper, even though old age and distance has diluted it. And I won't follow them and not just because they're headed out of state to Washington, where my mother's brothers live. I know my home is here with Jon and Lily. Yet I feel even now the pull of the earth home, the lake house, the dream home, all of the others, too, wrenching me backward into the bedrooms and basements and kitchens of my childhood, moments of violence and palpable fear. My sister and I are not done confronting my parents with our truths, but for the time being, my focus is elsewhere. Motherhood has shifted my fear and vigilance away from myself and onto my daughter, and I *am* a nervous mother. But I'm not a careless one. I'm determined to create for Lily the safe, warm home I've always wished for the little girl I used to be.

*

Late one night, Lily catches me down on my hands and knees by my bed. "What are you looking for?" she asks. I am aware this could be a pivotal moment. She views me as her guide in a world she is still

uncovering. I turn to look at her, innocent in her unicorn pajamas and her hair still damp from the bath, and for a moment, it's as if I'm looking into a mirror at my ghost-child self. Except I'm not. That child is long gone, and Lily is here now. Will I pass my irrational fear of intruders and my compulsive behavior onto her? *No. I won't.* There are things Lily should fear, but her home doesn't have to be one of them.

"Oh, I lost a sock, but it's not there," I say, standing. I carry her back to her bedroom, where she needs only a goodnight kiss, warm sheets, and moonlight to fend off the night's unknowns and uncertainties. I kiss Lily's forehead and then watch from her bedroom doorway as she falls back asleep. Mothering her has given me the strength to chase the boogeyman from my brain. I won't check under my bed again.

PART TWO

Under the Skin

The Maternal Lizard Brain

Lizard Brain (lĭz′ e rd brān)

> Noun

1. two almond-shaped clusters of cells located deep within the gray matter of the temporal lobe. The second oldest part of the brain, the lizard brain is responsible for fear and may override the thinking brain, resulting in fight, flight, or fright.

2. the part of the brain that senses danger; the amygdala.

> *Uses in a sentence*: Emerging from the top of a spinal column at night, moonlit and glistening, the lizard brain is hardy, bent on protecting its young.

> *See also* paleomammalian brain, the boogeyman, monsters under the bed.

When my husband and young daughter are sleeping, my house made peaceful with the hum of a floor fan and the soft hoot of a great horned owl in our backyard maple, my lizard brain buzzes with neural activity. *Amber Alerts, lead-contaminated tap water, cancer cells, accidental drownings.* My biological family tree has limbs bending from inflammatory autoimmune disease: lupus, rheumatoid and psoriatic arthritis. What does this mean for my four-year-old daughter Lily, the only biological family member I've ever shared a home with, who sleeps in a room across the hallway and has never been sick with anything more serious than an ear infection? *Butterfly rashes and swollen fingers and toes, hands that won't open, elbows that won't bend.*

When I was a girl, I rode the school bus with a busty girl who had an easy laugh and an I'm-up-for-anything attitude, the opposite of my shyness, my flatness. The boys liked her. I admired her for possessing

what I never would. We became unlikely friends until her popularity pulled us apart. A few years after we graduated high school, what she understood about her body began to change. She lost her balance and slurred her words. Swallowing became an ordeal. She moved back into her parents' home, and in her final months she refused to talk; her resentment of the able-bodied family members who cared for her was her last defense, her last holdout against death. *Degenerative brain diseases, salmonella, meningitis, Ebola, Zika virus, whole body fevers.*

Once, while driving to my first period high-school biology class, I turned left without looking and wrecked my car. Afterward, blood ran from my knees. My eyes swelled. When asked, I could name the president and told the officer who arrived first on the scene that my mother thought George H. W. Bush was a fool on economic issues, but when I tried to complain about the loss of my lunch—a paper sack that flew from the backseat to the front when the other car and I collided head-on—I couldn't pull *lunch* from my brain. I found a different L. "My lizard is all over the front seat," I said. Unlike me, the other driver had been wearing her seatbelt and was fine. The officer looked at my mangled car, the now deformed guardrail into which I had spun, and then looked at me, slumped in the back of an ambulance. "You shouldn't be alive," he said, his eyebrows raised. Two decades would pass before I would understand the implication of his words. *Blind spots, fatal car wrecks, teenage drivers, splattered lizard brains.*

Fear keeps me alone and threatens to suffocate me. I grab my husband's shoulder and shake him. *What exactly am I worried about? And how do I say it without sounding crazy?* "I'm worried . . ." My voice trails off into the certain blankness of the night. Groggy, Jon mutters, "Stop listening to NPR." He rolls away from me in our bed, unwilling to succumb to thoughts of what hasn't happened, to thoughts of chance and vulnerability, loss and inevitability. But me, I'm a bipedal turtle without a shell, my foolish heart beating inches from the surface of my skin. *Get a grip*, I reprimand myself. *You can handle this. Lily is going to be fine.* Light from the neighbor's floodlights snakes through

the blinds and illuminates the lamp, casting a shadow-child with an irregularly large head on the bedroom wall. The backyard owl calls *Hoo-h'HOO-hoo-hoo.* There is one unnerving thought I can never rid myself of: *Some children will be fine and some won't. How can I know which kind mine is going to be?* My lizard brain hisses: *Silly woman. You can't.* The lizard brain is as wild and as feral as children without mothers would be.

*

I've read that when a woman becomes pregnant, her body undergoes complex changes at the physiological, cellular, and molecular level. A moving fetus can "tickle a woman's unconscious," arousing the woman psychologically and readying her to care for her infant. Neurologists have discovered that during pregnancy the anatomical structure of the brain changes in ways that are so profound that they describe the transformation as "brain remodeling." The lizard brain, responsible for emotion regulation, empathy, anxiety, and fear, increases in activity, growing in the months immediately before and after the baby is born. These and other maternal brain changes may explain why many new mothers suffer from postpartum blues and anxiety disorders, compulsively checking their infants at night for signs of life, overcome with thoughts of uncontrollable things that can affect the baby.

I tiptoe into Lily's moonlit bedroom, push back her sweaty hair from her sleeping face, and study her familiar, yet ever-changing features. Every night she's shed a former self, the yesterday-self gone, the young child in her bed growing and growing—this is a good thing, the right thing, and it fills me with dread. Touching her cheek is enough for me to wish for a parallel universe where children never die, a place where all of Lily's former selves will go. Her cheek is warm with life.

*

Watching my family through the smartphone held out in front of him, my neighbor, M, jogs across the street and into our driveway, his

thin white legs sticking out of his jean shorts. Lily and Jon sit on the concrete driveway, legs open wide in Vs, rolling a plastic ball back and forth between them. "I'll make a video," M says. "Something to show the grandparents!" I'm loading backpacks into the car for a summer outing. My prefrontal cortex begins to process this scene, neurons fire, and scrambled messages are sent into a cerebral file marked "Decode." M, a man in his midfifties, is standing behind my husband, his smartphone camera pointed at Lily and her baggy blue shorts.

"No," I say. My arm hair rises and my teeth chatter with current. "No, thank you. I don't think so."

M lowers his phone, smiles without teeth, and turns toward his house. "I'll make a copy for the grandparents!" he calls over his shoulder.

"Something just happened," I say.

"What just happened?" Jon stands up and brushes dirt from his jeans.

I can't vocalize this gut feeling. We casually know M the way one casually knows next-door neighbors. He's shown up on my lawn with hand-me-downs for Lily. A water-damaged Candyland. Bubble wrap from a UPS package. A solar-activated flower that opens its yellow plastic petals on Lily's windowsill, one of the petals melted, grotesquely wilted. Busy taking out the trash or weeding the yard, I'll startle at his sudden presence on our grass, down on one knee talking to Lily. He jumps up before I can talk with him, waving his retreat across the street back to his house, where his wife and two grown sons live. Jon says, "M: the Boy Scout. He always wants something in return." It's true, he asks for Jon's crosscut saw, scraps of drywall, and other home improvement things. What does he want in return this time?

"Go after him. Make him delete that video," I say.

"Okay." Jon looks confused, but he's not the worrier in our family.

I take Lily inside to her room, remove her blue shorts, and help her into black leggings. She repeatedly asks me "Why?" in frustration,

but I won't tell her that from where M and I stood we had a clear line of vision to her white underwear with the pink birds and pink elastic band.

Jon returns several minutes later, his cheeks flushed. "He says he deleted it. He was downloading something on his computer. I never saw anything." Jon takes a deep breath. "So—what just happened?"

I shake my head. Maybe nothing just happened. Or maybe something. I watch as Lily plays with a plastic elephant on the carpeted floor of her bedroom. Somewhere deep within the cluster of cells in my hippocampus I remember the African elephant that Lily and I watched on Animal Planet. How she and her baby were drinking from a muddied river when a crocodile emerged from the water and snapped at the baby's trunk. How she rose up on her two enormous back feet. How she stomped on him and pushed him deep into the river—seven thousand pounds of *primalmaternalinstinctuallizard-brainfearfuryandlove*.

<p style="text-align:center">*</p>

The media calls her *the woman with no fear!* "SM," an Iowa mother in her forties, cannot explain why fear eludes her, only that it does. I find the fearless woman during an internet search for "women without fear" because I wonder what it would be like to be the opposite kind of person, a woman who steps outside her front door in the morning without a cloud of fear following. SM's amygdala is damaged from Urbach-Wiethe disease, a rare condition that can leave calcium deposits in the brain. Will she behave similarly to monkeys with impaired amygdalae, who in one research study "started batting snakes around like sticks"? Researchers throw down the fear gauntlet in order to find out. They expose SM to spiders (she reaches out to touch a tarantula; a pet-store employee, afraid she'll be bitten with poisonous venom, stops her); snakes (she strokes a snake and fingers its darting tongue); *The Ring*, *The Shining*, and *Seven* (she inquires after the name of a horror movie clip so she can rent it later); and

the Waverly Hills Sanatorium, a haunted attraction (she laughs and pokes a monster in the face). She is interested in the little terrors that frighten others. Enthused. Fear doesn't register.

Having an amygdala that is unable to process fear means that SM has a brain that does not alert her to the things she should be afraid of. She chooses to live in an impoverished area with high crime. She approaches and then stands very close to strangers. She's not worried about *what happens next*. What happens next is that she's held at gunpoint. What happens next is that she's the victim of domestic violence. She doesn't learn what or who or why to fear. *What happens next* is what the lizard brain strives to avoid, but she goes back for more, once returning at night to the park where a man threatened her with a knife at her throat the evening before.

The two sons she successfully raises to adulthood don't have any memories of their mother being afraid. The oldest recalls an incident with a large snake slinking across a road, stretched head to tail—it was *that* long—his mother running out into the road and holding back traffic with one hand, the other hand full of snake so that she could bring it to safety in the grass. A doctoral student studying SM says, "Indeed, it appears that without the amygdala, the evolutionary value of fear is lost."

*

Antidepressant drugs quiet the lizard brain, and so do alcohol, marijuana, and a bioactive component found in the Mexican magic mushroom. But why would I want to do that? Love lives there, too. When a new mother looks at her baby, the reward system of her brain intensifies, and on brain scans resembles a constellation of stars lighting up. Neurologists say that "becoming a parent looks—at least in the brain—a lot like falling in love." Arms out in a T, I fall backward into a six-inch-high snowdrift. The two of us wear snowsuits. Lily is bundled so thoroughly that only her eyes and nose show through the fur of her hood, yet I'd recognize the shape of her head and body anywhere. At the grocery store, strangers look at the child riding in

my cart and then back at me. "She looks just like you!" *Thump, thump* goes my turtle heart. "Is she your only one?" they ask.

She acts like me, too. Lily stands next to where I lie in the snowdrift, then falls backward, arms out, just like me. We watch our breath. We lie there, two nuts from the same tree. My genetic future. One basket. One egg. How could I not be terrified now that I'm the one who walks out of the grocery store with the child at my hip, a small arm thrown casually around my neck, eyes the same color and shape as my own staring back at me, reflecting the beginning and end of my line? My *only*.

*

Fetal cells travel through the placenta and live in other parts of the mother's lungs, liver, kidneys, heart, and brain for years—even decades—after childbirth, a scientific marvel called fetomaternal microchimerism, named after the Greek Chimera: a fire-breathing monster with the head of a lion, the torso and limbs of a goat, and the tail of a serpent. Under the skin, the maternal and fetal cells compete for resources, fundamentally altering the mother. Fetal cells might behave like stem cells and aid in maternal wound healing and even prevent certain cancers from developing, or they might set off autoimmune diseases in women, who are three times more likely than men to develop them and most frequently during the perimenopausal and menopausal years. It's possible that the maternal immune system has a confused response to the fetal cells—which it recognizes as half its own and half foreign invader—and attacks its own tissues.

Mothers and their children are woven together through a communication of cells and a transference of DNA, interconnectedness at an emotional and physical level. Fetal cells can even become nerve cells that live and communicate in the mother's brain. It is common knowledge that when a woman becomes a mother, her heart cracks wide open, eventually rebuilding, healing, and growing. It's more surprising to learn that her brain cracks open, too. Mother: the head of a woman, the heart and brain of a child.

*

"You can't get rid of fear," an older, seasoned dinosaur in a Pixar movie says to a younger, timid one, "but you can get through it." The younger dinosaur's fear inadvertently causes the death of his father, but I like his story more than I like the children's story of the young donkey, Sylvester, who makes a wish on a magic pebble and turns into a rock. Sylvester's parents are worried when he doesn't return home that first night, which, as the next day passes, gives way to panic and neighborhood-wide search parties before becoming grief. The lives of Sylvester's parents are characterized by their grief over the loss of their only child—"*Life had no meaning for them anymore*"—until several pages and one year later, when another wish on the same magic pebble reunites the family. The book's message confuses me. Is it meant to be an illustration of fear and poor decision making? Of consequences? Of wish fulfillment and happiness?

I study the illustration of Sylvester's mother, eyes downcast, wearing her red-and-white housedress, searching the grounds near their neighborhood with a pack of anthropomorphized dogs. The dogs sniff around dirt and large rocks that could be Sylvester but don't smell like him, the dim blue sky, like a dim blue hope, fading behind them. I take down two Mason jars from a high shelf in Lily's closet. The river rocks, pebbles, and stones that Lily collects from our daily travels fill the jars. I line them up on the top of her dresser and count: twenty-two. I rub each one between my fingertips and thumb. Some surfaces are smooth and slick, others bumpy, jagged, and rough—as varied as children. I touch the rocks from the Mason jars in Lily's closet in order to make my own magic wish. *Please let her live a long and healthy life. Let her outlive me by one hundred years.*

*

Shaking, I abandon my destination and turn into a neighborhood, parking on a side street. Reaching into the backseat, I roughly buckle

Lily in for the fourth time since we left home ten minutes ago. I had warned her: "The teddy bear will go to some child who wears her seatbelt!" I roll down my window and throw the two-foot-tall teddy bear into the snow. Gripping the steering wheel with white knuckles, I snarl, "You *will* wear your seatbelt!"

"You are a bad Mommy!" she wails, kicking her feet.

"You aren't safe without it"—my voice is lower now, a growl. Me and my brain, what one professor of neuroscience calls a "cobbled-together mess," have seen what can happen when one car smashes into another. I push away thoughts of dismembered arms and legs, bloody mouths, lizard brains, and black holes where life-as-you-know-it disappears. Statistically the inside of a car is the most dangerous place for a young child to be. Everyone knows this, but it isn't my child's responsibility to care—it's mine. In a flash of metal, everything I care about most in this world could fall into a black hole. Does this thought make me vigilant—a better mother?—or does it make me neurotic? I don't know. I never worried about car crashes before she was born, even after surviving the one that should have killed me.

"It isn't safe to ride without a seatbelt. I want you to be safe."

I throw the car into reverse, and I don't feel anything when the tire rolls over the bear's stuffed body, but I see it lying face down in the snow afterward.

"You ran over my Buddy Bear!" Lily screams.

My frontal lobe finally takes control of the situation, and anger, frustration, and fear drain from my fingertips. I didn't mean to run over Lily's bear. I stop the car, climb out, and grab the toy from the snow, staring at the black tread mark on the back of its bald, infantilized head.

*

"The defining characteristic of mammals is that females nurse and care for their young; without this, the neonate has no chance to survive." This sentence, which I find in an article about the survival rate

in the offspring of pigs, sheep, and rabbits, soothes me. I decide that if a proactive, hyperalert mother is a good mother, then my fear has a use. But is it a primal fear, left over from my ancestors who slept outside on the ground and had to be alert to the threats of wild-life and poisonous spiders? Does my fear hinder my child's sense of adventure and well-being? To what extent does the maternal lizard brain strengthen my mothering and to what extent does it weaken it? I think of David Phillip Vetter, the Bubble Boy, who lived in a sterile chamber until his death at age twelve. I don't want to be Lily's bubble.

Scientists have discovered a direct correlation between the size of the lizard brain and social behavior in humans: the bigger the amyg-dala, the more positive social interactions one has. The inverse is also true. Criminals are more likely to have smaller, damaged amygdalae. Of course, most brain studies are done on rodents. Less is known about the human brain.

<center>*</center>

There was a feeling of panicky aggression coming from the preschool director's office that morning. Two strangers, a man and woman in starchy business attire, the wrong clothing for a church preschool, were talking intently with the director. I learned that the young teacher who had dyed a chunk of his hair to match the red superhero cape he wore was thinking of hurting someone, maybe himself—or maybe one of the children. After his confession earlier that morning, he had fled for home. At preschool he ran around the fellowship hall, wearing his red costume cape, chasing the laughing children. I tried to remember when we'd last spoken.

A memory came to me: Lily and I walking together at the Henry Doorly Zoo a few weeks ago. We held hands while we walked through the Butterfly and Insect Pavilion and looked for butterflies, moths, and hummingbirds, but when we arrived at the outdoor Cat Complex, she let go of my hand and climbed the railroad ties and giant boulders lining the concrete pathway nearby. "Be careful," I said. "Not too high."

She climbed high anyway, with a boy a few years older she'd just met. I talked with the boy's mother. Behind the bars of his enclosure, a three-legged Malayan tiger paced and panted. It was good for Lily to climb away from my worry.

Later, Lily and I were walking downhill toward the petting zoo when I saw her teacher from preschool walking on his tiptoes up the hill that led away from the goat enclosure. I noted the new red streak in his hair and liked it, thinking he must be artistic. "Hello there!" I called out. I'd forgotten his name. He was alone and had a hard time making eye contact with me, his glasses slipping down his shiny nose. He mumbled something in greeting. It was a miserably hot Saturday. I thought, *He must be more comfortable around children than adults.* I wondered why he'd spend his free time at the zoo, alone without friends, surrounded by so many overstimulated children, so much parental exhaustion. *Isn't he tired of children?* We walked off in opposite directions.

The night Lily's preschool teacher confessed he might harm one of the children, I didn't want to frighten her, but she was already afraid of the dark that was gathering outside her bedroom window and beginning to creep into her room. She needed her nightlight and now also needed the lamplight from my bedroom. Developmentally, her fear of the night and of a mysterious, dreamed Green Puppet was normal. I got down on my knees, eye-level, and held onto her shoulders when I asked in words that I hoped she understood, "Has your teacher ever touched you in a way that hurt you or made you feel sad?" Then, "Has he ever touched you where you go to the bathroom?" It's distasteful, this question that must be asked and the cutesy way we must ask it. She shook her head no. I rubbed her back until she fell asleep and put my other hand over my mouth to stifle my sobs.

*

I dream about losing her. We celebrate as Lily turns another year older, and still, I dream of loss. Perhaps because of the 2016 news story of

the three-year-old boy who crawled through a barrier and then fell ten feet into a moat in the gorilla enclosure at the Cincinnati Zoo. Or because of the alligator who seized and then drowned a two-year-old boy wading in a Walt Disney World lagoon. Or because of my zoo memory of the preschool teacher—who, it was eventually discovered, had been molesting a young stepsister—I lose her at the zoo. In my dreams I hear the orangutans' lip-smacking and the children chattering back, but I don't hear Lily's voice. I turn my head. I sense that she is near, but the frame of my dream won't widen enough for me to find her; the axis of my dream world slips, turns, spins too fast. Walking through the calm, shaded aviary. Inside Hubbard Gorilla Valley looking through handprint-smeared glass at gorillas. Watching for the albino alligator in the swampy semidarkness of Kingdoms of the Night. In all these places, her fingers slip from mine and she disappears. I look for her, but I can't find her. I've done something wrong, something irreversible, something that can't be forgiven. *Where is she? I only turned away for a second.* A rush of adrenaline wakes me, shoots me straight up in bed, and charges my thinking brain: *That we live in a world where children die is too much for some mothers to take. What about me? Can I take it?* I'm afraid of the things that happen to other children and other parents. What or whom should I fear? I don't know. What I do know is this: You can't wish vanished children back into existence. They remain stones.

<p style="text-align:center">*</p>

The lizard brain formed before the first word was spoken, before the first group of mothers on park benches chatted while their children played.

Did you hear about the mother in Arizona who accidentally sprayed her toddler with 150-degree water from a garden hose? Who would have thought water from a garden hose would get that hot?

I heard on the news that a mother found her three-year-old son floating under a dock in Waterloo.

That's terrible! I never let Oliver go near the water without a life jacket. If the sign says, "No Swimming," then don't let your children swim! Are these moms stupid?

Are you talking about the boy who died at Walt Disney World? Have you seen the hateful Facebook posts written about the mother? She's grieving. We should support her.

But the sign said, "No Swimming!"

It could happen to any of us. The sign didn't say anything about alligators.

At least two dozen children die every year from being left in hot cars. That wouldn't happen to "any of us." Some of these moms are negligent.

At my son's school a seven-year-old girl died from a peanut allergy after her friend gave her a peanut "just to see."

Where were the mothers?

I guess the friend's mother was in the next room.

You know that my son has a peanut allergy. What if it had been Oliver?

But we mothers can't be everywhere at once—

—Oh! Jody! Lily just fell!

"Lily! I'm coming!" I run to the monkey bars, leaving the other mothers behind. I know what we're doing with our mean-spirited gossip. We're trying to move as far away as possible from these other mothers' tragedies, as if the distance will protect us. But it won't. Lily is flat on her back, crying. I kneel beside her, help her into my lap. Nothing is broken. The floor of the playground, pea gravel, angers me. Recycled rubber tires wouldn't hurt like gravel does.

"Let me see your back," I say. I lift her shirt and see two wounds, the size and shape of quarters, drops of blood beginning to dribble down her back. "Shhhhh. It's going to be okay," I soothe her.

"It hurts, Mommy," she cries open-mouthed.

"I know. I'm sorry." I study the injuries on Lily's back—a sign of my negligence or of chance?—and I imagine red blood cells coursing through her limbs and lungs. I wish that I could go backward in time, before she fell, and then I would know where to stand and how to hold my hands so that I could catch her. How many times each day do

mothers wish for the same power, preventing the small hurts that one day turn into bigger ones? If I could, I'd travel back farther, to a place before the first mother tongue was spoken. I would unravel DNA and look for hidden connections, black zigzagged lines of interdependent systems, tangled cellular clusters. I would find constellations of cells, consciousness infused into tissue, cells splitting and bonding within soft gray and pink matter. I would watch cells multiplying inside of brain circuitry, forging pathways that transmit nerve impulses into maternal behavior. Into choice and consequence. And then, into love.

Neural Pathways to Love

Falling in love is not a metaphysical phenomenon, but
rather a series of chemical reactions in our brain.
—ALONSO MARTÍNEZ, "What Happens to Your Brain
When You Fall Out of Love with Your Soulmate?"

1. When I look at my husband sitting across the kitchen table from
me, I see what other women surely must see when, for instance,
spotting him at the grocery store as he compares flavored yogurts.
Or, as he gets down on one knee and hugs our daughter outside
of her kindergarten classroom. Or, as he walks through their front
doors dressed in Carhartt work Dungarees with his five-gallon dry-
wall bucket swinging from his hand, a sign he is ready to repair the
holes in their walls (and in their middle-aged hearts). Here is a fit
man, midforties, with thick black hair (some gray), an angular nose,
dark eyes communicating equal parts compassion and mischief, and
lean legs built for long-distance running but which he lately uses for
indoor ice skating and paddleboarding on Nebraska rivers. I wonder
if some of these other women, looking at Jon and recognizing a few
of his attributes, experience a slight increase in dopamine, one of the
feel-good chemical neurotransmitters. Brain scientists say dopamine
assumes several key roles, including traveling along the neural path-
ways that lead to arousal.

Maybe a few of these women experience a larger dopamine wave
and allow themselves to fantasize that here is also the kind of man
who cried when his only child crowned (and gets sappy whenever
she reaches major milestones), a man who helped his sixty-nine-year-
old father to the bathroom and then into bed during chemotherapy

treatments, a man whose secret passion is drawing and who sets out fancy pens and paper on the kitchen table to draw the musculoskeletal system from many different angles and on many different bodies. A man who I used to have dreams about, dreams that involved my teenage dream-self at summer camp, even though I've never been to summer camp and Jon and I met when I was thirty-two years old. Now I dream about faceless bodies, anonymous men walking with me on dirt trails under canopies of trees in full bloom and near olive-colored lakes, always desiring more than the walking even while sleeping.

As Jon makes return trips to their homes for drywall patches, maybe their production of dopamine (and other feel-good chemical neurotransmitters) continues to increase and bumps into new receptors, creating new neural pathways deep within their brains. While he jokes with one or two of them that he is good with his handheld cordless drill—drill posed midair and buzzing—their adrenal glands produce the hormone adrenaline and their hearts start thumping faster, louder. Breath catches in their throats. They go a tiny bit weak in the knees from the release of the hormones norepinephrine and epinephrine. They feel lust, or at the very least, the deep pleasure of the moment, the noticing of him; exactly what I experienced when I first saw him and continued to experience when we dated for the next two years, but the opposite of what I worry I've been experiencing lately. I recognize his attributes and observe the store of our shared memories, but it's as if the woman participating in the present moment of this nearly ten-year love story isn't me, not my blood or bones, and I'm no longer having these chemical reactions in my brain.

At our kitchen table, Jon furrows his eyebrows. He says, "Do you still love me? I'm afraid that you don't."

It isn't the first time we've questioned the strength of our relationship, but it's the first time it feels so dire. Behind him on the wall hangs a two-foot tall, hand-painted lizard sculpture we bought when

we wed in Mexico over eight years ago (or was it from the hiking trip we took two years later to the Grand Canyon when I was a few months pregnant with our daughter?) Troubled memories crowd out romantic ones. Below the lizard, a ponytail palm droops nearby the kitchen door. Jon bought the plant for his small house in Omaha when we first met, when I was a graduate student in Kalamazoo, Michigan, when we used to lie naked and entangled in his sheets in his bedroom talking for hours, our neurons firing love signals but never using the particular neural pathways leading to the right prefrontal cortex where our negative emotions—our criticisms and judgments of the other—lay dormant, as yet undiscovered. These parts of our brains are fully alive now. I wonder: *Is our love affair now like the ponytail palm, limp and devoid of something?* I've been keeping most of my thoughts about us to myself lately. *Are we normal? Am I normal? Or is something wrong with us, our love?* Instead, I've started searching for answers in basic neurobiology.

"Of course I love you." I reach across the table and touch his hand, calloused from the years he's spent working in construction. Sometimes his is literally a tough hand to hold. "I always will." I withdraw my hand. *But it doesn't mean I will always be* in love *with you.*

Once upon a time (just like in the beginning of a fairytale), we would enter a room and other people would call us lovebirds. As in, *Oh, look, the lovebirds have arrived*, sometimes with genuine affection toward us and other times with a smirk that I've recently begun to interpret as *Just wait. In a few years, things will change.* Now, we are more likely to be the only couple at the dinner party not touching one another or later bickering in the claustrophobic car on the way home, irritated but not fully understanding why. Where is the all-consuming love that drew us to each other, and in the beginning when we dated long-distance, had the two of us boarding planes to and from our states every third weekend so we could fall into each other's arms? Where have those passionate feelings—our chemistry—gone? I'm terrified that our love affair is over.

I love my husband more than I love my children.

—AYELET WALDMAN, "Truly, Madly, Guiltily"

2. The real trouble with Jon began when I fell in love with our daughter, a deep and endless, bottom-of-the-well love that I've since read was activated in my brain when her cells began splitting in my womb and intensified the moment after she was born as the nurse put her to my breast and I wept. Even before Lily and I first saw each other, my amygdala—the two almond-shaped clusters of neurons in our brains responsible for our experience of emotions—grew and neural activity intensified. Production of oxytocin, the love hormone, swelled. These and other maternal brain changes motivated me to be more attentive to my newborn (and less attentive to my lover). Men are hormonally affected after the birth of their children, too, though to a lesser extent. Their testosterone plunges and their estrogen increases, fluctuations thought to prepare new fathers to be more nurturing toward their offspring and less interested in sex. Changes in both men and women promote the survival of the human species, or so the theory goes, and utter disinterest in one's spouse supposedly lasts for only the first few months of the baby's life. It had lasted longer for me—two years, to be precise.

In my head, I hear the chants from the marital advice columns on the internet, in magazines, and from the mouths of married women: "Why I Put My Husband before Our Kids." "The Marriage First Household." "4 Key Reasons Why It Matters to Put Your Spouse before Your Children." "Happy Parents, Happy Kids." All the advice I've ignored for the past five years. I put *her* first. Women who write about loving their partner more than they love their children astound me. When I comfort my daughter from a nightmare or a minor sleep disturbance, I receive a hit of oxytocin. Simply looking at her sleeping face rewards the feel-good parts of my brain and stimulates my urge to protect her. My brain doesn't reward me anymore just for looking at my husband like it did early on.

The harvest is always richer in another man's field.

—OVID, "Art of Love"

3. I arrive for a casual work meeting at an older man's condo near the university where we teach, and when everyone else eventually leaves for their Friday night plans, I stay put. At home everything is the same and Lily will already be sleeping. What would I do? Read a book while Jon watches TV? Fold laundry? Turn in early? When the same neural pathways are used over and over again, the reward centers stop lighting up. Same old, same old. Love can't defeat the dull passage of time. Complacency sets in. *What did Jon and I last talk about that morning? A domestic negotiation, no doubt. Unloading the dishwasher? Putting air into the front, passenger-side tire of my station wagon? Cutting the apple for Lily's lunch box?* The man is divorced, older than my husband by more than a decade, somewhere in his sixties, with a daughter off at college. He pours me another glass of wine, pulls his chair closer to where I sit on his leather couch so our knees almost touch and stares at me through his bifocals. We've also always been just work friends, and I trust this unspoken understanding because there's never been a reason not to. Nonetheless, the freshness of our more personal conversations (minus the risk of infidelity) lights up the reward centers in my brain.

We've been talking for some time, enjoying each other's company when the man says, smiling, looking at me through the bottom window of his bifocals, "I knew there was something between us when we first met"—pausing as if searching for the right description, with his hands open, palms up—"this attraction, this chemistry." *So, we don't have an unspoken understanding.*

What does the man see when he looks at me? Possibilities? Unknowns? Intrigue? Surely not what Jon and I see when we look at each other. Love is blind—but only for so long. During the early stage of love, couples experience a decrease in the production of the neurotransmitter serotonin and obsess about their loved ones. Activity

in the area of the brain associated with fear and aversive learning is reduced. These and other brain variations, like an increase in the production of the hormone vasopressin, cause couples like Jon and me to overlook faults in our lovers as we're getting to know them—only to see those faults very clearly a few years later. His impatience. My self-righteousness. His laid-back approach to parenting. My hyper-vigilance. His temper. My knee-jerk reaction to his expressions of frustration. The question is: can you accept those faults, or will they break your relationship (and your heart)?

At the word "chemistry," I tense, my skin pulls tight, like shrink wrap. I grab my purse and fumble for my phone, offering the excuse that my husband needs me at home. At his door, he leans in close for a sloppy kiss on my cheek. (How moist that kiss! How hot his breath near my ear!) Drunk, he wobbles and giggles. I take the stairs outside of his condo two at a time, feeling his eyes on my back. He calls out, "See you later, sweetheart!" I roll my eyes and chide myself. *Idiot. Don't be the last woman to leave a single man's dinner party unless you are ready to ruin your relationship.* I'm not. I want to find "chemistry" again with Jon, not someone new. But how?

> How much you love somebody does not depend on that
> somebody; it depends on you—your genes and brain
> chemicals and how much you have of them.
>
> —DR. FRED NOUR, "When It Comes to Love, Just Follow
> Your . . . Brain? A Neurologist Explains Why"

4. *Come back. Come back to your life, Jody,* I think to myself while my friend, a colleague at the university, speaks about her frustrating morning rounding up two young children with her husband already at the office. "He doesn't understand how difficult it is!" she laments. My lunch of leftover stir-fried vegetables sits untouched on the break-room table in front of us, my appetite gone (maybe a symptom of *lost-love* sickness). Between bites of her apple, my colleague talks about domestic compromises, a subject we have worn thin, and I try

to ignore the fantasy of single life shaping up in my mind. *But married life is the life you know. This is the life you want. Right?* I don't know anymore, and the chance that I might not terrifies me.

On our best days, which have happened less and less over the past two years, Jon and I see through to each other, past years of lingering hurts and endless compromises, past the moody disenchantment of daily domesticity to the possibilities we once saw in the other. The brief movie montage of our life together plays in my head: us sitting in a friend's backyard in Omaha while Jon brings my bare foot to his lap and traces it with his finger, and I smile shyly at the initial pleasure of new touch; groping at each other under a blanket in a park in Kalamazoo; me shedding tears at the airport near Grand Rapids when he flew back home after our weekends together; him proposing on a pontoon boat on my favorite childhood lake; him consoling me after my miscarriage; us hiking down into the Grand Canyon with hydration packs on our shoulders and the secret of another pregnancy; our family of three together in San Diego, Spokane, Orlando, and elsewhere, together on various bike rides, swimming and hiking outings. Always holding hands. Always touching.

So why, late at night, do I sink to my knees in the kitchen and put my face into my hands and weep silently so Jon and Lily won't hear? It has taken me a while to recognize these moments on the kitchen floor for what they are. Expressions of grief. Of loss. Of fear. Our relationship is changing. The "true love" stage is over and I mourn it. I hope for something else in its place, but what? And when? How long should I wait? I don't have answers to these questions. Few of the married women I know talk openly about them, and the divorcées I know mostly talk about the bliss of independence and dating again.

I tune back into the present moment and hear my friend express her surprise at the recent disintegration of the decades-long marriages of a few of our colleagues and friends. "I know marriage is hard, but I wouldn't *divorce* my husband. We're glad to have our friendship with you and Jon," she confides, leaving me to guess at what she means.

How do you see Jon and me? I wonder. *Stable? Happy? Nice? I'm not so nice, not if you really get to know me. Ask my husband. He knows me.* Maybe I'm like one of the women I've read about who have fewer oxytocin receptors in their brains or who produce less oxytocin than other people when touching or talking with their partners.

Darker images appear in my mind, not a different truth, but a private truth between two people. The trash can Jon kicks around the backyard when his painting project maddens him; the hundreds of cobwebs and spindly water spiders on the underside of the pontoon roof where Jon proposes; my depression after the miscarriage and secondary infertility after Lily's birth; the separate bedrooms we sleep in after Lily is born so he can rest and I can breastfeed (an arrangement that outlasted the breastfeeding by several months). Our fights over money, methods of parenting, growing our family, where we should live, uses for our free time, my coldness, his unhappiness with his job. Our marriage story isn't unlike others. Scientists theorize that the most notable brain changes during a new romance last around two to four years, and then one of two things happens: either the brain stops responding to the love-induced neural activity or the activity itself stops. Time plus love equals ordinary disappointments, which as it turns out, has been enough to harm the good feelings and brain reactions Jon and I used to have for one another.

> All members of the human species may come equipped with the mental hardware for both falling in love as well as for ending a relationship.
>
> —BRIAN BOUTWELL, J. C. BARNES, and KEVIN BEAVER, "When Love Dies: Further Elucidating the Existence of a Mate Ejection Module"

5. All couples eventually fall out of love as our culture understands this early euphoric phase. *Love* is initially based on a chemical reaction in the brain that is not sustainable. Parts of our brains shut off so we can consume ourselves with thoughts of our loved ones. We're flooded with feel-good chemicals. We can't wait for our next "hit." Humans wouldn't be productive in other areas of our lives if we walked around

in a euphoric cloud of love all the time, so early love has a shelf life. After the initial phase (two to four years) comes a deeper attraction and trust (the next five to ten years), a time when our brains return mostly to normal though we still experience an increase in oxytocin and vasopressin when we're intimate with our lovers, and finally, around the "Seven Year Itch," a third phase for the lucky 50 percent or so of couples who make it: "compassionate, routine" love. This last stage is also the most long-lasting and enduring, and brain chemicals and activity mostly return to baseline except during sex, when couples continue to experience an uptick in oxytocin, which in turn, increases estrogen and testosterone production.

When I was leaving the first and then second stage of love with Jon— two stages that brought a natural "high" and with them, a feeling of excitement but also peace (I had found the elusive "true love" everyone always talks about!), the world suddenly seemed more uncertain and unforgiving. A sense of foreboding set in. What was wrong with us? With me?

One afternoon, Lily and I hold hands on the downhill walk from her elementary school, and she breaks away from me and skips into the fading white stripes of a crosswalk. As she leaves my side, an suv speeds downhill on a parallel trajectory from where she skips. My brain processes a rush of unrelated images: the van suddenly turning left toward her; the brown grass, leafless trees, and warm, almost-spring air; me, at fourteen, wearing a red-and-white tank and shorts for a high-school track meet; and me and Jon packing our belongings into separate boxes for separate homes. I feel afraid. I picture myself lonely and unsure, bent over with my fingertips on the thin white line, my feet pressed into starting blocks—the way I felt at the start of every track meet, the way I'd feel if I messed up my family. I've gotten a glimpse of the emotional reality of starting over. Alone. Without Jon.

"Be careful!" I shout. Am I talking to my daughter, who skips across the street and safely onto the cracked concrete sidewalk, just like I knew she would, or to myself? *Be careful.*

I wish I could mute the desire-seeking parts of my brain, which are the same pathways that establish pleasure and reward in response to love and also to drugs like cocaine, so I can live, as my mother once advised, satisfied with the way things are instead of pursuing more. *More. More. More.* If I can learn to accept *enough*, like my mother has done in her fifty-year-plus marriage to my father, I, too, can hold my tongue if, for instance, my partner donates my only eyeglasses to charity by mistake. "What good would it do," my mother asked, "to tell him now?" Annoyed, I replied, "But it upset you; how else will he learn how to treat you?" And my mother, as always, said, "Let some things be in a marriage, Jody. Let some things be enough." My mother's acceptance of "enoughness" was ultimately too much: praising my father's strong work ethic while forgiving his frequent tantrums and the mercurial nature that kept everyone around him on edge. I've read that the practice of being grateful, even if it's just for one small thing each day, can light up neural circuits, increasing dopamine and serotonin production, similar to a response from taking an antidepressant. I can't undo the damage already done to my relationship, but perhaps I can reduce its power.

Passion is but a prelude to
Years of gradual unfolding.
—DENG MING-DAO, *365 Tao*

6. Jon and I are talking at the kitchen table by the wall lizard and the drooping ponytail palm when I realize: It isn't drooping. It's reaching for the sunlight. After the night of our "Do You Still Love Me?" conversation, I read a love experiment that involves pairs of strangers looking into each other's eyes for four minutes and asking each other personal questions. At the conclusion of the experiment, many participants report feeling close to and even attracted to the stranger they've been partnered with. Six months later, two of the participants marry. I told Jon about the experiment; we both wondered when we'd last taken the time to stare into each other's eyes and ask questions

unrelated to childrearing and household management. It'd been a long while. So for the past several months we've been setting aside time to ask each other personal questions, if only for four minutes. Are we heading toward compassionate, routine love? It's too early to tell, but we both enjoy these moments where we're willing to be vulnerable with each other.

This evening, I stare into Jon's eyes. "What would you like from a marriage?" I ask. It isn't the first time we've considered the question, but like our relationship, our answers are changing and evolving.

"I want my wife and me to be able to stand side by side in this kitchen, wash our pots and pans, and put our child to bed, together, afterward. Every night," Jon says, a sad smile forming at the corner of his lips. "What about you?"

I want this humble (yet complex) image of harmony too and, as usual, more: "I want my husband and me to have adventures together. I want us to be interested in each other—like you and I used to be." It feels good to say aloud what I've been thinking.

"Yes," Jon says. "I *am* interested in you. I'm sorry if I haven't been showing it."

"I'm interested in *you*," I say. I mean it. I start to cry. His eyes soften. Having calm, honest conversations about our relationship releases a pressure valve.

"I can see this is hard for you," Jon says. "We're in a transitional stage." He reaches out to touch my arm. He takes my hand.

"Yes," I say.

"It's hard for me, too."

When Jon holds my hand, the physical sensation of him interlacing his fingers with my own causes what scientists would say is a predictable reaction in my brain. Information travels from one neuron to the next, the stuff of synapses, of electrical and chemical signals, of muscle memory and associations. Of hundreds of hand-holdings and hundreds of moments like this one where we sought each other out in the most basic human way. How much of staying in love is the result

of brain chemistry? Of willpower? Of accepting disappointments? Of learning gratitude? Of touch? Of having courage? There are some questions scientists can't answer, so I pay attention to the sensation of his warm fingers. I like it. I smile. He smiles back. Simple. And yet complicated. Somewhere within the lumpy, gray matter in my skull a new neural pathway takes root.

Body Language

On the day my father-in-law begins chemotherapy in a hospital in midtown Omaha, my husband punctures his thumb with an electric screwdriver while at work. Meanwhile, I ram my knee into a weightlifting bench at the gym across town. The surrounding skin immediately swells and turns red. Before leaving work for the day, my husband slips on some stairs and strains his lower back, while at home I use a chef's knife to cut slices of red bell pepper for our four-year-old daughter. She dances around me while I stand at the kitchen counter. Holding the pepper steady with my left hand, I cut into my middle finger, leaving a red half-moon from fingernail to finger pad. Lily stops dancing. "Show me," she says. "I want to see the blood." I rinse the cut in the kitchen sink and then bend down on one knee so she can examine it. "I want to touch it," she says. She studies my face when I wince. "Does it hurt?" she asks. I tell her, "A little."

Earlier that morning, Jon and I sat with Bill while the first dose of chemotherapy was delivered intravenously. The nurse explained that Bill's port-a-cath would allow for more comfortable long-term treatment. I watched Jon watching Bill, his sixty-eight-year-old, otherwise healthy father, as the first dose was administered. *Long-term treatment.* Did those words mean that his doctors anticipated he would live long-term, or be sick long-term? I was afraid to ask. Neither Jon nor I had ever witnessed someone's cancer treatments before.

In bed that night, unable to sleep, I pressed the cut on my finger. Jon was also restless because of his sore back and the stress of his father's illness. It occurred to me that Jon and I were hurting ourselves subconsciously, punishing ourselves for what we could not do for Bill and for each other. Or perhaps we were inflicting a manageable injury,

one where the outcome was within our control. Or maybe, and more logically, the injuries meant nothing, merely a result of our distraction. That morning in the hospital, Bill had joked he'd always thought his mind would go first. "Is it worse to lose your mind or lose your body?" he asked. No one answered. Pain is an effective messenger for the body, bringing bad news to the mind. But pain did not lead Bill to his doctor's office and to an eventual diagnosis. He felt fine. Better than fine, he felt great! Only his longtime partner's concern about the bruises that had suddenly and inexplicably appeared on his back brought him to a physician.

Several months before the fingertip-sized bruises began to appear on Bill's back and then the rest of his torso, I woke up one morning to the sensation of my left hand being on fire. My fingers were hot, red, puffy, and stiff. The feeling dissipated by midmorning but returned the next day and the day after and so on, until a few weeks later I awoke to find the sensation not only in my fingers but also in my wrists, ankles, and at the bottom of my feet. The pain startled me—sharp, sudden, migratory. I thought of the pain as an *it*: an *it* that wasn't tied to an action that might have preceded the discomfort I was feeling, an *it* that was separate from my body, an *it* that was moving around under my skin, a Pain-Thing. Surely, the Pain-Thing would soon go away. Over the course of the following weeks and then months, it did the opposite, spreading to my elbows and the back of my legs instead, lastly settling in my knees. It brought pain I had never felt before. Or maybe I had. Most people don't have a good memory for pain. For instance, I have words to describe the experience of childbirth, but I have memorized the words, not the pain.

Finally—and only because I value my knees and what they allow me to do more than other joints—I saw my primary care doctor ("You're fit. You don't smoke. Probably an injury"), who sent me to an orthopedist ("The ligaments and joints of your knees aren't injured"), who sent me to a rheumatologist ("Your swollen knees are likely

the result of overuse; the pain in your hands is unrelated"). When someone in the medical field says *likely* about your body, it represents the vast, ambivalent space between life-as-you-know-it and life-will-never-be-the-same. The rheumatologist used a long needle to draw fluid from my left knee; the syringe filled with fluid that was opaque and pink. He seemed surprised. "Come back for the results," he said.

During the follow-up visit, he drew a diagram on a small marker board. The left side was for inflammation related to normal wear-and-tear, injury, and age-related arthritis, while the right indicated autoimmune diseases such as rheumatoid arthritis and lupus. He made a dash with his marker on the right side of the board. I said, "But I'm barely forty." To which he said, "Rheumatoid arthritis usually appears in women between the ages of forty and sixty." Angrily and with a certain amount of self-pity, I thought, *Then why can't it wait until I'm sixty?* I have always regarded sickness in my own body as an inconvenience. I realize now that it's an arrogant attitude granted only to those who are healthy or who have access to affordable healthcare.

All day long, my fingers fly over the keyboard, corresponding with my students, creating lesson plans, evaluating writing, occasionally sending messages to my husband who is unable to answer his phone during his workday. With my fingers—the most efficient extension of my body—I practice the language of the mind. My success as a teacher of writing at a university depends on my ability to use my mind and the hours of each day that I am willing to devote to its exercise and practice.

But I learned the language of the body first. My growing-up years were spent at a human-made lake in eastern Nebraska near my favorite grandparents' home. Hours and whole days passed where I hardly spoke to anyone. Instead, I repeatedly dove from my grandparents' dock into the tepid water—overheated by the summer sun—and held my breath as long as I could. I swam laps in front of a rocky embankment. Some days I went for runs around the lake and con-

centrated on the sound of my own breathing. Even now, when I'm frustrated or sad, I go for a walk. I feel my feet pressing down on the sidewalk, the muscles in my thighs contracting, and my diaphragm rising and lowering. I am aware of my breathing, of the movement of my limbs, of existing inside of a body and what it can do. I feel better for it. Healed mentally. I've never before had to worry for long about healing physically. My body has always behaved predictably, and I feel pride in its strength.

Deformity but not death. An expected shortening of my lifespan by a few years, maybe more (ten on average), and a higher risk of developing heart disease, lung cancer, and lymphoma. That's my prognosis and it's considered good. Manageable side effects from medications called DMARDs—disease-modifying antirheumatic drugs; at best they might cause things like hair loss and stomach ulcers. At worst, they might result in a weakened immune system causing hard-to-treat infections; damage to blood cells, liver, and more; retinal injury; a brittle skeleton.

The language of my body and the language of my mind are not in unison. My mind says, "I'm well!" but my body says, "I'm sick!" and sends in more white blood cells and antibodies, attacking the fluid that surrounds my joints and protects bones, making everything inside inflamed and angry. *Is it worse to lose your mind or lose your body?* When I wake, I look first at my hands. I can't open them all the way. It hurts to hold a brush and fix my daughter's hair. In the shower I stare at my piggy toes and burst into tears. Everything is bloated. Because I'm most afraid of the damage being done to my knees, I look at them last.

"Try not to be around sick people while on this medication," the rheumatologist said after my diagnosis, handing me a prescription. Since rheumatoid arthritis is caused by the immune system attacking healthy tissue, the medications are designed to suppress the immune response. I stared at him. Lily sucks her fingers and attends preschool.

My students share flu viruses as if they were handshakes. I'm always around sick people. Still, the benefits of the medicines outweigh the risks. Until a future date when a cure is discovered, rheumatoid arthritis is a chronic disease. With DMARDs, the damage to my joints and surrounding tissue should be delayed and significantly reduced, though some damage is inevitable.

Parked outside of the medical office, I took my hands from the steering wheel and placed my right hand within my left. I felt the fragility of my own bones.

Without successful chemotherapy, a team of five oncologists says, Bill will die within six months. They want him, his three adult children, and his partner to understand the severity of his cancer. Because of his age and his rare type of leukemia, his long-term prognosis is poor—though only the medical literature I will read later in private will be this direct. His doctors want him to get his things in order. Jon calls to tell me what Bill has been told, and I pull my car over to the shoulder of the road because I can't see where I'm going. I cry for myself and for the love I feel for Bill, a father-figure in my life who has made me feel safe and accepted. And I cry for my husband, who has stopped sleeping through the night since the day his father was first diagnosed. When he does sleep, I watch him, stroking the dark hair on his head, the same color as Lily's hair. I feel maternal toward him, protective. I think three words when I see his chest rising and falling: *father, son, baby.*

One evening, before cancer, Bill, his partner Linda, Lily, and I met for dinner at a place that serves fresh seafood on red-checkered tablecloths. He told a story about the first date he had with Linda: At her door before the kiss goodnight, she swung her long hair and it snagged the gum right out of Bill's mouth, like a fish on a hook. "That's how she caught me, too," he said. When he laughed, his cheeks bunched up under his blue eyes.

Bill wore jeans, a Hawaiian print shirt, and wire-rimmed eyeglasses. His thick gray hair was neatly combed. Linda wore her long brown

hair in a ponytail, the same as in the early seventies when she, a single parent, put herself through medical school. I watched the two of them holding hands and thought of them as each other's counterparts. One physical, the other intellectual. Bill built the drywall business that my husband now manages literally with his own hands, on his own back. My father-in-law understands the language of the body. Linda works long hours as a radiologist and tells horror stories of the diseases she detects in X-rays and MRIs. All day long she uses her mind to interpret images of what's deep in the body. She knows the language of the mind. But it's an artificial dichotomy—mind versus body. One enables the other, together tethering us to life.

Linda, who is Bill's longtime partner but not Jon's mother, asked if the rheumatologist had given me a diagnosis yet. I told her he had.

"Everyone gets something eventually," Linda said. "Some things are so much worse."

I agreed with her, though suffering should not be a competition. I looked at her shapely sixty-year-old body and thought, not unkindly, *But what do you have? You're in perfect health.*

Now her observation has become eerily prophetic.

One morning, I find the words *acute leukemia* written in Jon's handwriting on a piece of paper. Flipping the paper over, I see it's an invitation for us to renew our family membership to a museum. Lily sits near the slip of paper, playing with her cereal. Illogically, I move the paper off the table, away from her, though Jon, his brother, and sister—and Bill's ten younger siblings (all in their fifties and sixties)—have been told his type of leukemia is extremely rare and not hereditary. Genetic predisposition for disease, illness, and defect is written into the language of the body from birth. When Jon and I had sought medical intervention to help us get pregnant with Lily, our doctor had asked us if we wanted to undergo genetic testing. We'd glanced at each other and then said, "No." We wanted a child no matter what the tests said and both of us were healthy, so why undergo them?

Lily is sick only in the ways that most children are. She once suffered from three weeks of unexplained vomiting and diarrhea when she was two. Her pediatrician said she had an infection, though he couldn't name it and wasn't entirely sure if it was bacterial or viral. Jon and I tried everything to return her to health and cheer her up, to get her out of her supine position. At the tail end of her sickness, we brought her to Eugene T. Mahoney State Park for a weekend getaway at a cabin. She was getting better, we thought, looking and acting more like her usual self. But when we brought her to an indoor activity center with a giant climbing structure, she lay on the mat on the bottom level and whined. I was so tired of the whining. My tolerance for the expression of her discomfort was reaching its limit. We gave up and left, and I moodily pushed her in a jog stroller on a path that led back to our rented cabin. "I wouldn't be a very good mother to a sick child," I said to Jon.

I meant a chronically sick child, one who behaved this way long-term. It was an awful thing to say, something that mothers aren't supposed to feel, something that some mothers don't have the luxury of feeling. And what was I really saying? I didn't *want* a sick child. I couldn't *love* a sick child. Was my love tied up in the physical promise of her and her ability to do with me the things that I enjoyed? Taking long walks through the neighborhood. Swimming at the lake where I'd grown up and where Bill and Linda now owned a cabin (I had thought that a good sign of my future with Jon when we first started dating). In Lily's young body, I saw the promise of strong legs, agility, and ceaseless energy. The physicality of my own childhood-self reflected back at me. Would I love her still if she lost these bodily attributes? I'm certain that I would love her as fiercely as I do now, just as I'm certain that our relationship would not be the same.

When the news of Bill's cancer was sinking in, the college students I taught were composing portrait essays of people they were curious about but did not yet know well. In one such paper I read: "Looking

at Tommy, I was certain of only one thing. He had a problem with his hands. His fingers looked as if they were glued together side by side, curled inward. 'Don't you want to ask what's wrong with my hands?' he asks. 'I have rheumatoid arthritis, lost almost half the range of motion in both of my hands.' He is staring out into the sky, lighting up his second cigarette, when he begins to tell me more. 'This shit sucks, I hate it. I developed it a couple months after leaving Iraq in 1995. Doctors can't say what triggered it, but I call it karma.'"

I've always wondered what horrible things people have done when they relate their suffering to karma. Had I hurt someone so badly in this lifetime (or another) that now I would suffer for it? My words echoed back at me: *I wouldn't be a very good mother to a sick child.* Maybe I had developed an autoimmune disease in order to learn tolerance. And what about Bill? What kind of past mistakes brought cancer? His cancer could be related to years of smoking, a habit Bill quit shortly after he and Jon's mother divorced some twenty years earlier. Or it could be a result of his exposure to environmental contaminants in Vietnam, where he served two years in the army and was awarded eight medals, two of them Purple Hearts. Benzene is a human carcinogen and directly linked to leukemia, and it's a component both of cigarettes and Napalm. Or it could be something else entirely. No one knows what triggered his first cancer gene.

One afternoon when Jon and I are visiting Bill at the hospital, he begins talking about his time in Vietnam. He recalls firing an M-79 grenade launcher into the jungle "where Charlie might be." During another visit he remembers dead bodies "out in the boonies." The helicopter gunships got them, he says, and he and the other GI had to remove their headgear. He goes silent and won't say more. People who believe in collective karma say nations as well as individuals are subject to its workings. In this kind of thinking, all actions taken by the United States military during the Vietnam War (or Iraq War) will come back to its individuals. If a nation acted out of fear, anger, and hate while in Vietnam, then these same feelings and experiences

would come back to haunt American soil. Karma is not supposed to punish us. It's supposed to help us learn. Bill was a twenty-year-old farm boy who grew up sharing hand-me-downs and rationed food. He was hanging drywall and lived in a shitty basement apartment with two friends when he was drafted into the army, where he would witness bodies, some of them of his close friends, in various stages of human-made destruction. What new lessons could karma bring?

We never tire of showing each other what our bodies are capable of. Before Bill was diagnosed with cancer, Bill and Linda took dance classes, scuba dived in the ocean, parasailed, cycled on trails all over the globe, kayaked, rode horses, and exercised on a treadmill and elliptical machine in their basement. Before I was diagnosed with rheumatoid arthritis, Jon and I hiked the Grand Canyon and snorkeled in the Caribbean Sea; we rode bicycles, ran races, and waterskied. We still hold hands during neighborhood strolls.

It's generally assumed that as we age, we'll have to modify some of the activities we enjoy or stop them altogether. I've read that scientists theorize aging is a result of "damage accumulation" from environmental factors, lifestyle choices, cell abnormalities, and genetic predispositions. After scientists completed the Human Genome Project in 2003, they had the ability to decode, or "map," approximately 90 percent of the body's DNA molecules. With this information scientists may predict the eventuality of disease. The hope is that one day they will be able to correct weaknesses at the molecular level, further prolonging our lifespans or possibly turning off the aging process altogether. But not yet. A friend in her early seventies, suffering from undiagnosed gastric distress, says, "Diagnosis always advances before treatment." She meant doctors can effectively diagnose disease and illness several years (or several decades) before they are able to effectively treat them.

"Watch what I can do," says Lily one morning in our kitchen. She hops up and down on one foot while simultaneously tapping her head. "You hop, too, Mommy."

I try to hop, but I can't today. I wonder how soon I will have to modify the activities I enjoy with her. Before old age? Not that anyone knows what "old age" means anymore. Will she love me the same even when it happens? When illness and aging inevitably change our bodies or our minds, the change is often so startling to our loved ones that we are accused of becoming a "different person." Lately, I find myself pondering depressing—and terrifying—"Would I rather?" scenarios. Would I rather be an old woman who has all her wits about her but who is confined to a wheelchair? Or an old woman who stashes her purse in the oven and can't remember the names of her grandchild but whose body is relatively healthy and strong? And if my body is already changing, would I rather keep my hands or my knees? Today, the answer has been temporarily decided for me.

"I'm sorry. I can't hop today."

Lily frowns and runs out of the room.

The rheumatologist—he's now *my* rheumatologist—calls the returning condition of fluid around both of my knee joints "moderate to severe knee effusion." Using a long needle to draw out excess synovial fluid, he nearly fills two syringes. In a healthy knee, he explains, synovial fluid is a mixture of cells that function to lubricate joints and provide nutrients to cartilage. My synovial fluid production has increased abnormally, leading to joint swelling and potential injury.

At home, I spend the rest of the afternoon looking up symptoms and complications on my computer. *Fingers like sausages. Shoulders hurt and upper arms ache. Feel tired. Dry, red eyes. Pain that moves around the wrists, ankles, and pads of feet.* In the microtext of Google search results I see *deformed, eroded, debilitating.* I make the mistake of clicking on images: witch hands, monster toes, alien limbs, elbows with bumps and sacks of fluid. Most of the body parts pictured belong to the elderly. I fear my body will look similarly one day. One man writes on an RA message board, "At 47 years old, I've been able to play ice hockey and soccer in adult leagues (gotta do it now before this gets worse)." I think of things I should do before it gets worse.

More neighborhood strolls with Jon. More backyard play with Lily. Or maybe I need to do activities that I've never done. A hike through the Devil's Garden in Moab, Utah. An overseas trip to India. Scuba diving lessons. I make my mental checklist, though I have less time for activities because of my increasing commitments at the university. Mind versus body.

Bill's type of leukemia is extremely rare and not hereditary. Jon's mother has had her knee joints replaced with titanium because of her rheumatoid arthritis. After my diagnosis, I reached out to a biological aunt I'd never spoken to before and learned that my biological father's side of the family is ripe with autoimmune disease: lupus, rheumatoid arthritis, and psoriatic arthritis. (Why my birth father hadn't thought to tell me remains a mystery.) Lily has inherited a genetic predisposition to autoimmune disease but not to leukemia, though the medicines for RA are already more effective now than they were twenty years ago, and I hope that twenty years from now a cure will be within reach.

Some change doesn't happen slowly, it happens overnight. We just don't notice. I think of Bill at unexpected moments. Unlocking my office door at the university. Helping Lily into her pajamas at night. Looking at the dark circles under my husband's eyes. Watching an old couple at a restaurant. A memory comes back to me of hiking through the Heron Haven wetland one spring with Jon, Bill, Linda, and Lily. Lily rides on Bill's shoulders because her short legs are no match for our longer ones. Her body is tired but her smile is exuberant. Bill's cheeks bunch up under his eyes with his own grin. Linda and I hike on either side of them. Jon takes a picture, and this is what I frame and bring to Bill in his room at the Lied Transplant Center. The photograph I have brought him represents what I want it to say about our relationships with each other. The only way to stop his cancer is to follow chemotherapy with a stem cell transplant. None of us are talking about this future yet.

He sits on the bed. Linda sits nearby on a couch. Three tubes trail out of the port-a-cath in Bill's arm, down to the floor, and back up to a stand where three bags of medicine are hooked to an electronic IV pump. One bag is red, containing the strongest medicine and also the one with the worst side effects. Machines beep. Lights blink. Bill hasn't been getting much sleep although the nurses give him a pill to help. His shoulders droop when he looks at the picture. He's crying the way a child cries—full-bodied—but not from physical pain.

"I should have spent more time with her, had more days like this one," he says. He looks at me.

Rarely have I stared into anyone's eyes at the exact moment that person registered new pain. We cannot feel each other's pain, but we can see it. I put my hand on his shoulder. "You'll have more days like this one," I say. "You will."

Linda says, "Bill is going to do great! He's going to recover!" She's determined to lead him to health with positive thinking.

None of us is saying anything unique to this floor of the hospital. None of us are feeling emotions that are unique, either. But we must change rapidly in response to circumstances that are suddenly unique to us. We don't have time to contemplate, least of all Bill. He will change. The body changes despite the mind's insistence that *it should not!*

The day Bill is discharged from the hospital, his first cycle of chemotherapy complete, the cut on my finger is gone. Healed. I won't think of it again. Once these small injuries and illnesses are over, we don't dwell on them. Our capacity for empathy for someone's pain—even our own—is limited. Even our cells are hardwired to help us move on. After Lily and Jon are asleep at night, I read that some cells are damaged or die and are replaced in our body every day (or every few days) when others divide. Other cells regenerate every five, seven, or fifteen years. Cells in the bones, brain, and heart hardly regenerate at all.

Cancer cells are renegades. They don't listen to the language of the body, and they don't die when they're supposed to. Instead, they continue to reproduce and divide faster than their noncancerous counterparts, hogging resources, breaking through boundaries of tissue and organ. The drugs forming Bill's chemo cocktail stop the cancerous blood-forming cells that divide and multiply quickly. The drugs also stop other cells that divide quickly: cells that form hair and line the inside of his mouth, throat, reproductive system, and digestive tract. More alarmingly, chemotherapy can lead to permanent nerve and organ injury and cognitive dysfunction. Or, it can cause few to no side effects at all.

Bill is at home and has completed his first cycle of chemotherapy (he is in the hospital for one week and then out for two) when his hair starts to fall out in handfuls. Jon, Lily, and I meet him and Linda for dinner. "Do you like my new do?" he jokes. But he is distant during the meal, watching other diners and deep in his own thoughts. When no one else is paying attention, he says to me, "I don't know if I can beat this thing. There's only so much anyone can do."

Then he's back in the hospital for cycle two. He looks healthy, unchanged except for hair and weight loss, which mostly shows in the increased wrinkles on his face. He's still handsome. "You look like Mr. Clean," a nurse tells him. He feels healthy, too, and is suffering few side effects. I'm his only visitor now, telling him an anecdote about Lily when he says, "I don't want to alarm you, but . . ." For a moment, I think he'll tell me there *is* a genetic link to his type of cancer, but then he continues. "When you're my age, you realize that you're leaving parts of your life that you'll never return to, never get back. I see my life in periods of twenty years: my childhood, my twenties, my forties—when already I didn't want to work as physically hard at my job as I did in my twenties—and now my sixties. I have a quarter of my life left." He uses his forefinger to wipe the skin under his eyes. I don't know if he's crying or just tired. "If you think about

it, it's really"—his eyes grow wide—"scary." I nod. "Lily has her entire life before her. Isn't that amazing?" he asks.

It is. Youth is associated with the body's ability to recover and return to the healthy state it was in pre-illness, injury, or disease. It is a universal truth that at some point this will not be the case. I pray and hope that for Lily this point is far off in the distance.

Even with my father-in-law hooked up to chemo on the seventh floor of the Lied Transplant Center, I feel compelled, at home, to show my husband an injury to my thumbnail that occurred when I absentmindedly slammed it into my car door a few months before. It's dying at the bottom, yellowing and flaking away, while the top of the nail remains affixed to the tissue underneath. New cells are increasing in number, each cell "piling up" with others and compressing, forming a hard protein, pushing a new nail forward. Why do I want to show him this now? How could it possibly matter? These daily injuries matter to no one except the very young or immunosuppressed. He examines the nail with some interest. Maybe it reminds us of the simple ways the human body regenerates itself.

Later the same evening, Lily falls from a bench on our deck and onto the small landscaping rocks below, a three-foot fall. She cries and then calls for me. I sit on the deck holding her on my lap, kissing the red welts and scrapes on her back. I feel comforted while comforting her. With every injury she incurs—small or large—she follows me around the house, calling "Mommy!" and demanding I acknowledge the place of injury. Such behavior ensures our survival. Throughout the many small cuts and scrapes we endure each day, the mind sends signals to the body so it will work quietly and unnoticed to heal us. I told no one at the university about my autoimmune diagnosis. But a woman I work with noticed something was different with my walk, which resembled a hobble that day. We spoke about my inflamed knees as we slowly weaved in and out of groups of students on campus. I felt instantly closer to her, grateful for the opportunity to admit the

disappointment I was feeling with my body. I remember this moment still and think of her kindness. It's how I want to behave toward others who are in pain. Now I hold Lily on my lap and breathe in deeply the smell of her hair. I realize that I won't be able to hold her like this for many more years. There will come a day when she won't report every hurt to me, a day when she will keep her pain to herself, or worse yet, a day when I won't be able to help.

"What do you want to do now?" I ask. I squeeze her tight and she wriggles free.

"I want you to play with me." She looks at me with dark blue eyes, flecks of hazel in the left one. She smiles, her baby teeth forming the underbite that she inherited from me.

"Okay," I say. I realize then that pain isn't the only thread connecting body to mind. Play does, too. *Is it worse to lose your mind or lose your body?* It's an impossible riddle: we cannot lose either mind or body and remain whole. For now, there is play.

"Let's jump, Mommy."

We stand up and hold hands. Mine is calloused, slightly swollen, and envelops hers. Hers is soft and small. "One, two, three!" I say. We jump safely from the deck onto the dirt, river rocks, and grass below, where our feet find us. Our minds tell our bodies and our bodies tell our minds: This is *living*.

Side Effects

"It's M Day," I warn my husband.

"Okay," Jon says, glancing at me to assess my mood and tolerance for conversation and physical touch. We stand side by side at the kitchen sink, him rinsing a cereal bowl from breakfast, me popping open a tab of my pill box. He knows that I mean it's Methotrexate Day, when the side effects of the strongest medication I take will reach their peak strength in my body. Every morning I swallow a handful of pills, sometimes together with a big gulp of water; other times one by one so I don't gag. The medium-sized, tube-shaped white pill I take twice daily. It's an antimalarial drug, but for reasons that aren't understood can also reduce inflammation and pain in autoimmune diseases. (Side effects: mild dizziness that vanishes after an hour. And: after five years, increased risk of retinal toxicity and macular degeneration.) Next, in rapid succession, and without unwanted side effects: the yellow turmeric capsule for its natural anti-inflammatory properties; one tiny round folic acid pill, to prevent folate deficiency caused by the methotrexate; two brown milk thistle capsules to clean the liver; and an extra-large calcium supplement for my bones and because I'm premenopausal. One hour earlier, as prescribed, I swallowed my thyroid medication to boost a low hormone. (Side effect: tolerable, mild hot flashes.)

The methotrexate injection will come later, after my husband leaves for work and I've walked Lily to her elementary school, so that I can be alone, like a stray dog crawling under a secluded porch to chew up grass and dirt, puking out what ails it. Or so I imagine the metaphor when I'm feeling pitiful.

*

"You don't believe I'm really sick!" I've wailed at my husband more than once. No one likes to be underestimated, and now I don't want to be overestimated. It's the "arthritis" part of rheumatoid arthritis that causes the "oh well, happens to everyone eventually" shrug from other family members and friends, conjuring old ladies and their swollen, knotted fingers and hands, their at-home, lonely struggles to unscrew the lid from atop a pickle jar. Their single-minded pursuit of winning on Bingo Sundays. Instead, imagine a knife thrust in and drawn quickly out at any point where two bones meet. Imagine, too, a quieter but more insistent and widespread pain, sinking into tendons and ligaments. Imagines knees that won't bend, spongy as overripe grapefruits.

The irony: I don't want anyone to see me as a sick person, but I desire a place and a person who will support my grief over the health I once had. The grief over the person I once was, before the diagnosis that became a widening moat that I'll never again be able to swim across, reaching a past-self forever trapped in a fairytale castle of perfect, pharmaceutical-free health. Finding this place or person at home seems impossible, where my roles as capable and loving wife and mother so dependably take priority. (Side effects: selflessness, needlessness.) This was a stupid, short-sighted precedent set by me once upon a time, before the disease ignited in my body, burning away the image I held in my mind's eye of my robust muscles and bones. (Side effect: figuring out what I need from a partner and how to ask for it. When I'm feeling particularly rotten and too stubborn to say so, I passive-aggressively pick fights with Jon, and whether he takes the bait or not, I slink off to mourn alone.)

But also: once the methotrexate metabolizes, I want to go dancing! Have a drink! Flirt! I'm reborn from the worst side effects! My husband—his health stable—wants to stay in, watch a movie, snuggle in bed. (A potential side effect: the day-before-methotrexate is a

day for running away, for falling in love, but I never do. How many patients on methotrexate begin the cycle of medicine all over again the day after?)

If the disease can't be blamed for the recent uptick of skirmishes in my marriage, the aftereffects of this medicine can. Does anyone but my mother want to hear a weekly rundown of my side effects, week after week, month after month? She, who knows this body intimately, from years of bathing and clothing it, kissing all wounds. "Bony butt," she'd gasp in pain when I wriggled onto her lap as a young child. "Ouch! Off!" Skinny, scrawny, thin, *bony*. A deceptively strong body, I'd argue, one that, in its prime, was built for endurance running, leg-pressing twice my weight at the gym, and swimming half of a mile across Hanson Lake when it flooded from the Platte River, the only time ski boats weren't allowed to leave wakes in their trail. (Side effect: but I *did* want someone to listen to my daily complaints, someone who would inhabit my body and know my pain, too.)

Now, my disease endangers these strong bones, risks brittleness and brokenness. What happens to bodies with severe rheumatoid arthritis left untreated is akin to body horror. Lumps and bumps on joints of hands and feet. Sacks of fluid on knees and elbows and shoulders. Fingers and toes and spines knotted and twisted like branches of an old, leafless tree. The invisible damage is worse: fused bones, joint and cartilage destruction, narrowed blood vessels, inflammation of the lungs and heart. A body compromised by its own overeager, high-achiever, A+ immune system.

It hasn't escaped my notice that my six-year-old daughter Lily has inherited my build.

*

Dr. Yusuf Yazici, MD, an assistant professor of medicine at the New York University School of Medicine, says, "There's no reason to be afraid of methotrexate." Though he isn't my doctor, his name is cited in many of the articles I find that discuss the long-term side effects of

methotrexate, this one on the Arthritis Foundation website. (Another side effect: hours spent researching medicine on the internet when I should be parenting, teaching, writing, walking—living.) But I *am* afraid. Methotrexate (MTX) comes with a black box warning, the most serious warning from the FDA, because of its potential to do harm, what one article I read cavalierly refers to as "incidental maladies." These "incidentals" include severe damage to liver and lungs, cancer, and a decreased ability to fight off infections. Methotrexate can terminate a pregnancy and was once prescribed for that very purpose.

In my role as armchair researcher, I discover that nearly 1.5 million people in the United States suffer from rheumatoid arthritis. Ninety percent of them, or 1.3 million people, will take methotrexate at some point, according to the Arthritis Foundation. Patients stop the medication, a DMARD, for a variety of reasons: the drug loses its effectiveness or never worked in the first place, or the side effects are intolerable. Most patients who take methotrexate will suffer from a few but not all of the less detrimental side effects: nausea, vomiting, hair loss, mouth ulcers, headaches, diarrhea, and fatigue.

But then the Fog rolls in. How to describe it? For one to two days after I inject myself, I feel as if I have a chemical flu. No, it's worse. A black-out drunk the night before, chemical hangover, something I gave to myself. Dry eyes, skin, and tongue. Dizziness and nausea that are heightened with movement, loud noise, or strong smells. Exhaustion, a failure to locate the right word in my brain. A mental and physical slowness, a body and brain in molasses. Nothing compares: I've never felt sick like this before. My scalp is sore. My eyeballs throb. The wrong cells die.

The Fog is never named or described in the patient information sheet accompanying the prescription, though it's a well-known entity in the RA community, the shorter split-tongued devil's assistant you bargain with so your skeleton can be whole a little while—maybe years—longer. The Fog leveled me my first time, leaving me unable to leave my bed except to hover over the toilet seat. But I'd also been

recently leveled by a resurgence of my unruly immune system, too—a frantic mob of white blood cells had overpowered the antimalarial pill that had been working on its own. Patients react individually to medications and experience different side effects due to genetics and environmental factors. What's tolerable to one person—diarrhea? nausea? the Fog?—is too much for another. "Intolerable" and "unacceptable toxicity" are used interchangeably in some of the medical literature I read, leaving me to wonder why toxicity is ever acceptable (but of course, it is) or why patients are asked to tolerate it (we are and we do). The little glass vials of methotrexate the pharmacist hands me have the words "cytotoxic" printed on the label. *Toxic to cells*. (Side effect: anger that I'm poisoning my body to make it last longer.)

After M Day, I tell my daughter, "I'm sorry but I can't play right now. I feel really icky today." Much too early, I climb into bed, eager to sleep it off, unable to power through. Or, I kick off my shoes and stand in my backyard, feeling the cool ground or snow on my feet. Or mud, squishing between my toes after a rain. I once read on some hippie blog that literally grounding my body with the earth would alleviate the unwanted side effects of drugs. It doesn't, but it doesn't make them worse, either.

*

I seek alternatives. I visit my rheumatologist regularly the first year I'm on methotrexate, asking about my options. (Side effect: hours spent analyzing risks versus benefits. Hours inside of my head, decision-making, doubting.)

"A good drug, a strong drug," my rheumatologist insists. "It's safe." She is logical, sensible, and schooled in Western medicine; she once visibly winced when I mentioned alternative therapies, Eastern medicine, and diet. "Research doesn't support the theory that diet has a significant effect on RA, though you may want to avoid gluten," she said. When I pressed, she allowed that a Mediterranean diet might help.

"I dread my methotrexate day," I confess to her now, my voice faltering. "I lose the entire day, often the next day, too. Every week."

"You *dread* it?" she asks, surprised, but she doesn't turn away from the computer screen where she's ostensibly typing notes into my file.

Breathing deeply, I reach for reason instead of emotion, a place to bridge the gap between doctor and patient, for a loss she'll understand: "I'm not productive on methotrexate day. I can't think straight. I'm slower on this medicine. *In my brain.* It's affecting my career." I'm overstating my case. I don't take the drug on teaching days at the university. (Side effect: a good teacher, a strong teacher.) Or on weekends. (Side effect: a good parent, a strong parent.) I take it on my research and writing day, the only day I'm beholden to no one but myself. To be accurate: it's affecting my writing. (Side effect: resentment, digging like a worm in my brain.)

"Hmmmmm," she muses, rotating on her chair, finally turning away from the computer. At the mention of my career, I have her full attention. "Take it on Saturday. You'll be ready to work by Monday." She looks at me, unblinking, through her brown-rimmed glasses.

Like me, she's a mother to a young child. *What a foolish suggestion,* I think but nod at her because I trust her and I need her help. She rotates back to her computer screen. She might not agree with me or the way I prioritize my concerns and she might never have taken methotrexate before—she hasn't!—but she listens and massages my knuckles with her thumb and forefinger, feeling for what she calls "bogginess." The only one who touches my swollen fingers and toes this way and understands why I bite my lip, she offers me ephemeral but tangible moments of kindness. Still, I imagine Jon and Lily, the hikes through Fontenelle Forest, the hours of walking at the zoo, the bike rides around Wehrspann Lake—the physical ways we populate our weekends and make up for the hours we spend away from one another each week. Which day do I pick? Which day should I surrender to my medicine so that my body can be whole longer? (Side effect: the illusion of control.)

*

I look for camaraderie online in RA forums. (Side effects: seeking support outside of family and friends. And: belonging to a chronically ill community that I once, arrogantly, thought I'd never have any need for, one that on some level I was fearful of needing.)

> NOMOREHEELS: I think most of us who are taking or have taken MTX can relate to some degree of cognitive issues . . . What we call brain fog seems to be pretty much the norm.
> HOBBITS: MTX helped me in regards to my inflammation, it was a miracle relief from years and years of suffering. . . . but the side effects were not tolerable. Along with losing 50% of my hair, developing beaus [*sic*] lines in my nails, chronic infection. . . . I lost my ability to navigate and critically think. EX. When I had to go to the bank, I could picture the bank in my mind . . . but I could not drive there because I could not remember how to navigate there, I literally lost all sense of direction . . . and this was my bank for over 20 years.

*

By my side at the kitchen counter, Lily watches me pop open a daily tab on my pill box. She pulls her index and middle finger from her mouth, cuddles a favored stuffed elephant. "I want my medicine, too, Mommy."

Alarmed, I close the lid, slide the red latch so the box locks. Down on one knee, eye-level, I say, "Medicine isn't something you *want* to take. You have to take it when you're sick."

"Are you sick, Mommy?" She's curious, not alarmed. She doesn't understand "sick," though her grandfather is now a cancer survivor and has chemotherapy-related nerve damage that has him riding around on a motorized scooter, even if the walk from his truck to our destination is fairly short, a stroll through a parking lot. Before chemotherapy, he was biking several miles a few days each

week around the nature preserve near the home he shares with his partner.

"No, I'm not sick." It's hard to explain. I don't look sick to anyone, but my body thinks it's sick and keeps sending in more white blood cells to invade the healthy tissues and joints, inflaming my body inside out. A diagram from the University of Ottawa, titled "Society, the Individual, and Medicine (SIM) Curriculum," illustrates that the word *disease* refers to the medical establishment's perspective, the "biologically defined" pathology. *Sickness* refers to societally and culturally shaped reactions, like fear and rejection, which affects how patients like me react to a diagnosis. Historically, sickness has had moral connotations (e.g., she is sick = she is malevolent) while disease refers to a physical condition. (An accumulative side effect: more hours spent online, trying to understand the evolving story of my body.)

"I have a physical condition," I say. "I take medicine to keep it in check so that I don't get sick." A half-truth but I'm unwilling to let *disease* shape her understanding of me, her fears, her possible rejection. Unwilling to let *disease* shape her future, though I can't control it. "You look just like your mother!" or "She has your eyes!" strangers say to us in grocery stores and shopping malls. Not even now does Lily recognize the gravity of my "condition," the pull of our DNA, our genetics—my daughter and me. What lies beneath the surface, inside of her cells? What else has she inherited besides my build, my blue eyes, my underbite, and my stubbornness? A genetic gun? Because I'm adopted, my medical history has large gaps. While I see both of my birth parents occasionally, only my birth mother has been proactive about sharing family medical information. Rheumatoid arthritis wasn't something I saw coming. After my diagnosis, I learned that on my birth father's side of my family tree, rheumatic diseases run rampant. My birth father and I see each other once each year—at a family reunion—and the last time I saw him, his bare forearms, legs, and neck were speckled with red, scaly patches, as if someone had snapped a huge paintbrush of psoriasis at him. He removed his hat,

scratched his head. Like dust, his skin floated in the air around him. "It doesn't bother me," he said when I gasped. The airborne flakes repulsed me.

Will an environmental trigger set *disease* in motion for Lily? If so, which one? Can we stop it? (Side effect: obsession with nature versus nurture.)

*

Stiffness and swelling prevented my sausage fingers from firmly grasping the lid of the pickle jar. I smacked the lid on the kitchen countertop, trying to loosen it. The jar slipped from my grip, dropped to the floor, and broke into shards. Pickle spears flopped on the kitchen floor like dead fish. I bent down to clean up my mess. Sticky pickle juice leaked into my socks. Reflected in the shards, I imagined the faces of ladies with gnarled knuckles and red bingo chips, their wise and rheumatic eyes staring back at me. (Side effect: empathy.)

*

The waiting room of the Durham Outpatient Diagnostic Center is half-filled with the sick and tired on a spring weekday morning. (Another accumulative side effect: so many hours and so many waiting rooms given to blood draws, at least every six weeks for the past three years, to check my body's response to the strongest drug I'm prescribed.) I take note of the group of us waiting on the same side of the moat that separates the healthy from the ill: A young Black couple across the room from me hold hands and whisper. An older white woman with stringy, long gray hair and a walking cane reads a local newspaper. A white man my age, wearing boots and a cowboy hat, pushes an elderly woman in a wheelchair. After he parks the old woman next to me, she and I make eye contact, sharing sudden smiles of recognition. We both waited in this room six weeks ago. She holds my gaze for a moment or two longer than what's comfort-

able. (Another side effect: something complicated passes between us, something I'm just beginning to understand.)

*

The pill box with faded days of the week printed on each of the seven tabs sits on my kitchen counter, next to a box of tissues and a piece of blue construction paper with cotton ball clouds created by Lily. The pill box and the handful of pills, choked down with tap water, is the very image of old age and poor health that I held in my mind as a teenager, watching as now-deceased grandparents stood at their kitchen counter, popping pills. The very image of old age and poor health—and I admit, what I judged as imprudent life choices—that I held in my mind as a young adult watching my parents with their own pill boxes. (Side effect: humility.) My pill box. Me: the pill-taker. My pills. I hate them and the glass vials of methotrexate I keep stashed in a cabinet above the refrigerator, safely out of Lily's reach. Or more accurately, I hate my dependence on them.

What would my body be like without my medication? The first rheumatologist I saw, who was as surprised by my diagnosis as I was (*"You're young! You exercise! You've never smoked!"*), a man in his midthirties—only a few years younger than I was then—who talked about spending entire days biking trails throughout Omaha, had his opinions: "The disease will explode throughout your body. I've seen people end up in wheelchairs within ten years of their diagnoses." After he claimed there was nothing I could do to slow the disease except medicate, I left him for another. Denial kept me from accepting that it was my disease and medication was necessary to slow it. The next one waved his arms in the air dramatically, wanting me to begin methotrexate *immediately*, though the symptoms and pain were controlled by steroids and the antimalarial pill at the time. Instead, I found my current rheumatologist, one who would listen to my concerns instead of dismissing them with a wave of her hand. Who would help me understand what was happening to me and wait tolerantly

through several appointments until I would consider the medication she wanted me to start injecting. Who would politely busy herself with my chart when I lost my composure and cried. When I first laid claim to RA, saying "*my* disease," I sat on the edge of the examination table in her office, her brown eyes approving.

An anti-inflammatory diet, milk thistle and tinctures suggested by a holistic doctor I saw on the sly, exercise, Epsom salt baths, and turmeric cooked into all of my meals: I soon discover that none of it works as well at beating back my overexcited immune system as methotrexate does. There is no cure for my disease, only medication to slow its progression. Rheumatoid arthritis, as it turns out, is indefatigable, but as for me—the host—I'm not. (Side effects: Fatigue. Wasted mornings after the injection, when I crawl back into bed, childlike, wanting my mother to butter some toast, to put her hand on my forehead and tell me I'm going to be okay in the morning. And: indulgence in self-pity, like the warm, thick blanket I imagine my mother drawing up to my chin, heavy on this body, calming the violent throng of white blood cells underneath my skin.) Sneaky disease, affecting as it does, all the connective tissue holding a human together and organs, too, including the heart, especially the heart.

*

At what point do the side effects outweigh the benefits of the medicine? I've been asking myself this question every injection day for the last three years. (Side effect: fear that my choice to medicate is the wrong choice.) I find an online passage in a scientific article that comforts me: "Patients' experiences of coming to terms with taking methotrexate are complex, and their experiences of dissonance are particularly problematic. Experiences might be improved by supporting patients to assess necessity (particularly in the presence of side effects) and by providing information to moderate unnecessary concerns." *Yes.* This is what I need: support and a response to my fear that methotrexate is doing more ill than good. Of course it's doing

more good; this is exactly what the FDA decides before approving any drug for sale (though sometimes the most dangerous side effects aren't discovered until after a drug has been on the market. Or, the knowledge of the side effects is withheld from the public or downplayed by pharmaceutical companies). At least, this drug is doing more good in the way I define "good" in relation to the ways I enjoy my body and without pain.

Left untreated, RA can and will disable its host, joint by joint. Yet about 15 percent of those who take methotrexate will stop it because of clearly defined unacceptable toxicity: serious reduction of the white blood cells that fight off infection. Abnormally low levels of platelets. Deficiency of red blood cells. Liver function abnormalities. Then again, some of these side effects might not be due to the medication but rather are a direct result of the autoimmune disease. About 70 percent of RA patients will suffer some degree of joint erosion and 60 percent of people without effective treatment will be unable to work within ten years of diagnosis. Which one—medication or disease—has the potential to hurt my body more? Potential damage is a tricky thing, a fine line. Is it best to hedge one's bets?

Anti-pharmaceutical rebels in the online rheumatoid arthritis support community talk about how, years earlier, they abandoned Western medicine altogether for a completely natural approach. Eventually, the disease defeats the herbs, tinctures, magnets, Epsom salt baths, vegan diets, yoga, acupuncture, hydrotherapy, tai chi, and medical mediums. They write about their first cane or walker. They write about operations for hip, knee, or shoulder replacements. Their first wheelchair. (Side effect: fear of becoming elderly in body before chronological old age takes hold.)

Without permission, I gave myself a medication vacation one spring when we flew Lily to Walt Disney World. I'd heard the term, *medication vacation*, from my rheumatologist who was describing a woman she'd been treating for twenty years. "And she only has one minor bone erosion," she'd said, attempting to calm my fears during

a particularly stubborn flare, a time when I had convinced myself I would need knee surgery before my fiftieth birthday. This other woman, representing a gold star patient my "rheumy" was holding up, had achieved remission and was allowed a medication vacation. (Side effect: acquiring new lingo that cements me as a member of the RA community.) Medicine free for a month or more. Some doctors argue that people with autoimmune diseases never achieve a true remission, since once off their drugs—bam!—the disease returns, usually unrulier than before. Nonetheless, I stored this anecdote away, during a future time when I, too, planned to be noncompliant and recklessly rebellious, against what or whom I don't know. My body? The medicine? My medical practitioners?

After four weeks on my self-prescribed medication vacation (three weeks longer than our one-week Disney vacation), my disease came back like a hammer on bone. Only metaphors for rage will do here. It hurt. I hurt. A lot. Most of the pain and inflammation settled in my hips, knees, and ankles. The aching frightened me but not as bad as the disability it represented if the disease's activity couldn't be stopped. What had I done? Had my recklessness enabled the disease to grow stronger? Steroid shots directly to my knees pacified the white blood cells. Yet fury filled me. Believing for those four weeks that my body had self-healed, that my immune system could once again be counted on to do what it was designed to do, the truth that my body was continuing to hurt itself—*myself!*—was too much.

Some people in the online chronic illness community—sexists— theorize my disease is a direct result of unaddressed anger from childhood, untreated rage, a "women's disease." While stress can be a contributing factor, it doesn't account for the fact that people either have the RA gene or do not. One of my well-meaning friends, a woman, suggested I could mitigate the havoc RA creates with positive thinking. Either my thoughts are not positive enough, or this idea is also shit.

*

KRISTY7: Dear Methotrexate Gang,

Hi—I'm writing this post because my father has passed away from methotrexate toxicity in February. This cause of death has been officially confirmed. I'm in a state of shock and I really don't believe that the general public understands the severity or danger of this drug.

As I've read here many MTX patients have been on this drug for months if not years. My Dad was on this drug for only five days.

*

Because of the asymmetrical pattern of swelling in my joints and limbs and the recent appearance of a scaly rash on both of my elbows, my rheumatologist changes my diagnosis to psoriatic arthritis. Except for the hours I waste worrying about developing psoriasis on visible places on my body the way my birth father has, not much changes for me. The two diseases are similar enough in how they disable if left untreated, and the "first line defense" for both is methotrexate. Dr. Joel Kremer, a former rheumatologist and director of research at the Center for Rheumatology in Albany, New York, writes, "It has been speculated that MTX is probably the best and most widely studied drug the world has ever seen." Unlike with newer drugs, both short-term and long-term side effects are well-documented.

Side effects, by definition, are secondary and with a bit of luck, temporary. The hope is that they'll wear off. They'll go away, and a more recognizable, normal-self—a healthier-self—returns. This isn't always the case, and some side effects are permanent and debilitating. (Side effect: I find irony in places where it hasn't been intended, like when Kremer also writes, "MTX is the drug that keeps giving and giving. . . .") At worst, side effects are fatal. Medicine hasn't advanced yet to prevent unwanted side effects, and maybe it

never will, given that Big Pharma's financial incentives and patient demands for instant results commonly outweigh consumer safety. (Side effect: my belief that, for now, I have to take this drug. "For now" keeps me going, gives me hope for a better, different choice someday.)

And so, after my husband leaves for work and Lily is at school, I take my supplies upstairs to the bathroom where Lily submerges into bubble baths, creating stories for toy mermaids—benevolent half-fish, half-women whose bodies are perfectly built, plastic-strong, and disease-free. I pull down my pants or pull up my dress and sit on the closed toilet lid, preparing for a different kind of intimacy—one where my body and medicine merge. In the beginning, a nurse had to teach me how to inject myself, and my hands shook with adrenaline. Now I complete the routine with the composure of a physician. I swipe an alcohol wipe on the fleshy part of a thigh, insert the needle into the glass vial of yellow liquid and draw in the medicine, thump out air bubbles, then aim and push the needle straight down. Hilt hits skin and fat. (Side effect: if the needle enters muscle instead, the puncture hurts. Otherwise, I feel only a quick pinch.) Plunge. A few drops of yellow fluid mixed with blood occasionally bubbles from my skin. I wipe the counter and wash my hands. Later I'll dispose of the needle and vial in an emptied laundry soap container stored on a high shelf, out of reach, and marked in permanent black marker: "Sharps."

After straightening my clothes, I look at my reflection in the mirror, still recognizing the image that I see as me, my body, *mine*. Then I throw open the bathroom door to my home, my neighborhood, my city, and the life I want. (Side effects: in thirty minutes, the first wave of chemicals will crest, sometimes sooner. And: feelings of anger and loss crest, too. But I know now that the emotional side effects, like the physical ones, recede—if not soon enough.)

Two days later and as predicted, the Fog dissipates, and I'm reborn: I've been given another chance. And the following week at the same

time, I'll be given another choice, however troubling and ultimately consequential in the long-term. Neither choice, to medicate or not, will restore the health I once had. I will always be ill, either from the medicine or from the disease—or, more likely, a combination of both. This fact is the toughest pill for me to swallow.

I choke it down.

PART THREE

Risings

My Grandmother and the Sleeping Prophet

For life is continuous! There is no halting.
We either progress or retrogress.

—EDGAR CAYCE, *Many Mansions: The Edgar Cayce Story on Reincarnation*

On my favorite grandmother's bookshelf, alongside the seminal books she had already pressed into my childhood hands like *I Know Why the Caged Bird Sings* and *Jonathan Livingston Seagull*, she kept *Many Mansions: The Edgar Cayce Story on Reincarnation*. Reading from the dark blue paperback one afternoon, my grandmother told me, "Someday, you'll be ready for this one, too." She sat in her closet-sized office, where she kept her books, sewing machine, and sketch pads. From where I stood behind her chair, my wet swimsuit dripping lake water onto the carpet, I could see through the office window to her vegetable garden and beyond that to the gravel road, but not to the lake we loved so much, which was visible from the opposite side of the house. "But not yet," my grandmother said, and closed the book. She snapped the cap onto the yellow highlighting marker she held in her hand and placed *Many Mansions* on a high shelf next to the true crime novel *The Executioner's Song*, out of my preadolescent reach. Nearly three decades would pass before I'd read it.

As a young girl, I understood little about Edgar Cayce or reincarnation and what either one meant to my grandmother. While she—my father's mother—attended monthly meetings with a handful of women who believed as she did and repeatedly urged my devoutly Catholic mother to read *Many Mansions*, I only managed to read the blurb on the back of the book, left out on her desk one day, which used words like "clairvoyant" and "prophecies." I knew that

my grandmother, whose first name was Grace, had been named with the Christian concept of divine grace in mind, yet as an adult she was wary of the Catholicism she'd once accepted (*With Catholics, you only get one shot to get it right!*). But I didn't know why she'd strayed from the Methodist church she grew up in, where her own father had been the minister. No matter. The mere presence of the book offered me enough proof that my favorite grandmother's beliefs were eccentric, like her.

Once, my grandmother showed Debbie and me a piece of unlined paper that had faint pencil sketches of half a dozen faces. Though not intricately detailed, each face was unique enough from the other, representing men and women at various ages and plucked from different time periods. One was a sketch of a preteen girl wearing a house bonnet recalling Nellie Oleson, the whiney *Little House on the Prairie* TV character from my mother's favorite show, whom my sister and I accused the other of resembling in soul, if not in appearance. My grandmother told us she was sitting in a candle-lit room with a few other believers, pencil in hand, when the candles were suddenly blown out, and then her hand started to move—pushed by some outside force—etching the faces of her past lives onto the paper. To me it sounded like magic. But to her, it was faith.

Growing up, Debbie and I spent summers and endless sleepovers at my grandmother's, swimming all day in the lake near her tiny home and then staying up until our eyelids were heavy from watching *Tales from the Darkside* or black-and-white episodes of *The Twilight Zone*, my grandfather snoring in the only bedroom. We fell asleep in our swimsuits on one of the two couches so we wouldn't waste precious lake time in the morning by having to change. Her favored outfit—a turquoise, one-piece swimsuit with a sweetheart neckline—showed off her ample cleavage and lean legs, but my grandmother never shaved her bikini line or armpits and seldom showered. She claimed to prefer the look and smell of human bodies in their natural state. There was no gold or silver cross dangling between my grandmother's

large breasts. Still, in addition to her boob job, she had a small number of conventional vanities, like the pink Merle Norman masks she slathered onto her face, the pin curls she bobby-pinned in her gray hair at night, and the deep red lipstick she kissed onto toilet paper every morning. No rocking chair and rosary sessions with repetitive Hail Marys for her, unlike my mother's mother, Rose, who during rare sleepovers scrubbed my sister and me in the bathtub before sending us off to kneel by twin beds to pray. No weekly religious education classes for children, called CCD (Confraternity of Christian Doctrine) and for us taught by nuns. No spontaneous signing of the cross on one's forehead and chest. My mother and Grandma Rose were religious, which I equated with being tidy in home, appearance, and thought, while Grandma Grace was spiritual and rejected the idea that church was a *Twilight Zone*–like portal for one's relationship with God.

And she was messy. The cigarettes my grandfather and she chain-smoked (Marlboro's and Winston's respectively) and the foods she deep-fried (chicken, bologna, donuts) stunk up her house, turning the white walls and ceiling as yellow as her false teeth. The carpet in her home was too thick, always damp and gritty from sand stuck on feet and bodies dripping with water from Hanson Lake, which would have sent my mother and Grandma Rose scrambling for a vacuum. In other words, my favorite grandmother was also the fun one. I idolized her, but I never thought to ask her about her beliefs in reincarnation, which I equated to just another one of many eccentricities that I accepted but didn't try to understand.

After I turned forty, I finally opened *Many Mansions*, which had been bequeathed to my parents and then to me on the occasion of my grandmother's funeral about fifteen years earlier. In *Many Mansions*, biographer Gina Cerminara writes that Cayce, called the Sleeping Prophet by another biographer and then by his legions of followers, first gained celebrity for his ability to perceive people's mental and physical ailments while in a self-induced trance. Eventually he devel-

oped his abilities so that, while in a trance, he could offer philosoph-
ical thoughts on the bigger picture: the "relationship of man and the
universe." As I went deeper into the pages, I discovered prose devoted
not to the fantastic past lives one might have lived, like the faces my
grandmother had once sketched on paper, but to the necessity and
constancy of human suffering.

In the first chapter, "The Magnificent Possibility," Cerminara asks,
"Why do I suffer?" And then, without directly answering, writes,
"Until the suffering of the most insignificant, most remote of crea-
tures has been accounted for, nothing has been accounted for, and our
philosophic grasp on life is incomplete." This passage, highlighted in
thick, straight yellow lines by my grandmother's own hand, stunned
me. I no longer believed one could make sense of suffering—it was
a natural consequence of being human—and I'd long ago stopped
imagining that my suffering was a God test or released my Catholic
ancestors from Purgatory (an overcrowded celestial waiting room).
I'd opened *Many Mansions* hoping to find a belief system that would
provide an antidote to the fears that were overcoming me as a woman,
mother, and wife. I imagined afterlives free from the reverberations
of prior choices. An endless loop of time-traveling adventure and
possibility—and fun! *If only I could embrace a belief in reincarnation*,
I thought, *then I could live fearlessly for me and for Lily*. (I'd also con-
fused reincarnation with transmogrification, the soul returning to
earth in the shape of an animal or insect, an idea that I would learn
"repelled" Cayce.)

The sentences my grandmother highlighted or marked with blue
and yellow sticky tabs deal almost entirely with the origin of all
suffering, karmic retribution: "Know that in whatever state you find
yourself—of mind, of body, of physical condition—that is what you
have built, and is necessary for your unfoldment." My grandmother,
it seems, believed one reawakened not to begin anew—unlike the
one-shot Catholics!—but to suffer and learn from mistakes made
in previous lives. Did my grandmother believe in an endless loop

of time-traveling suffering? How could it be? I *knew* her. She was the fun one! The fact that my grandmother had a life separate from the one I shared with her hadn't occurred to me, in the same way my own life wasn't real until the night my daughter was born. In the tender premorning wakings that followed, I would lie awake in moonlight listening to the raspy sound of her infant breaths, willing God, Gautama Buddha, Allah, Vishnu—whoever and whatever was out there—to watch over her, to please let her live a long and healthy life. Inherent in my pleas to the universe was my wish that she wouldn't suffer needlessly during her only lifetime on Earth. Isn't this what we all want?

I first learned about suffering in a book about saints my mother gave me. Suffering assured redemption, and for a few chosen ones with "heroic virtue," it presented a path to sainthood. The Catholic Church recognized several St. Margarets, and as I now remember it, one had been a child my age when she alighted upon the idea of tying knotted ropes around her waist, wearing them until her sides bled. St. Margaret "offered up" her self-inflicted sufferings to those who were stuck in Purgatory, a place where the dead waited while being cleansed of their sins so they could enter Heaven—and where my father seemed destined to one day wait it out before someone else's suffering would release him, too. He committed the same sin during every Sunday mass: As soon as the congregation filled in and the first wavering hymn began, he fell fast asleep, worn out from working the graveyard shift as an electrician at the railroad, still smelling of rail grease and cigarettes even though he'd changed out of his Dickies work coveralls. His snores rose from the pews like the flames from a little devil.

Like most young children with any life in them at all, I found the droning recitation of prayers, the brown-gravy sound of organ music, and the adults-only homily exceedingly dull. A most horrible way to spend a bright winter morning that could otherwise be spent on

ice skates on the patch of frozen lake my grandfather had cleared and smoothed with a shovel and push broom, dance-skating with my sister to "Don't Stop 'til You Get Enough," which played from a boom box attached to an extension cord. Apart from a few, clear fragments—a young priest's jet-black hair, a mother of six sobbing outside of a confessional—my memories of Sunday mornings blur in my brain as if cloaked in a heavy Catholic smog. Sunday Mass was for fall and winter but as soon as school let out, my parents sent us to my grandparents' home for entire weeks at a time, where the lake—barely thawed, perfectly chilled, or bathwater-warm—became our church. If my grandmother was on the end of my childhood spectrum with FUN written in all capital letters, Sunday Mass was for me on the other, near SUFFERING, the state of being that I thought all good Catholics were supposed to welcome.

St. Margaret's suffering was not alluring to me; nor did she become a role model, if that's what my mother was hoping. My own pain registered briefly as fear—until I figured out the source of it—and then filled me with anger, not a generosity of spirit for others. (Even as a young child, I railed against the injustice of living in a human body wired for pain.) For a spiritual role model, rather, I chose my grandmother, who wasn't interested in waking up early to iron church clothes, preferring to drink coffee and read literary classics at a picnic table on the patio while my younger sister and I trod water and dunked each other in the lake. My grandmother's spiritual practices extended to her life philosophy. *Try everything at least once. Don't be afraid!* She said it when she handed my sister and me an "edible" flower-weed, plucked from a ditch. When she asked us to carefully hold a granddaddy longlegs clinging to the tips of her fingers. Or when she brought out her Ouija Board, the planchette gliding across the board under our hovering fingertips, answering in the affirmative that the neighborhood boys wanted to kiss us, too. Again at midnight and under cover of moonlight, when she led us down the steps made from rotting, wooden railroad ties so that we might skinny dip for

the first time, our squeals of laughter echoing across the cove. Her lessons on the value of curiosity and adventure—fear's opposites—were subtle and effective.

There were only rare instances of her seeing controversial issues in black or white. The in-between gray is where her thoughts existed, where hell was a way of thinking but not an actual place. Once I grew into my teenage years, she began to talk with me privately and candidly about women's issues, the two of us side by side at her small sink, hand-washing the lunch dishes or rolling raw chicken in a bowl of flour. She told me women can be soulmates with each other. *You and I are kindred spirits.* She told me about women leaving the farms or small homes they were raised in to put themselves through school. *Learn to support yourself.* She told me about women who married too young and landed in domestic wars with men they couldn't grow close to and the coat hanger abortions that sometimes followed. *Nobody has a right to judge a woman for making a choice like that when the government won't support safer methods.* She told me never to judge another woman's choices. *No one really understands what a woman goes through but that woman.* And she told me she believed in me and in the young woman I was becoming. *Your special talent is in your heart.*

She was my prophet, shedding light on the relationship between woman and the universe. No other single family member had as much influence on who I'd become in my adult life (one example: I teach the same books to college students that she'd insisted I read as a child). When I doubted myself—or my identity as an adoptee—she knew just what to say. *More people should be sensitive like you.* I felt like an outsider, an oddball, the only nonbiological member of our family—but wasn't my grandmother an outsider and oddball, too? And as a child I loved her most. With such open-mindedness, she created the environment for what later became my Happy Place, the memory of which I would sink into as an overwhelmed young adult on a therapist's couch, or while pacing my living room, living alone for the first time, insomnia and fear my only companions at 3 a.m.

She also planted the seed for my own spirituality. I took pieces of Western and Eastern religions and science, cobbling together a messy Faith Plan that made sense to me (or suited the predicament I found myself in). Still, assuming we would have plenty of years left together, I never asked her any questions about her belief in reincarnation while she was alive, thinking there'd always be more time, and now the highlighted passages in *Many Mansions* had me wondering what else I didn't know about her. I had believed she fashioned her fearless life philosophy because she embraced only the fun, rejecting the pain that drew Catholics like moths to flame. But I was beginning to see I'd been wrong.

Cayce's origins were not unlike my grandmother's. Both were born into poor farming families, Cayce near Hopkinsville, Kentucky, in 1877 and my grandmother in Hancock, Iowa, in 1927. Cayce left the farm as a young man armed only with a ninth-grade education. He worked as a bookstore clerk, an insurance salesman, and as a photographer's apprentice. My grandmother finished high school, but similar to Cayce, she worked a series of low-paying jobs. She waitressed at places around eastern Nebraska and later worked as a cafeteria lunch lady, wearing a hair net and scooping processed meats onto the trays of high-school students who rarely knew her name.

A bout of laryngitis changed everything for Cayce when he was twenty-one. While under suggestive hypnosis he diagnosed himself, and he soon after tried his "talents" on others suffering from medical ailments. Despite Cayce's reluctance, friends and associates began taking down what Cayce said while under hypnosis, referring to them as "readings." In time and with some prompting from others, Cayce's readings came to address not just the internal ailments of the human body but also the external ailments of the human condition as it related to suffering and the soul's need to incarnate in a new human form (never animal or insect) until a "perfection of consciousness" was achieved, perhaps after billions of years. "The soul," Cerminara

writes, "is like an actor who takes different roles and wears different costumes on different nights." Maybe in one lifetime a soul wore the costume of a high priest in Egypt, and then in another, a physician in Persia, and perhaps next a clairvoyant in Ohio—all three roles that Cayce believed were once his.

Similarly, a pregnancy changed everything for Grandma Grace when she was eighteen. Her own mother, my great-grandmother Mary, would divorce her cheating, minister husband when Grace was in her early thirties, but she would never relate her divorce or life's failings to what she perceived as her daughter's mistakes. Mary never forgave Grace for her shotgun wedding. She expressed her disapproval in small cruelties, such as buying Easter suits for her other grandsons and fancy Easter dresses for her granddaughters, but never buying anything for my father, and later, after his birth, my uncle.

Many Mansions was published in 1950, four years after my pregnant grandmother married my grandfather when he was nineteen. It's possible my grandmother bought *Many Mansions* the year it hit the bookstore shelves, when she was a stay-at-home mother of two young boys. My grandfather worked long and often sporadic, labor-intensive hours as a railroad machinist and when I was a teenager, admitted, "The railroad is hard on a marriage." Sometimes my father also echoed vaguely that life had been tough then or times were different, and after I began reading *Many Mansions*, I pestered my mother to tell me more about my father's parents. My grandfather had been ruthless with his belt, my mother eventually confessed, and what had once passed as discipline would now be considered child abuse.

The only specific detail my grandmother had shared with me about her growing-up years was about peanut butter, which wasn't rationed like other foods during the Great Depression and was plentiful, cheap, and a daily "meal" in her home. "Government peanut butter—blech!" she'd say, wrinkling her nose and remembering the stiff texture while my sister and I, both young girls, sat in her

tiny kitchen, eating the peanut butter sandwiches she'd made us. She told us that she hadn't so much as tasted peanut butter in more than thirty years. That my grandmother grew up very poor was a given, but as a child I naively heard her anecdotes about poverty, the Great Depression, and food rationing after WWII as if they merely added to her grandmotherly charm. It seemed to me she was always in good spirits, cackling or singing in her off-key, raspy smoker's voice, a vision of cheerfulness in her frayed, cut-off jean shorts and faded swimsuit. I had thought my grandmother was the model of happiness, and her home a place free of suffering, while at my home, things weren't so happy.

At home, we—*I*—suffered. The Union Pacific Railroad had laid off my father. Once when I was in elementary school. Then after recalling him when I was a teenager, twice. He expressed his distress in violent behavior I'd never before witnessed from him or anyone. After his tantrums, he'd pour Bacardi into a glass filled with a smidge of Coke and retreat to the garage for hours, insolently banging around in there, where only the poor, loyal dog was brave enough to keep him company. I became afraid of him, and I avoided him. If he entered a room, I left it. If he started speaking, I went mute. Who was this man, who played catch with us in the yard and took us fishing at the Platte River, but now yelled, wildly waved his arms around, and slammed his hand or fist into tables and doors? His words were often harsh, and if we didn't follow his commands or dared any attempt at benign teen rebellion, he flew into a rage.

The profound effect my father's escalating temper and violent outbursts would ultimately have on me represents the only way my grandmother ever let me down. Sitting outside at her picnic table, over fried-bologna sandwiches after school one afternoon, she dismissed any chance of me asking for her help. She knew something was wrong, and yet, "Now, I don't ask about you and your father. That's your business—the reason you keep your distance from him." We never spoke of it again.

The words my grandmother had highlighted in *Many Mansions* brought my summers with her into sharper focus, adjusting the lens just enough so I could see the life that had overlapped with my own had been difficult for her, too. One of Cayce's readings told of souls reincarnating together with the purpose of playing out their marriage drama, until during a future lifetime, they would finally learn from their past mistakes: "Souls related to each other closely by family ties, friendship ties, or the ties of mutual interests were likely to have been related before in similar ties in previous eras." Like Lucy and Ricky Ricardo on TV, my grandparents slept in matching twin beds, except there wasn't any clowning around between my grandparents. Rarely in the same room as my grandfather, she once sat on his lap during their morning cups of coffee, sending my sister and me into fits of laughter. (I didn't yet know that the real Lucille Ball and Desi Arnaz had divorced and that Ball had called their off-screen marriage "a nightmare.") Until the moment of her death, when my grandfather lifted himself from his wheelchair and, after placing a single red rose on her chest, kissed my grandmother's sunken cheek (she lay stone-still in a hospital bed), the lap-sitting moment was one of the rare times I witnessed any romance between them.

I thought that's just how my grandparents were. He tinkered in the garage and bullshitted with neighborhood men on the patio while she taught us to embroider dish towels, curated our summer book selections, and showed us how to tend to her garden (her only act of cruelty toward any living creature: we plucked green hornworms from tomato plants and drowned them in buckets of soapy water). My grandfather went to sleep in his twin bed by 9 p.m., while my grandmother fell asleep after midnight in a living room chair, a cigarette with a dangerously long ash still in her hand. Their nonrelationship was normal for grandparents, I thought, just as it was normal for my grandparents to keep a full keg and Styrofoam cups year-round and for men to drink foamy beer all day long, as my grandfather did, shirtless and in swim trunks.

Although I remembered him as mild-mannered, my mother told me my grandfather had been a domineering and abusive husband and father and an alcoholic (which I'd figured out by then). Perhaps that explains the other story my mother told me when I was a grown woman: My grandmother didn't return home one evening after waiting tables at the Hillside Café, a small restaurant known for its fried chicken. By then, my father was making a life of his own and had recently married my mother. No one knew where Grace was. About a week after my grandmother had gone missing, my grandfather spotted a personal ad addressed to him in the morning paper. It read: "Jim, I'm okay. Grace." My grandfather wrote back: "Grace, come home. I love you. Jim." The two corresponded in a similar stunted manner through the *Omaha World-Herald* for several weeks. Finally, my mother called the newspaper's billing department pretending to be my grandmother and found out Grace was renting a basement apartment in a nearby Iowa town. "I knocked on her door," my mother told me, "and she was shocked. She was not ready to be found."

In a chapter called "Human Types," my grandmother highlighted these words from a Cayce reading: "The seed sown must one day be reaped. You disappointed others. Today, from your own disappointments, you must learn patience, the most beautiful of all the virtues, and the least understood." I wonder, now, if she thought her unhappy marriage was her karmic retribution for disappointing others in past lives, perhaps even an earlier incarnation—or "human type"—of my grandfather. It's possible that because she was seeking lessons in patience, she returned to him and to their home, which at the time was a small apartment above the Hillside Café, though neither of my parents claim my grandparents' lackluster married life improved much. For lack of a better description, my grandmother stomached it.

Other disappointments pockmarked her life. My grandmother had dreamed of being a comic book artist. When we were children, she drew sketches of my sister and me on her yellow legal notepad while we sat uncharacteristically still. She kept a sketch pad full of comic

book and cartoon characters she'd drawn in high school: the Hawk-man, Li'l Abner, Daisy Mae, Moonbeam McSwine. The drawings were as good as the ones I'd seen in my father's *The Fantastic Four* comic books. Perhaps in that Iowa basement apartment she imagined what her life might look like had she not been a teenage mother and bride or had had the financial opportunity to pursue her own interests. Instead, she focused on her family, on her grandchildren.

There was more. My father, expelled from two high schools for fist-fights, found purpose through the military and then his work with the railroad, while my uncle's struggles with a learning disability, booze, and women continued. Kicked out of junior high for bad behavior, my uncle was sent to an alternative school for troubled boys. But purpose never came. My uncle dropped out of high school, moved to Kansas City, promptly broke into a bar with plans to rob it, and landed in prison. Once on the outside again, he found intermittent work as a mechanic and lived in a trailer home in Iowa, where he drank too much. The children from my uncle's first disastrous marriage lived with their mother and stopped speaking to him. A second marriage brought its own unique troubles. Blaming herself for my uncle's pre-dicaments, my grandmother felt she had failed him in some essential way. Much to my grandfather's dismay, she sent my uncle and his second wife a large sum of money each month from my grandfather's railroad pension. My grandparents had little left over for themselves.

I grew up not knowing any of these struggles and indeed spent early adulthood none the wiser. My grandmother protected my joy-filled childhood, but to do so, she had to keep a part of herself from me: her pain and suffering. She left me clues though, highlighted in *Many Mansions*, trusting that someday I'd be ready for this lesson, too.

During my teenage years, my relationship with my grandmother predictably changed as I prioritized my peers and sought her out less frequently. Her chronic phlegmatic cough, the slow pace of her walks to the mailbox (the thwacking of her flip-flops growing farther and

farther apart), her sudden apathy toward swimming: she'd changed in ways my highly judgmental teenage self didn't approve of. I started to resent the things I'd once loved about her. She'd always wanted me to spill the gossip on my friends, especially the charismatic boy who'd grown up next door to her and on whom I had a painful crush, but now her interest seemed like unbridled neediness. It repulsed me in the same way my own newly discovered need did. To survive high school and the weakness-sniffing teenage throng that populates it, I thought, one must never show signs of hunger for anything.

And there was my father's anger, which by this point had thrown the two of us into separate corners as enemies, barely able to speak to one another or make eye contact. But I didn't know how to communicate any of what I was feeling to my grandmother, and I was afraid she wouldn't welcome what I had to say about my father, her eldest son, of whom she was proud. As it turns out, we both kept some things a secret. "Why don't you come around like you used to?" she asked those few times I bothered to visit.

When I was away at college in another small town in Nebraska, our relationship lived on through the mail, her care packages of home-made Melba toast and handwritten letters, everything smoky but made with so much care. "My happy memories of you brighten my life now," she wrote. I threw out the Melba toast and read the letters, collecting them in a shoe box that, during one of my many moves over the next decade, I'd toss by mistake. (There is still a hole in my heart for those letters.) The notes I sent back were short, perfunctory. I loved her madly, but I was self-absorbed and independent of my family for the first time. Our relationship weakened. We were never again as close as we'd once been.

I visited my grandmother at her home in Bellevue just a week before her beliefs in reincarnation would be tested in a hospital room. That afternoon, unbeknownst to both of us, would be the last time we talked. She sat in a wrought-iron patio chair in the backyard of the

single-wide trailer home she shared with my grandfather. It wasn't a happy situation or a happy way to enter the last years of one's life. After decades of teaching grandchildren to water ski and hosting annual Fourth of July family reunions, my grandparents had been forced to sell their home on Hanson Lake. The Lake Association had voted to pave the dirt roads and replace septic tanks with city water from Omaha, which meant a steep increase in taxes that my grandparents and other retirees who had long ago bought modest property couldn't afford. Mostly populated by a younger, wealthier generation, the Lake Association didn't care. They welcomed young couples with the economic means to bulldoze one and two-bedroom "cabins," replacing them with five-bedroom luxury lakeside homes.

Ultimately, though, the human-made lake would never fully reincarnate into the destination lake the younger generation wanted. It would always be so murky that swimmers could barely make out their own hand underwater, full of toothy gar and other undesirables from the Platte River flooding its crawdad-infested banks. In other words, it would always be my grandmother's lake.

By then my grandfather was wheelchair-bound after losing one leg to gangrene brought on by years of smoking and boozing, and my grandmother was slowly starving to death. Her doctors couldn't figure out why (though later my father speculated she had asbestos poisoning, which my grandfather had gotten from railroad work and had already received a small settlement for, and which my grandmother may have gotten from years of laundering his asbestos-covered clothing). Her response to her gastrointestinal distress was just as unorthodox as the rest of her, though the electromagnetic pulse belt she used to control the pain and self-heal ultimately failed. She never once mentioned her pain to me.

I started blubbering at the sight of her in the tiny backyard behind her trailer, the way her cheeks hung loose on her skeleton, her eyes deep in their sockets. Why had I waited so long to make this trip? Finding people who truly care about you is rare. I felt ashamed, awash

in loss and my own neediness—needing her to live long enough to witness me turn into the kindhearted adult she'd always promised I would become.

I couldn't tell her the truth. Directionless after graduating college, I was waiting tables at a blues joint to pay rent and hanging out at rundown rentals where people I'd just met wore Dead Head tees, where the toilet paper dispenser in the only bathroom was empty, where drug use was casual, dangerous, and turned tongues black with residue. On the sly, I was also sleeping with the manager of the restaurant, who snorted cocaine "recreationally" and left threatening messages on my answering machine when I wasn't home. I'd also conflated suffering with intensity, depth of emotion, and nonconformity. And so, like St. Margaret, I sought out situations that would produce my own suffering. The person I had become in my private life wasn't someone my grandmother would have recognized. Or maybe she would have. Like Cayce, she understood that once you begin to uncover the story of someone's soul, or even a fraction of it, it becomes clear that every life is full of self-inflicted wounds. Cayce said, "Know that every soul eventually meets itself. No problem may be run away from. Meet it now!"

I sat down across from her and started to sob in earnest. She reached across the patio table, placed her bird-boned hand on top of mine, and scolded me: "Don't you cry for me." Her voice was as strong, as sure, and as rebellious as ever. "I've had a good life. Remember what I've taught you."

Images of my grandmother, younger sister, and me flashed through my mind: doing "dolphin-dives" from the dock; lazing in inner tubes while watching the black slips of fish near our dangling feet; waterskiing next to each other as my grandmother taught us how to hold up one leg so we could learn to slalom ski. But I wasn't a young kid now, one who didn't mind sleeping in my damp swimsuit or the overall slow pace of time spent with my grandparents. I was who I was, and the sight of my sick grandmother slumped in front

of me mirrored back the lost time that couldn't be made up. Once she'd been about possibilities, and now her neck was too skinny to hold up her head.

In the chapter "An Answer to the Riddles of Life," my grandmother had highlighted another passage: "All pain and all limitation have an educative purpose; deformities and afflictions are of moral origin; and all man's agonies are lessons in a long-term school for wisdom and perfection." According to Cayce's readings, physical ailments—along with moral ones—can be traced to one's poor choices and bad behavior in past lives. Maybe Cayce's readings offered my grandmother comfort, "an answer to the riddle" of her suffering when her doctors couldn't diagnose her. (It seemed all the disappointment she had stomached over the years was now eating away at her actual stomach.) Of course, this meant she believed that in a previous life she had committed terrible acts. Still, if she believed her suffering had an "educative purpose," then it ceased to be meaningless. Likewise, if she believed her suffering wasn't meaningless, then her belief in a compassionate Creative Force was restored, or at least, in a Creative Force who wanted each soul to evolve during each lifetime spent on earth, in pursuit, one might argue, of divine grace.

"Don't be afraid," my grandmother said that day, one of the last things she ever said to me.

It took my reading of *Many Mansions* to open my eyes to my grandmother's bravery in the face of it all, my fingers tracing along the passages her fingers had once passed over. With these memories and my many regrets, I find some measure of comfort in Cayce's words: "Know that in whatever state you find yourself, that, at the moment, is best for you. Do not look back upon what might have been. Rather lift up, look up, now where you are." Lifting up, looking up, now, where I am: I see human failure and the limits of human love. I see my grandmother anew and maybe for the first time. (And I see my father through more compassionate eyes.) I

see that both joy and pain filled her life, and will fill mine, too. I see now that she worried about how pain and suffering would affect me—a "sensitive soul"—and that she was teaching me how to be brave and have fun, despite it. It turns out she taught me how to live fearlessly after all.

Cayce, who died from a stroke at age sixty-seven on January 3, 1945, prophesied that a soul eventually stops reincarnating when one becomes spiritually evolved ("perfect"), after which the soul reunites with God, the "Master." The title *Many Mansions* refers to a biblical passage Cayce quoted during one of his readings: Jesus said, "In my Father's house are many mansions." In its historical and biblical context, "mansions" refers to the countless adjoining rooms in God's eternal kingdom. Cayce defined it thusly: "Many mansions are in that body, many temples. For the body has been again and again in the experience of the earth; they are sometimes mansions, sometimes homes, sometimes huts." Both the biblical scholars interpreting the passage and Cayce believed souls related to one another would end up in adjoining rooms (or homes or huts) in an afterlife—a family reunion of sorts. Isn't this what we—Catholics, Christian mystics, Buddhists, Jews, Muslims, and more—all want? To bring our loved ones back to us from the dead? To have one more chance to address past wrongs and live among one another in peace? To finally, once and for all, untie the knotted ropes at our sides? On this point, Cayce and I agree.

Before his death, Cayce predicted he would be reincarnated in 2158 in—of all places—Nebraska. He also predicted that Jesus would return to earth in 1998. His followers are still waiting for both. I'm not one of them, but I'm not a Catholic, either. I'm a spiritual mutt, a mix of religious influences, one who believes we live our many lives right here on earth in the myriad ways our loved ones come to see and know us. When my grandmother died on September 8, 2000, she was seventy-three and too young, too sick, and no longer drinking her morning coffee near the lake. I vow to always remember her—*all*

of her, but especially the joy, especially the fun—and to pass down her stories to my own child. The moment I was deep into labor with my daughter, my body visibly full of pain and suffering (a moment I had premeditated), I panted out to my husband, "I want 'Grace' to be our daughter's middle name."

Of course, he said yes.

In-Between

Fear threatened to swallow my fantasies of a happy family when we first brought Lily into our home. Without the comfort of medical practitioners and the accoutrements of "just in case"—tiny blood pressure cuffs, fetal monitors, and emergency feeding tubes—I felt vulnerable to future pain, as if my entire being was a gaping wound and not just the parts that had stretched and split when I delivered her, birth being its own special kind of violence. Lily cried throughout the first and then the second twenty-four hours, and I realized I had only a phone number for an all-night nurses' line, my equally thunderstruck partner, and a rectal thermometer, just in case. I feared she would not survive the nights. I feared she would not survive the days. As one hormone dropped to new bottoms and another swelled to new heights, I went into the bathroom to silently scream at the mirror. To my blurry-eyed reflection I whispered, *You've made a mistake. You can't do this.* My close friends and family fretted over the baby and me.

Eventually, both my hormones and maternal fear plateaued (though my mother-fear has never left me entirely), and I accepted that new motherhood would be disorienting and sometimes painful. So when an out-of-town friend comes to my home for a visit—me, her, six-year-old Lily, and my newborn daughter Amelia out for a neighborhood stroll on a balmy spring morning—and asks me if I'm overcome with fear again—"Have you been feeling anxious a lot?"—I surprise both of us when I immediately say, "No." As we walk, I consider my answer.

I don't know anything as real or astonishing as the sensation of holding a baby against my chest during the final hours before dawn, complete darkness surrounding us except for an inch of yellow street-

light snaking in through closed blinds; the delicate baby-sounds of breathing and sucking; the heat from her body and especially her round head; a primordial language passing through our skin. There's a sweetness to this sensation, but also: Let anyone or anything try to take her from me and cause harm, and I will shred them, tear them limb from limb. My twilight love is ferocious but fleeting, these moments disappearing already as Amelia's body changes and she demands fewer nighttime feedings. I grow nostalgic for them as I also embrace the calm of sleep.

Now, unlike the days following Lily's birth, when I suffered through postpartum blues and my mother and mother-in-law asked, "Can we help, come over and cook you a meal, and rock the baby while you shower?"—I receive their visits, instead of bawling in breastmilk-stained pajamas, nipples bleeding, behind my locked bedroom door. These days I feel joy—and exhaustion. I feel contentment, a *this is right* in my body. My hands don't tremble when I wipe the gray, rotting stump of umbilical cord and the two pulsing fontanelles on Amelia's head. I look at her wrapped tightly in a blanket, being pushed by Lily in her stroller, brown eyes unfocused but aware. My turtle heart leapfrogs over fear and safely lands a few feet away, steadily thumping out *I'm in love. I'm in love. I'm in love.*

"No, I don't feel afraid."

"Do you think you're less afraid because she's not biologically yours?" my friend, who I've known and trusted for over twenty years, asks.

"No," I answer quickly. "I'm not afraid because I've done this before."

I won't understand the insinuation in her question until later.

*

Four years earlier, I'd brought Jon and Lily along with me to my reproductive health specialist's clinic. It was Halloween morning, and while I cried and clung to Jon in the hallway outside the examination room—where moments before a transvaginal wand had probed me for the third and final time and found an unhealthy egg—a gaggle

of nurses gathered around Lily. They hoisted her onto a counter so she was eye-level, making a fuss over the Little Candy Corn Witch costume she wore for her school's party. Her pointy orange-and-yellow-striped hat (too big and slipping down over her eyes), her orange-and-black striped tights on her chubby toddler legs, her tiny black Mary Janes covering stubby toes: an image I cannot help but sentimentalize even now. Our Lily, who called me "Mama" or "Mommy" dozens of times every day and who should have been enough for me, but somehow wasn't.

I wanted to parent another child (actually, I wanted to clone Lily in case the unthinkable happened)—but how? Even with the various chemicals Jon had injected into my body, my eggs proved they were too old and too few. Adoption is conventionally viewed as the final option for sad, mostly aging, childless couples and singles who've likely depleted their financial reserves for high-cost medical interventions (if they can afford them) and who've been told by family and friends, "Well, you can *always* adopt." Framed this way, adoption becomes a last resort, the safeguard against being childless or the parent of an only child, and as an adopted person, I'm troubled when I overhear this sentiment or see it pop up in social media, offered as a consolation to someone who's grieving a miscarriage or reproductive roadblock.

I recently chatted with a woman in the locker room of my gym, and when I asked her if her daughter, struggling with secondary infertility, had considered adoption, she said, "No. They aren't that desperate." Such a disquieting word choice in this context, but one that many people feel. I stood before her in my underwear and sweat-stained sports bra, ready to expose more. Gently, I said, "I'm adopted. My mother says I was a great baby. I hardly cried." Adoption is not a first or even second choice for many—and it wasn't for Jon and me—but it still gut-punches me to think of us adoptees as the "third time's a charm" and "last call" of family-making, the desperation after other failures. Yet I've learned that people don't seek out adoption because of love in the same way as when they try for a pregnancy. People come

to adoption because of loss, like Jon and I had and like my parents had when they adopted me.

*

After my friend climbs into her family van, heading home to her husband and three children in another state, I hold Amelia in my arms while she sucks from a bottle. I think about my friend's words. *Not biologically yours.* I stare at the little black hairs sprouting on her hairline, her brown eyes and thin lips, and I wonder: *Who do you look like? Where did you come from?* She feels like my baby, head nestled in the crook of my arm, but she isn't my baby. Not wholly.

A few days later, I obsess over my friend's words, which have begun to pollute my typically warm feelings for her. *Not biologically yours.* A therapist once told me anger is a "racket" feeling covering up an authentic feeling, one that is even less socially acceptable to express, like fear or sadness. And I'm angry enough that I want to call her and confront her. Why? What do I fear? That my friend, who gave birth to all three of her children, believes adoptive mothers worry less about their adopted children? Care less? Love less? Does my adoptive mother love me less, as if mother-love is singularly the result of genetics and the brain changes that occur during pregnancy? Do I have less fear this time because my maternal lizard brain was unaffected by the arrival of Amelia into our home? Rebecca Walker, Alice Walker's daughter, famously wrote in *Baby Love: Choosing Motherhood after a Lifetime of Ambivalence,* "I don't care how close you are to your adopted son or beloved stepdaughter, the love you have for your non-biological child isn't the same as the love you have for your own flesh and blood." (Ironic, considering Rebecca and her own biological mother are now estranged.) I don't believe that experiences of love or fear for a child depend solely on biology—though biology always has some impact—especially since my mother unfailingly said she forgot I was adopted. "I just think of you as my own!" she'd say. Do mothers love their adopted babies as much as their biological ones?

Yes! But when Amelia is four months old, Jon says to me, "I never knew I would love her so much."

*

Over a year and a half before Amelia was born, Jon and I sat in a sensible grandmotherly type's office for an "intake interview," which in retrospect seems more like an interview of dangerous questions, aimed at revealing the frail spots in a marriage. Jon and I had encountered weak spots in our marriage before. (Who hasn't?) But after a particularly hard year, we'd rekindled our romance through, among other things, our attempts at a second pregnancy and by simply making more time for each other. Now, we felt stronger than ever, further bonded by our mutual desire to expand our family via adoption. We steeled ourselves for the woman's questions. "What brought you here today to discuss adoption?" "How have you grieved your infertility?" "Have you ever required marital counseling?" "Have you ever discussed divorce?" "Describe your relationships with your extended families." "What do family gatherings look like?" "Have you ever struggled financially?" "How do you settle disagreements?" "How do you define adoption?" "What scares you about adoption?" We got through the two-hour conversation, and soon after Jon and I embarked on what would be a year-long adoption process.

We attended classes about the hopeful triad of open adoption and how it might work: birth mother, baby, and adoptive parents all in varying degrees of contact and togetherness. We paid for background checks and official fingerprint cards, waiting at the same state patrol office where a man, unnervingly, waited to register the gun he fondled in his hand. We visited over several months and several times with the caseworker assigned to us—sometimes at her office and other times at our home for a "home study." Lastly, we wrote the adoptive family profile our caseworker would share with pregnant women. While we waited to be chosen (or not), we attended adoption support groups that were dismayingly well-populated. We'd been warned that at most

adoption agencies in Nebraska, less than 30 percent of us would be chosen to parent a newborn during any given year. Some of us, never. Once (if) a pregnant woman chose us, we would all meet with our caseworker, getting to know our new family, a triadic structure, while also making plans for the birth: Would the birth mother be comfortable with us in the delivery room? Did she want a few days alone with the (her) baby after the birth? When could we bring the (our) baby home? Unlike with my closed adoption, our adopted child would grow up knowing something about her other mother, and maybe her other father and grandparents, too. We'd make these decisions, together, with the birth mother, and the *open* in our open adoption would range anywhere on the spectrum from weekly family dinners with a birth mother (or birth family) to only exchanging letters and photos. Medical and personal history questions could be answered. Relationships could be formed. The new school of thought on adoption went something like this: Feelings of guilt and shame (the birth parents'), loss and grief (both the birth parents' and adoptees'), confusion from unknowns (everyone's), and the trauma of separation and abandonment (the adoptees') could be worked through together. In a closed adoption, the triangle was fractured, the identity of the birth family sealed off in court documents—as my birth family's identities had been.

While we were waiting to be chosen (or not), I answered my cell phone at the university where I teach, anticipating a reminder about our soon-to-expire background checks and also the argument Jon and I were likely to have about how much longer we wanted to pursue adoption (I, forty-two, would wait indefinitely, while Jon, forty-five, felt he was close to aging out of new parenthood).

But the woman on the other end of the phone didn't ask about our background checks. Instead, she told me a baby girl had been born three days earlier, and her birth parents had chosen Jon and me for a closed adoption. The baby would be transported from the hospital soon. If we said "yes," we needed to pick her up from the adoption

agency in less than three hours. For a few seconds, I forgot to breathe. I knew my answer before she even finished her sentence, before she even asked—the moment she'd said, "A baby girl," I knew. When I reached Jon by phone, he was driving to a work site in his white van. He said, "I have to pull over to the side of the road. I'm going numb. Is this really happening?"

I arrived at home first, Jon shortly after. We embraced for a long while. We cried. We laughed. We panicked; we didn't have any baby supplies. We called our parents, who cried with us. (Overjoyed by Amelia's adoption and caught up in their memories of my adoption, my parents would quickly sell their Spokane home and relocate to a small town in Nebraska.)

"I can't believe this is happening!" we said to each other. It was surreal. We didn't have time to think about the *closed* in our new daughter's adoption.

*

My friend is correct about one thing: Amelia will never be biologically mine and biology does matter. She'll one day understand that my body couldn't have made her, couldn't feed her, couldn't have created the moments that pass between us on its own. My age. My secondary infertility. My autoimmune disease. I'm aware that this is the final time I can manage twenty-four-hour care for a baby, and it feels so entirely right. But there is a wrongness to any closed adoption. The birth mother, the woman who has Amelia's cells intermingled with her own through fetal microchimerism, has been disappeared, and this absence will be painful for Amelia. (*Who did I come from?*) Peter Van Leeuwen and the other authors of an article in BMC *Physiology* write, "In the human life cycle, there is no time when two individuals are more closely physiologically intertwined than in the period before birth." I vow to be my adopted daughter's guide when I can relate to what she's feeling and soothe her when I don't have answers (and conversely, accept when she needs to rage). But I wonder: How

can any adoptee heal from this trauma if they've never met the one they were once physiologically intertwined with? Or if they meet her too late?

I'd separately met both of my birth parents during my twenties (I met them after I'd sought out their identity through Catholic Charities, the agency responsible for my adoption). Still, none of us were in frequent contact, and the family reunions I did attend, while fascinating to me (*Who do I look like?*), never left me with a feeling of belonging. Without any shared childhood memories—or any shared anything other than a half or a fraction of my chromosomal make-up—I stood outside of them and their easy interactions, born of years of memory-making together. I made my memories with my adoptive family, and they are my family in most ways, but they aren't "my people." I don't have "my people" in the same way someone says, "I'm of these people and of this place." My blood is not thicker than water. I often wonder what kind of person I'd be if things had gone differently: nature or nurture? I think about the question of hereditary versus environment, and I research it, too. It is an unforgiving and illogical dichotomy, yet people want adopted people like me to pick a side. Which one has more influence on who you've become?—the answer affirming their beliefs about behavior, or cosmic destiny, or God, or Darwinism, or their own parenting misreckoning. As an adoptee, I find myself eternally in between two families: the one that raised me and the one that made me.

*

I tell my friend how her question hurt me, as an adoptee and an adoptive mother (I'm now adoption times two). When she becomes defensive, I move beyond hurt and lizard brain alarm, beyond our shared history and love for one another, and into outrage: *How dare she?* Both of us, upset and feeling misunderstood, pause our relation-ship until some future date. Months later, right before we reconnect and apologize to each other, I realize it was never her I was upset

with. I'm angry with my forlorn child-self, the one who still lingers deep inside of me and in darkness, below the surface of my good mother-self, and who still fears that adopted children are less-than biological children, that they deserve less love because their (her) birth mothers didn't keep them (her). There is a deep, wide space inside of me where a birth mother's love, reassurance, shelter, and genetic likeness should be—the in-between space where *closed* meets *adoption*. After this realization, I am determined to allow my child-self to grieve these feelings of loss, not just for what for I've lost, but for what Amelia has lost, too.

*

When it comes to my ability to keep Amelia alive through her infancy, I am confident; I notice only a lack of fear in this realm. (Well, I harbor at least three new mother-fears: Will her birth mother always think she's correctly chosen me? Will Amelia one day wish her birth mother had raised her instead of me? Can I live with either answer?) A restlessness in me has been quieted by her adoption. Yet I am also a woman who will never be completely free of fear. Is anyone? I'm occasionally sleepless, awake in bed and listening to the great horned owl in our backyard, wondering about how I'll safely ferry two daughters from the protected island of childhood over to the wild country of wild grownups. And I must get them safely across the rough waters of their teenage years while both defending their naturally imaginative worldviews and allowing them room to discover the sinister nature of civilization, our many "isms," our propensity for violence and retribution. I must teach them what and who to fear, without always knowing what or who they should fear.

I suspect most of us exist in a liminal place, somewhere in between our hopes for the future and our fears, in between our curiosity for life and interest in other people and our uncertainty of what danger lies ahead. I am not free of fear, but neither have I gotten down on my knees and looked under my bed for the boogeyman in a long, long

while. Mothering daughters has healed the afraid young child (and young woman) I once was. But I still have work to do.

*

When Amelia is five months old, one month from when we will finalize her adoption in court, I have my first adoption dream since we brought her home. The court date marks a milestone, as the state will amend Amelia's original birth certificate—which is sealed with her adoption records—and create another one. My name will appear in the box for "mother" instead of the name of Amelia's birth mother. It's also the last opportunity for a biological family member to oppose her adoption, though the chances of that happening are rare. I'm eager to finalize, though the altered birth certificate disturbs me in the same way my own altered birth certificate does (one mother disappears while another mother becomes). I dream of Hanson Lake, the Happy Place of my childhood, the place I return to in dreams, except I dream of ski boats underwater and flooded, the naturally olive-green water turned muddy and black, thrashing with waves and shrieking wind. A young couple with two small children arrives at my grandmother's dock, soaked and shivering. They and their small boat are weather-beaten. We—my mother, Grandma Grace (back from the dead), and me—grab their hands and guide elbows, helping them climb onto the dock, which is somehow steady. Above us, thunderclouds turn gray. We stand in front of each other, rain falling like ice on our faces and bare arms. The woman is young with brown eyes and dark brown hair. She won't look at me. The man is short, with eyes so dark it's hard to find his pupils, just like Amelia's eyes. Their infant son, held by the father, looks like Amelia's twin. A child Lily's age hides behind the woman.

The father looks at me with his black eyes and says: *We're having a hard time. We're still dealing with the fact that we gave her up.*

The language of adoption has changed since I was once given up. You don't say "gave her up," you say, "placed her for adoption." The

latter phrase seeks to erase the social stigma of adoption, reflecting more benevolently on the birth mother and the enigmatic—and as our caseworker says, selfless—choice she's made, and this is what I think but don't say to the young couple. Amelia doesn't appear and so they never see her, and that surely must be what they want and what my dream-self refuses. Is my waking-self ready when and if the time comes? I say I am, but I suspect I'm in another middle space: somewhere in between accepting that she's not fully mine and, like my adoptive mother used to do, pretending that she is. Before I can answer the father and ease his suffering, Amelia cries out from her crib and the dream ends. When I go to her, right now as before during the twilight hours, she accepts the love I offer.

Runaway Daughter

I've never thought the rail yards where my father has worked are much to look at. Rotting railroad ties and out-of-commission boxcars lie scattered, as if in a train graveyard. Industrial buildings rise from the dirt. Several rusty tracks run parallel to each other. A few cross paths. Surrounding the boxcars and buildings: empty coal cars, piles of excess rail, dirt, and gravel—everything in shades of gray, brown, and black. The only color (and glory for pulling a train down the tracks) comes from the locomotives: metal beasts, painted orange with yellow stripes. I'm standing next to my father in the Burlington Northern Santa Fe Railway yard in Lincoln, Nebraska, but it might as well be the Omaha Union Pacific rail yards of my youth. It looks the same, even though it's the "125th Anniversary and Family Appreciation Day" and the place is jazzed up with banners, carnival food, and a clown. A crowd of about a hundred has gathered. My parents, recently relocated from Washington to a rural town in Nebraska, are happy to be among old friends. And I'm here with my husband, six-year-old daughter Lily, and infant daughter Amelia, standing next to my father in a rail yard that I don't think is much to look at, because I'm *trying*. I'm trying in the way people do when a relationship is damaged, yet still meaningful, in the way that finding meaning isn't always a straight path or pretty once you get there.

Old-timers and new guys alike slap my father on the back or cuff his shoulder; his cheeks flush with color. Ten years retired from railroad life, old age has taken hold, most noticeably in the length and color of his untamed beard (gray and down to midchest) and twenty pounds that've gone straight to his belly. The men say, "Hey Old Man!" or "Hey Dad!"—terms of endearment adopted toward the

last years of my father's career, when the new hires were forty years younger than him and didn't know the trains as intimately. They greet my white-haired mother, too, remembering the extra ribs, soups, and breads she packed up throughout the years, when my father worked as an electrician. Trained to inspect brakes and repair traction motor cables, my father understands what he calls "the power on the track." The point where wheel meets rail is, unbelievably, only the width of a dime. "You'd think the train would slip," he's said. "But it doesn't." One mistake—like a track defect or operational error—could mean a derailed train, a runaway. A pile of metal on the evening news.

When I was a teenager my father was hard-bodied and trim, with the unmistakable look of someone who's survived a hardscrabble upbringing. We fought weekly if not daily, or more accurately, he screamed at me, violently waving his arms around as he paced the room, and I sat hunched over the kitchen table, silent. My crimes: avoiding him. Mistrusting him. "Have I ever hit you?" he'd ask when I flinched at his fevered gesturing, a beefy arm thrown out inches above my head. No, he hadn't, but as a child I'd witnessed him kicking the dog around the front yard while wearing his steel-toed work boots. The dog yelped, tucked her tail between her legs, and crawled closer to my father, and he kicked her again, yelling "No!" and pointing to the hole she'd dug in the yard. He slapped my younger teenage sister across her face for smarting off. The threat was palpable and always close by, something I could sense, an electrical current running through his veins.

A few times I broke down and cried, and then he raised his voice a few octaves higher and mimicked me, as if he were a young girl crying, too. "Only a coward looks at the ground," he sneered while I stared at the floor. "Do you hate me that much?" It sounded like a demand, not a question, but I heard the tremble in his voice. We were both afraid I'd have the guts to answer, because then I would have wiped my eyes and nose, looked him dead in the eyes, and said: "*Yes*." It felt like hate, ready to burst through my chest like some sci-fi monster from the

movies and TV shows he watched, though I recognize now that what I was feeling is more complicated, a heady mix of fear, frustration, and need. I still needed his approval (and his love, though I never would have admitted it) and plenty of days he gave it, which only frustrated me more during the times his anger overcame him. But I didn't have the guts then, so I stared at the ground. "Get out of my face!" he roared. I ran upstairs to my bedroom, shaken but relieved, knowing better than to slam the door behind me. We repeated the kitchen table fights again and again (while my mother was at work and, she says, unknowing)—until I eventually forgot what it had felt like to love him.

Those complicated feelings have stayed with me through many moves and years, a career, a marriage, and two children. The worst between my father and me is over two decades past—though unresolved—so today I smile politely and nod as he introduces me, saying proudly, "My oldest daughter, the college teacher." He's trying, too.

After Jon takes Amelia on a stroll so she can nap and I've been standing around with my father long enough, I grab Lily's hand. Guiding us through a thicket of sweaty men, past a large building called the "storage house" where railroad wives serve hamburgers, baked beans, and potato chips, I lead us toward the clown performing old-school magic tricks for twenty or so children in front of another building. A cloth bunny appears from underneath a black hat. An impossibly long, rainbow-colored scarf is pulled from a sleeve. Lily releases my hand, pushing to the front. To honor my effort of trying, and the hope I still have for Lily's relationship with her grandfather, I ignore the perspiration pouring down the clown's made-up, white face, exposing his skin. The make-believe of trying laid bare.

My mother soon follows us in her orthopedic shoes and T-shirt with a cartoon picture of a birdhouse, the epitome of the Adorable Grandmother. Approaching their fiftieth wedding anniversary, my parents have always operated as a unit, a "we" instead of a "me," and so though my mother was gentle and levelheaded when my sister

Debbie and I were growing up, she rescued no one from my father's tantrums. "Why can't you just be nicer to your father?" she asked, exasperated, after he'd lost it again. She always stood by her man, even years later when as adults, Debbie and I told her about what we'd endured when she wasn't around. She hugged us both, her eyes filling with tears. Then, straightening up, she said, "Your father and I just remember those years differently than you do."

Those years. The first train I remember seeing remains formidable in my mind. At least a dozen separate railroad cars race past our family as we sit inside our yellow station wagon idling at a railway crossing, the sound a rhythmic rumbling, metal against metal. Debbie and I sit in the backseat, our legs sweaty and stuck to the vinyl seats of our car. One or another of the mutts my father has rescued from the rail yard watches from the rear of the car, tongue wagging. Our whole car shakes with the train's movement, shushing us. Through my open window hot air rushes against my face. I feel small, insignificant so near a massive, willful thing. After the train rumbles out of sight, the bells and lights cease; the red and white gate jerks into the air. My father drives our family over the railroad tracks. There was a time I used to feel safe because I was with my father.

The trouble for our family (and hundreds of others in Omaha and surrounding towns) started in 1985 when over four hundred craftsmen—electricians, machinists, blacksmiths, boilermakers, and car men—who had spent years sweating over box cars and locomotive engines were let go after the Union Pacific Railroad lost a coal contract. Due to a drop in oil prices, thousands more would be laid off or bought out during the following years. "Necessary layoffs," said company executives in pressed white shirts and ties. Debbie and I were in elementary school. Initially my father took it in stride, and within a week, he'd started a repair business, fixing up commercial properties. But soon it became obvious that his home repair business, named with his initials and stenciled onto his gray truck, would only provide

sporadic bursts of work, which meant my father spent more time around the house. Before long he grew restless. My father drank—his favorite drink is still Bacardi and Coke—and when alcohol loosened him, he lashed out in anguish. He struck a wall in our kitchen, leaving a noticeable hole. He yanked Debbie into the air by the collar of her winter coat. And then there was the dog-kicking incident, the yelping. Besides early childhood spankings, he never hit me, only bellowed and threatened—removing his leather belt for show—but his words left unseen injuries. My fear of him was new but potent. When my parents could no longer afford the house payments on my mother's salary alone, we sold our earth home in the country and moved to a smaller, rundown house in town that smelled of cat piss and despair. My father soon found work as a high school janitor, but without the railroad, he stayed mean. What set him off was arbitrary and usually minor, but when he was angry he barreled down our hallway, a tornado of man and machinery.

Most of the railroaders at today's festival are white or Hispanic men, with their own untamed facial hair and bushy eyebrows. They have meaty, calloused hands and thick thighs. They dress in Levi's or Wrangler's, and Harley Davidson or Nebraska Cornhuskers T-shirts—never collars, never shorts—and it's approaching ninety degrees with high humidity (if it were cold, they'd be wearing flannels or long-sleeved T-shirts). A few of them wear bib overalls or coveralls, which darken around the armpits, and swat away the flies. They've brought their own sons, daughters, and grandchildren and put effort into showing them around while showing them off. I wonder how many of the grown daughters had fathers like mine, ones whose goodwill was directly tied to their employment. My father fits right in. "Railroaders don't care about haircuts," he once told me, which wasn't true. They just don't care about the kind of tidy haircuts that mark someone as a company man. Back when my father was working, if any of his coworkers had a problem with a supervisor or railroad management, they'd be sent to

my father: "Go ask the Old Man." He knew the bylaws, contracts, and labor agreements inside and out. "I'm not a *yes, yes, yes, yes* man," he'd tell his supervisors. Eventually he became the union representative, typing letters to railroad management at night, my mother correcting his grammatical errors the following morning. He championed the laborers, many whose life's work was considered a dying, hands-on craft, men who scrubbed rail grease from underneath their fingernails at night and went a long while between haircuts.

Now my family stands together in a short line—the perspiring clown having finished his routine—waiting to climb aboard a three-thousand-horsepower locomotive for a tour. Young children in line are jumpy with excitement. A boy about Lily's age spouts random bits of train facts, and Lily turns her head to listen. Even as a young child I never got caught up in the magic of trains, which must have disappointed my father, though I eventually grew curious about his love-hate relationship with the railroad. Love-hate was a feeling I could relate to.

Becoming both teacher and crude poet at the rail yard, my father says, unprompted, "You have to be a survivor to work on the railroad. You have to have a creed. If you're wrong, take your butt-chewing, but if you're right, don't back down." He strokes his beard thoughtfully. Like him, the railroaders here come from the working class and lower- to middle-class backgrounds and, as physical learners, struggled in public schools. And they love the same things he does. Sadly, I've never loved the things that interest him, and he's never loved the things that interest me. We have always struggled to find common ground, a place where we can be together, peacefully. I guess we still don't know how to love each other. "Listen," my father says, "and the train will tell you. That's what happens when you really care about the locomotive. I can close my eyes and *feel* what's wrong with a train." He jabs his thumb toward the crowd. "Computers can't teach these new guys that."

I strain. I listen. But only the men in my family have been able to hear what the trains are saying. My father's grandfather, PJ—my

great-grandfather—laid track from Omaha to Denver and from Omaha to Chicago with a "track gang" in the 1920s, where men set up tent cities: horse troughs for bathing, places to sleep and eat, and brothels. Earning only enough money to drink, chase women, and fight, when PJ wasn't on the road he lived alone in a trailer home on three acres of land behind my father's childhood home. However sporadic, however tough, railroad work was respectable and even romanticized, owing some of its mythos to the historical moment Abraham Lincoln convinced Congressmen Oakes Ames to champion the railroad: "The road must be built, and you are the man to do it. Take hold of it yourself. By building the Union Pacific, you will be the remembered man of your generation." How many young boys heard or read those words and were swept up in the idea of becoming railroaders themselves? As family lore has it, PJ once clobbered a loud-mouthed hobo riding the rails, throwing him from a moving train and into a field. "For every mile of track," PJ told my father, "I'd be surprised if no one was buried under there." PJ offered his young grandson some advice: "You either get tough or you get dead and become one of those men buried under the rails." My father grew up wanting to be exactly like him and passed on PJ's stories to my sister and me. I never admitted I felt more kinship with the frightened hobo than with my great-grandfather.

In the 1940s my grandfather (the Hanson Lake grandfather), PJ's son, dropped out of high school at seventeen to pursue a machinist apprenticeship for the railroad. By the time I was born, in the seventies, my father, a third-generation high school dropout, was already making his way up the railroad hierarchy. The trains my father first worked on were the same trains his father and grandfather had worked on before him: Armour Yellow, shields with the colors of the American flag painted on the front locomotives, the words *Union Pacific* emblazoned in red on their sides. During my father's working years, he was fond of saying, "When you're on the railroad, your first obligation is always to them." But such devotion always comes at a

price. PJ's wife left him. Fibers from the asbestos used in train parts accumulated in my grandfather's lungs. My father's been diagnosed with emphysema, caused from years of smoking and inhaling diesel exhaust. Instead of Lincoln's words, I think of Thoreau's in *Walden*: "We do not ride on the railroad; it rides upon us." I think of the men who have lost physical health—and yes, even life—so the railroad could be built and continue its operations today.

Within a year of the layoffs, the railroad recalled most of their craftsmen, including my father. He quit his job as a janitor, and we upgraded to a home on Hanson Lake, where my grandparents lived in a one-bedroom home. I was a freshman at Springfield High School. Whatever happiness we all felt was short-lived. "Out the Gate in '88" was a pull quote a newspaper ran the day after railroad management announced the Omaha shops were closing. Over eight hundred workers had ninety days to relocate to rail yards in other states or find new jobs. Some were outright fired. The Union Pacific wanted to get out of the locomotive maintenance business, which is what the Omaha shops were. As my father once described it, "We pull a locomotive off the line, fix 'er, and push 'er out the door."

Hoping to prevent retaliation, the executives told the craftsmen to pack their tools, and that only supervisors would be allowed back on site. But these weren't *yes, yes, yes, yes* men. These were my father's people. Men with a creed. Men who refused to be left behind. Who sometimes became the scoundrels of their stories instead of the remembered men of their generation. A car man dropped a ball bearing into a traction motor and seconds later, the giant metallic motor blew up. Another worker cut wires on one of the locomotives. Ball bearings were dropped into turbo chargers. Other train parts were mysteriously broken. My father understood fear and hurt expressed this way—in violent outburst—but he didn't join in. During the final days the shops were open, supervisors blasted the song "Don't Worry, Be Happy" from the loudspeakers.

At home my father drank and whistled while hammering in his work shed. Sooner or later he turned sour and then he yelled at my mother, Debbie, the dogs, me. Nothing seemed too incidental to set him off. It was as if he yelled just to hear his own voice: "You're stupid!" As if he feared we, too, would forget what it felt like to be him: "You make me sick!" As if to make sure he hadn't disappeared altogether: "You can't do anything right!"

When my mother departed from her customary stance of loyally supporting my father and threatened him with divorce—the first time when I was in elementary school and again when I was a teenager—I allied myself with her. "Don't you love me anymore?" he'd ask my mother, and at his lowest moments, he'd ask my sister and me, too. I didn't know what to say. It didn't matter. The outcome seemed inevitable. He'd lose his composure and holler at whoever was closest, his hot breath rushing against our faces. "I might as well go somewhere else if I'm not wanted!" With my whole being, I wished for him to do just that. But my mother's heart wasn't in it—she was part of the "We." Her warnings of divorce were a bluff. I never understood why she forgave him, and for many years, she kept one reason a secret: When the trains whistled during the night, my father sat up in bed, listening. Some nights, he cried.

After a year, during which time my father briefly moved to Arkansas to work for the Union Pacific (a trial separation for my parents), followed by an even briefer period where he moved back home and worked at a wastewater treatment plant in Omaha (he couldn't live without my mother), my father was hired by the Burlington Northern Santa Fe Railway (BNSF) in Lincoln, working third shift, midnight to 7 a.m. A happy ending of sorts, though he'd start over at the bottom with the dirtiest job, cleaning traction motors. He would work for BNSF for the next seventeen years, only two less than the nineteen he'd devoted to the Union Pacific. At his retirement party, the men would honor his survivor's creed, presenting him with a canoe oar with the

words *Keep Stirring It* written in permanent marker. Working again, he was happy, his temper soothed. But it was too late for him and me.

I avoided him however I could. If I wasn't coming home late because of track practice, then I stayed late at school writing stories for the high-school newspaper (where I'd found *my* people). I spent entire weekends at girlfriends' homes. When I couldn't find somewhere else to be, I jogged over to my grandmother's house to sit with her on the patio and stare at the lake. My avoidance of him wasn't affected by his moods: It didn't matter to me if he was happy or irritated or if he took my acceptance letters from college down to the rail yards to brag about me to his buddies. It didn't matter that he clipped my articles out of the *Charioteer* and stuck them on the refrigerator (to this day, he keeps them in his desk), and that he came to my track meets, yelling from the bleachers: "Run! Jody! Run!" Something was set in motion during my childhood. I didn't know how to stop it. "Stopping a train is harder than starting it," my father has said. He's never recognized the truth in his words, the pain that's picked up momentum as the years have gone by, hundreds of thousands of pounds of force to reckon with.

When PJ worked for the railroad, brakemen jumped from one swaying railway car to the next and applied the brakes by muscling a large wheel on top of the train, the train screeching its displeasure. The engineer riding in the locomotive would signal the brakemen with a series of whistles blasts. It was an imperfect method, and when the whistle blasts were delayed, too early, or not heard at all, the train might derail or collide with another. The brakemen had to fend off snow and thundershowers and keep their footing on the sometimes slick, icy roofs of the railway cars. Many of them fell to their death while jumping from one car to the next. Even with new, safer technology, my father says it takes skill to bring a train to rest. The weight and momentum of the train must be overcome to bring it to a stop, and sometimes because of human fallibility—just one mistake—the train, pitching and swaying like a wild horse, becomes a runaway.

My father never missed my high school track meets, even after he'd worked a double shift and hadn't slept. He hollered at me from the football bleachers. I felt his voice in the cramped muscles of my legs, in the pit of my stomach, louder than any of the other parents', muffling the garbled shouts from teammates standing on the sidelines, louder than my frantic coach's. I couldn't see him, couldn't spare the seconds it would take to turn my head, but I could *feel* him lean forward as I neared the finish line. I needed his approval. I also needed to leave him behind. I pumped my arms, my legs, my heart.

After my eighteenth birthday, I moved away for college. I never lived full-time in my parents' home again. If it wasn't a holiday, I didn't make any effort to see or speak to my father. I ran like hell.

Back at the train festival, my family and I have gathered near what appears to be a one-hundred-foot-wide hole in the ground, a giant metal wheel in the center. "A turntable," my father says. He explains how it pulls locomotives out of buildings and spins them around, sending them off in the opposite direction. Because it's a festival, a few of the railroaders start it up. The noise is loud and hypnotic: gears grinding, clanging, a metallic *whoosh* that is somehow both too loud and too soft for the massive wheel's movement. Amelia sleeps right through it in her stroller. My father reminds me the Omaha rail yard has one, too, but it's either a lost memory or I wasn't paying close enough attention. These days, just one or two Union Pacific trains roll through Omaha, though Nebraska remains the third largest employer of railroaders in the nation. My father and I both like to shape stories, to remember in a way that makes meaning out of chaos, and I've recently recognized this is no small thing we have in common. But I'll never hear what the trains are saying like he does. Today I'm impressed and tell him so. We smile awkwardly at one another. Just then, Lily loses her grip on the red balloon in her hand and starts to cry. "Don't worry," my father says kindly. "I know a guy. Let's go get you another balloon." He winks at

her: "Or two." I watch them walk away, holding hands. Lily adores her grandfather.

My father has been more loving, patient, and stable as a grandfather than he ever was as a father. So I let my guard down. I try to remember how I must have felt as a young child, when trust and love came easily, when he used to throw Debbie and me into Hanson Lake from a dock, and we shrieked in delight, begging "Again!" as soon as we emerged from the water. When he played catch with us in the front yard and volunteered as our assistant softball coach. When he hung a tire swing from a tree and spent hours pushing us so high we screamed in both terror and joy because we knew our father would never allow us to get hurt. When he drove us over the train tracks. In a picture taken during those years, my parents joke with each other in our front yard, my father's arm around my mother's ample waist. She wears cutoff jean shorts and a red blouse. His hair is still light brown, his beard modest and trimmed, and he wears Wrangler jeans no matter how punishing the sun will become later in the day. Debbie and I goof around on either side of them, dressed in terrycloth rompers. In the picture, the railroad ties my father uses to prevent yard erosion are visible behind us, but only because I look for them. The coal tar creosote on the railroad ties melts, smelling of burnt rubber. Years later, I will read that the creosote is toxic, silently seeping into the soil and water, causing cancer in the bodies of railroaders who frequently handle the railroad ties. But on this day, bad news is not yet something I've grown accustomed to and we smile like people do in photos, like this is who we are.

The good days outnumber the bad days now, the latter are few and far between. Why can't I put our past behind me? Twice now, both times at my parents' dining room table while we shared the meal my mother had spent hours preparing, my father has lost his temper with Lily after she became whiny. Both times he rose from the table, slammed his hand down hard on the table, and yelled "Enough!" at her, his cheeks turning red. The last time it happened he became

infuriated because she disobeyed his rule—*You eat what you take!*—
and threw his plate of food into the air, his face twisted in a grimace.
"Do whatever you want, then!" he hollered at Lily. "I don't care!"
"We don't yell like that in my home," I said.

He looked defiant: "My house, my rules! If you don't like it, you
can hit the road."

After I'd sent Lily and Amelia outdoors with my husband—my
mother silently cleaning mashed potatoes and baked beans from the
floor—I told him: "We are leaving. If you act like that again, I won't
bring your granddaughters out here anymore. They'll grow afraid of
you just like I did. You'll ruin it." Unable to stand up to my father
when I was a child and a teenager, my role as a mother empowered me
to stand up for my daughters. Motherhood had given me the strength
I'd always wanted to confront my fears. And now, as a woman in her
forties, I was finally confronting my father on my own. It felt good.

He followed me to a guest bedroom where I started gathering our
things. "Forgive me," he said, choking on the words he never spoke
when I was growing up. "Please stay."

I turned, looked him straight in the eyes just like I'd always imag-
ined our day of reckoning, but it wasn't hate that welled up inside of
me. It was sadness. It was loss. The feeling overwhelmed me, yet my
voice was clear and steady. "I'm not a little girl anymore. You can't
bully me. Do you understand?"

He raised his eyebrows. He took a deep breath and coughed. "I'm
proud of you, the woman and mother you've become. Please give me
another chance." Tears filled his eyes. And though we drove away
from my parents' home soon after, I said I would. I've given him a lot
of chances. Perhaps too many. Perhaps not enough. There is no clear
answer in a situation like ours. My relationship with him will never
fully recover—I can accept that. What I don't accept is that our story
is done, his and mine, or without meaning. We've both been through
a lot. And I'm here at the train festival even after his plate-throwing
incident, trying.

When Lily and my father return with two new balloons, Lily's small hand in his meaty one, the turntable slows to a complete stop, the final *whoosh*. The turntable is in position to send a locomotive down the rails, except it's empty. A few kids cheer anyway. "We mostly used the turntable for the steam engines," my father says to me. "It's rarely operated now." I hear the wistfulness in his voice. Our family's railroading legacy stops with my father. There are no living family sons. My father points to the car parking lot where the steam engines were once kept, when they were once indispensable, but now like him, are part of railroading history.

Woman Running Alone

The annals of criminal history are writ large with
ordinary streets that hide dark secrets.

—PAUL HARRIS and ED PILKINGTON, "Ohio Kidnappings:
What Makes Men Take Women and Children Prisoner?"

A twenty-year-old woman goes missing during her evening run on a
single-lane road through Brooklyn, Iowa, a small town bordered by
soybeans and cornfields. She troubles my mind while my husband
and I walk a trail a three-hour drive from the area where she disap-
peared. She's a former cross-country and long-distance track runner,
and though competitive track and cross-country days ended for me
with high school graduation nearly three decades ago, I'm unable to
surrender this part of my identity. I still find excuses during casual
conversations to mention my history of running, one of the few expe-
riences where I felt powerful and unstoppable, a warrior wholly in
control of her body and her fate.

"I hope they find her alive," I say to my husband. But I don't
think they will. Too much time has passed, nine days since she went
missing on July 18, 2018, and I'm older, a mom of two daughters, and
have acquired enough cynicism (a byproduct of fear) to anticipate
how this story will end. A young girl or woman vanishes while
alone on a run—or hike, walk, or bike ride. *It isn't like her*, friends
and family say to the police and media, *to not tell someone where she
is*. Days, months, or years later, a body will turn up, unearthed by
police or stumbled upon by another jogger or passerby. That's what
she becomes, "a body," or worse yet, "remains"—a skeleton, a skull,
a Pain-Thing only dental records can identify. What is it about the

sight of a woman running, and especially a woman running alone, that some men cannot handle?

"That girl from Iowa?" Jon says. "What's her name?"

"Mollie Cecilia Tibbitts," I say.

We've walked ten minutes or so from the spot where the Big Muddy drifts underneath the Bob Kerrey Pedestrian Bridge, connecting eastern Nebraska and western Iowa. We walk in warm but dry heat, a hint of wind and hazy blue sky: romantic weather. We are, in fact, on a date. I birdwatch and spot a red-winged blackbird taking flight from a cattail on the side of the trail, a remarkable sight and one we never see in our suburban backyard. But I'm agitated, sullen. *Angry.* At him for not knowing her name? Or for not realizing his being a father of two daughters means he must pay closer attention? At male runners, who can step out for a jog without once considering their safety? The irony: solo running provides women a rare opportunity to experience uninhibited freedom in a public space while potentially exposing them to great harm.

I'm not sure who I'm angry at, but my body tenses. I think but don't say to Jon: *Maybe if you were a woman, you'd know her name—her full name. You'd know her story, too, or at least, the story the media has told. Mollie is a sophomore at the University of Iowa studying psychology, watching over children at a day camp for the summer. She has a lovesick, distraught boyfriend (cleared as a suspect). Divorced parents (now sleepless). Two brothers (also cleared as suspects). Astonished that a jog through a close-knit rural community has led them all to this point.* And what *is* this point? A misunderstanding and short-term crisis? Or something deliberate and evil, a long-term trauma? No one knows yet, but I suspect the worst. We women know about Mollie Cecilia Tibbetts. As for mothers, we talk quietly about her while our daughters skip ahead of us, just out of earshot but not our sight, on our morning pathways to school. Jon fathers Lily and Amelia lovingly, thoughtfully, playfully—but it doesn't make these gendered generalizations untrue. Women know about missing girls when men don't.

Cornfields surrounded my high school in Springfield, Nebraska, filling the air with a smell like musty earth and honey and the crackling sound of new growth. I butt-kicked with my high school cross-country team past the boys of my childhood, shirtless under their helmets and shoulder pads, banging into one another on the football field. Toward the end of our two-hour-long practices, I choked back bile and slipped on loose gravel on the paved road, the arches of my feet throbbing. My relationship to running was innocent and free of fear then, but it was not pure. Running provoked responses from all my senses, and the details I most absorbed were visual and male: rippling thighs and sculpted stomachs, beefy calves shining with summer sweat, lean arms with budding, hard mounds of biceps. The boys absorbed the visual details, too, telling me—then and later—I had nice legs. They meant that I had good runner's legs: longer than average, sharp-kneed, with developed hamstrings and brawny quadriceps. The boys—then and later—have also pointed out my visual shortfalls: my braces and glasses (easy marks), large pores (I ducked into the bathroom between classes and blotted my oily face with paper towels), my hand shooting up in class (*Know-it-all! Teacher's pet!*). Once, a soon-to-be ex-boyfriend, riled by some small misunderstanding I can't seem to recall, passed me a note I can't seem to forget: *Grow some tits and get to your normal sexual level.*

His words coated me like a new, shameful skin except when I ran, and then I shook loose any spiteful words ever flung at me and instead savored what I could make my runner's legs do. I wasn't the best in our state or even at our school, but I was good enough to win trophies and ribbons. Reckless, too: I once failed to notice the bulky tree root underfoot, tumbling down a hill during a cross country meet, scratching my legs and arms, bloodying them. I got back up, brushed the rocks from my knees, and finished the race. While running I acknowledged my body's one and only area of observable superiority. Sprinting past the boys on the sidelines, their faces bleeding together

in my peripheral view, a giant boyish smear, I thought: *Catch me if you can!*

Whenever a particular cocky football player—hair long and grimy-black, like an eighties rock god—turned away from a scrimmage to watch me dashing past, I propelled my arms and lifted my knees, breath ripping out of my chest, and ran faster. I imagined myself from his scrutinizing viewpoint: my suntanned, pumping, lunging, twisting torso. *Faster. Faster.* After on-again, off-again years of trying to figure each other out, baffled by our uneasy mix of mutual attraction and loathing (he played guitar, I wrote for the school newspaper; he oozed cynicism, I leaked sensitivity), this boy and I would meet up as newly minted twentysomethings after a drunken night at an Omaha bar where his band frequently played, and only then would we finally allow ourselves what we'd only guessed at in our adolescence. I knew that our story (soon to fizzle out) had begun with those thickly humid days when I ran past him on the practice field, his eyes averted from the football and instead absorbed by my legs, slick with exertion. "I've seen you running around town, you know," he whispered in my ear that night.

Even early on, the cornfields are a problem. A local sheriff tells the news, "We're surrounded by farm ground: corn and soybeans. Right now the corn is probably eight, nine feet tall. The only way you can search it is basically walk down every other row. It's difficult. Even the planes flying over have a difficulty looking down in the corn rows." Another week passes without any fruitful leads in Mollie's case, even with volunteers searching for her in "in every field, every ditch, every creek." It's possible for a bicyclist, speed-walker, or jogger to cover several miles without seeing another soul on these midwestern footpaths, country roads, and even some urban trails, not only in the gloaming but also during sunlit hours. Media outlets describe her early evening jog through the farming town as her "routine." An assistant director of the Iowa Division of Criminal Investigation reports, "She

is a creature of habit and went the same routes, so we're going back and covering those areas and interviewing people again." Mollie's boyfriend tells a news reporter, "She goes for a run every night. She likes to go whenever the sun's not down." Mollie's boyfriend, shrewd and protective, knows what some people say about young women who go running alone, especially in the dark: *Always run in well-lit places. Did she carry pepper spray in the pocket of her shorts? Women should run in groups. Ditch the earbuds so you can hear someone sneaking up on you. This wouldn't have happened if she ran with a sidearm.* On and on and on, the unsolicited advice and judgement appear in online forums for runners and within the comments' sections of online op-eds and news articles—as if female runners haven't heard these exact safety tips dozens of times already. Mollie's boyfriend adds, "She knows Brooklyn extremely well, better than I do and I've lived here my entire life."

Implied: She can find her way around these streets.

Mollie's boyfriend says she probably carried her cell phone with her, too.

Implied: Even if she didn't switch up her running routine, dissuading potential stalkers, even if she ran in early evening—but before sundown—she took precautions.

Mollie understood the risk of being a woman running alone.

"I don't want to hear how sexy—or not—I look when I'm running, thanks," reads a 2013 headline in the *Guardian*. The author, Sarah Ditum, writes in response to a cosmetic company's real-life marketing campaign that has DC frat boys holding up signs at female half-marathoners: *Hello Gorgeous. You look beautiful all sweaty. Cute Running Shoes.* A few hoist signs displaying their phone numbers, seemingly confusing a marathon with a nightclub. Ditum writes, "Because if I'm running a race, it's not so I can get an index of my bangability." Ditum's feisty response to corporate-funded street harassment begs the question: Why in running is it a common practice for men to catcall women, judging them not on their athletic performance but

instead on their desirability? And where are the public spaces where women are free to do as they please without being sexualized?

My relationship to running evolved throughout my mid- to late twenties as I moved around alone for college and jobs throughout eastern Nebraska and western Michigan, discovering what was around the next corner in my tennis shoes. I ran past homeless people day-sleeping on park benches, kids in frenzied clumps pumping their bike pedals, couples in matching sweat suits with golden-furred dogs, houses with shattered windows and yellow police tape hanging from front porch banisters, beige homes with three levels and extravagant black cars parked in massive driveways. An adult now without a team, I mostly ran solo. I was never truly alone, though. No matter the socioeconomic status of a neighborhood, I ran to whistles, honking, hoots, jeering, the occasional sexual gesture, and praise (like Ditum, I heard on several occasions, "You're doing great!"). And more than once, I ran while being tailed for a short time by a stranger in a car. One such male driver slowed down to lean out of his window and ask, "Are we having fun yet?" Raised to be midwestern-polite but surly enough, I rolled my eyes and swiftly changed directions, losing him.

These intrusions into my otherwise solitary runs annoyed me but didn't scare me, so I blocked them out by pumping rock music into my headphones (Metallica's "Enter Sandman" was a favorite song; I related to its fear of nighttime things). When the weather turned sour, I ran on a treadmill at the gym, where competent management, if present, governed social rules and nobody heckled me. The pleasures and pains of running were mine: I was no longer running *faster, faster* to impress a boy, though I wasn't any less aware of my sexuality. My running practice had matured, and so had I. When I wanted to be stared at, I could dance under strobe lights with friends at a club.

My ideal routes were on isolated country roads, like the ones near Mollie's town. As a young child, I used to run alongside my father's diesel truck on dirt roads outside of Springfield or Louisville—his way of training me for the only sport we could both see I showed any

promise in. Cupping his mouth like a megaphone, his knees steering, he would yell, "Run! Jody! Run!" while the truck and I both kicked up gravel. I ran over flattened toads, swarms of gnats sticking to my sweaty cheeks and lips. I ran to the sound of the cows grunting and cicadas zing-zing-zinging in the afternoon trees. Startled grasshoppers flung themselves at my knees. Occasionally a farmer passed us on a tractor, nodding his head, but often we saw no one.

As an adult, I yearned most to run alone. Without food and shelter, pushed to the mythologized "wall," running came as close to a transcendent experience as I've ever had. Whoever or whatever was out there, beyond our lonely planet, I felt a part of it: an atomic energy wave from the cosmos. Eventually the hard work of running slammed me back into my body. Sweat trickled down my neck in dirty, cloying rivulets. I spit loogies onto the side of the road. A white crust formed at the corner of my lips. My feet blistered so often my toes and ankles were raw, and over time bunions formed on both of my feet. Courting the runner's high, I overexerted myself and vomited over a patch of grass.

Afterward, in a prone position on the ground or my bedroom floor, I felt a heightened awareness of my anatomy, as if my whole being was reduced to a diaphragm raising and lowering in its rib cage, a heartbeat pulsing within a vein. It puzzles me that some bystanders view this test of bodily integrity as merely sexy and miss the survivalist grit. They don't recognize running as a sacred act between mind and body—or between runner and higher power. To them I say: Observe. Be in awe. Don't speak. Then, out of respect, look away.

It's been a few weeks since Mollie disappeared. Her father, buoyed in his grief by the expression of community support, says, "I think it's because people see in Mollie their own daughters, their own girlfriend, their own sister." Psychology major, day camp employee, friend, girlfriend, daughter, Catholic: It's Mollie's ordinariness that worries me, that once *was* me, before I aged out, statistically, of girls and women

who go missing. As my seven-year-old daughter—my oldest—now ages in. The media adores Mollie, bordering on fetishization. I, too, am unable to stop watching and reading, needing to know how her story will end. Lily looks so much like Mollie that the two of them could be mistaken for family, and this similarity unnerves me. "An archetype," Mollie's father calls the image the media has created of her. A Midwestern Sweetheart: conventionally pretty, long-haired, tanned, dark eyelashes, smiling big in a picture taken at a football game with her wholesome-looking boyfriend. Mollie's disappearance is zealously covered in what one article calls "missing white girl syndrome," a phenomenon where white, middle- to upper-class girls and women receive more media attention than Black and Indigenous women, other women of color, trans women, women from lower social classes, and older women.

But isn't this cultural adoration and objectification of girls why young men pull them from the road? Sexualization of and violence against women are intertwined, rooted in some men's hunger to display power over them. Instead of seeing a woman as a real person, they see only an idea of femaleness—and they want it for themselves. They feel entitled to it (her). Or they want to degrade her, reminding a woman of her place.

Mollie's perceptive boyfriend continues to fight back. He says, "She's not just a flier."

Implied: She's more than an idealized or romanticized notion of woman.

Mollie's father tells a news reporter, "We're trying really hard not to make her Saint Mollie." He adds, "Mollie is super average."

Implied: She's tangible and concrete, not the nation's longed for fantasy of "girl."

But Midwestern Sweetheart archetypes are tough to ignore or overcome. Mollie's former school principal says Mollie didn't have a "mean bone in her body." "You couldn't help but just love her." She's "sweeter than a button."

In my early thirties, I slow-jogged a familiar place, a strip of the Keystone Trail in Omaha, a concrete pathway behind the windowless backsides of blue-collar businesses, baseball fields, and skate parks. The parks were abandoned on a brisk weekday during the first weeks of fall, when leaves fell like fingertips on my face and shoulders. A man further up the trail crouched down for rocks to toss into Little Papillion Creek. Other than the Canadian geese crossing the trail, the two of us were alone. Dressed in baggy jeans, a collared shirt, and brown oxfords, he wasn't on the trail for exercise. What then? Near an entry point for the trail, about a mile away, cars parked in gravel outside of the White House Bar, and I wondered if he wanted sunshine after getting a midafternoon buzz in the gloomy bar.

He turned and spotted me, hurled a rock—sploosh!—and stood. Tall and thick like the oak trees that surrounded us and made the trail private, he smiled, a tooth missing. Something else was missing from his smile, too. (Later I tried to describe the smile to friends, and simply said "it was off"—a description they immediately understood.) I sped up when I jogged past him, stepping in goose shit, scolding myself. Say "Hello." Show him you're not afraid. Stop being paranoid. I hated the feeling of my swaying butt. I'd never felt afraid while alone on a trail in daylight before, and the fear gathering in my chest surprised me.

He wolf-whistled. A goose hissed. I looked over my shoulder and saw the man's hand pumping up and down, a pinkish blur, before I understood what I was seeing, before I started to run in earnest, lifting my knees like I'd been trained to do as a child so many years ago on asphalt tracks. My breath wheezed out in jagged words I hoped would cut: "Catch me if you can, asshole!" I didn't look back again until I reached the parking lot of the coffee shop, just a few feet from the White House Bar. I bent over, hands on my knees, coughing and gagging. I'd been trained in endurance running and had never been able to hold my own during a sprint. The man hadn't chased me and was too far back on the trail for me to see, but I wondered then—and

still wonder now—what he would have done if he'd caught me, had
that been what he wanted.

I believe Mollie's mother when she says there are "no words to describe
how you feel when you don't know where or how your child is." I
keep my daughters close, too close, because I fear the places where
words can't go, the places where words have no meaning. From them
I withhold the delight of walking off into the distance alone, though
I drive them to nature preserves and state parks, allowing Lily to
run away from me—if I can still see a hint of her, a swinging pony-
tail, the purple stripe of her running shoes. At one year old, Amelia
is only beginning to walk and is uncomfortable being out of arm's
reach, which is how I prefer it. Fear and paranoia sometimes guide
and shape my parenting. The odds that a child will be abducted are 1
in 300,000; at least, that's the statistic cited in one of many articles I
read. (The article offers some perspective: compare that to the odds
of choking, which are 1 in 3,400.)

Then during back-to-school week, several parents witness a white
male in a truck, circling the middle school Lily will one day attend. The
news later reports that the man attempted to "lure" the school children
into his truck. The small percentage of child abductions by strangers
(as opposed to those by estranged family members or acquaintances)
happen most often during the walk or bike ride to and from school.
After I swallow the fearmongering, it sits like a rock inside of my gut
instincts, and so I take turns with other mothers walking the neigh-
borhood children to school. "One missing child is one too many," I
parrot from the articles and websites aimed at nervous mothers like
me, recognizing how trite I sound. *Maybe next year I'll let her walk
with other children to school. Maybe then she'll understand that when a
man in a truck approaches you, you run away as fast as you can.*

As the days keep passing, the calendar flipped to August (or does
Mollie's mother keep it on July, when she last saw her daughter alive?),

the corn, of course, keeps growing. Searching cornfields is increasingly difficult—and painful, dry corn stalks scratch faces and arms—but they're running out of places to look. How far away could she have gotten? Nothing of note is found.

Then something. Police discover the corpse of a twenty-something white female in a ditch in rural Lee County, about one hundred miles from Mollie's jogging route. But she isn't Mollie. She's Sadie Alvarado, dead from "blunt force trauma to her head," sustained when she'd leapt from her boyfriend's moving car during a feverish argument. Her boyfriend fled the scene. Soon after, Vice President Mike Pence flies to Iowa and meets with Mollie's family on Air Force Two (more proof of missing white girl syndrome). Eventually Mollie's brothers return to their school, and her father reluctantly returns to his home in California. Volunteers return to the routines and habits they had before Mollie vanished. An entire month, too much time, has gone by, making it even less likely that she'll be more than a body when she's found. Mollie's mother tells news reporters, "You won't see me giving up hope. That's not an option." Her hope is her community's last hope, while the nation has mostly moved on, but I hear defiance in her words, too.

"They found her body," I say to my husband in our kitchen. It's August 21, 2018. I think, *Don't say "Who?"!* Maybe I omit her name because I'm testing him, though I don't know what my test would prove.

But he knows this time. "I heard." He reaches out a hand, squeezes my shoulder. He's a good man, one who feels some of this communal pain, too—as much as a man can. An ex-marathoner, he tells me he's never once been so much as hassled while running alone. He's never once felt afraid for his own safety or wondered what someone hollering at him from a car might want to do to his body.

It's a grim conversation, though not as grim as I felt when I first heard the news on the car radio, driving home with my daughters— *Body found believed to be missing Iowa jogger*—Lily piping up from the

backseat, buckled into her booster. "Whose body? Did someone die, Momma?" Lily was so proud of her growing bones when she moved from car seat to booster seat. I shut off the radio, met and held her eyes in the rearview mirror. "I don't know," I lied. "What's that song you're learning for school? 'Firework'? Can you sing it for Amelia?"

I ask: When does a mother teach her daughters about missing girls, the ones who become ghosts during runs through familiar neighborhoods, on foot trails, or through parks? Or while walking home from the grocery store. Or from work. And turn up as bodies or remains later, if they're ever found. When does a mother teach her daughters about the others who live but are harassed, molested, raped—never again the same? I want to promise my girls that nothing bad will ever happen to them—*I won't allow it!*—but that would be a lie. I can't always be with them, and I can't know their futures. Upward of 80 percent of American women will experience sexual harassment or assault during their lifetime. Twenty percent will experience an attempted or completed rape. Imagine the places that would light up on the globe if we knew where girls and women were going to be assaulted this year, this month, *this day*. Imagine the light—would it be like bioluminescent phytoplankton, an outline along dry land? Or more like a supernova, an explosion as massive, dangerous, and as devouring as our sun?

Did someone die, Momma? It remains a tension between Lily and me, unsettled, when I abruptly change the subject. Or when I yank her too roughly back to my side in a rowdy crowd of baseball tourists during the College World Series, a time when sex trafficking increases in Omaha. Or when I raise my voice at her youthful assumption that strangers bring only kindness and goodwill. "Use your brain!" I scold. I aspire to put the onus rightly on the men who harm others and the culture that raises men to view women as lesser-than, as objects, as fantasies and illusions for their wish fulfillment and egos. But what commonsense safety precautions should I teach her in the meantime? And when? For now, I "protect the innocence of her childhood," a

cliché that means, for us, I don't tell Lily the truth about life in a female body. I don't tell her about missing girls. Not yet.

I don't want my oldest daughter to know—*yet*—that men inexplicably kill girls and women, that a young man, allegedly Mollie's murderer, led the police to the exact spot where her body lay. My words would only confuse and frighten her. But one day I will tell her and her younger sister this truth: Mollie knew that "sweeter than a button" won't keep you alive when a strange man tries to catch you. Mollie brought her cell phone, and she told the young man who'd been shadowing her in his car, who'd jumped out to run alongside her, that she was going to call the police. And at that—her insistence on her well-being while running—he says he blacked out, something he admitted he was prone to doing when mad. What upset him? What about Mollie angered him? He doesn't explain. He tells investigators he "spotted a young woman in workout clothes, running alone." And he was drawn to her.

But what did he want from her? Researchers who have studied numerous cases like Mollie's, where men abduct and hurt girls and women, answer the question in one word: *power*. I come across this explanation in a *Guardian* article about the 2002–2004 kidnappings and subsequent sexual abuse and torture of three Ohio girls—Michelle, Amanda, and Georgina—abuse that lasted until 2013. All three girls were walking alone when the perpetrator approached them. The home where the girls were imprisoned was "fitted with ropes, chains and padlocks and secure rooms." These men, who I choose not to name, want the kind of power over another human being that few people experience (or want to experience). I'm struck between the similarities of the tools of these girls' captivity and the ones in Margaret Atwood's satirical essay "The Female Body," published in 1990: "Catch it. Put it in a pumpkin, in a high tower, in a compound, in a chamber, in a house, in a room. Quick, stick a leash on it, a lock, a chain, some pain, settle it down, so it can never get away from you again." Children grow up reading and watching fairytales

of restrained women and girls: Rapunzel imprisoned in her tower, forever brushing her golden hair (itself a symbol of idealized feminine beauty); Peter Pumpkin Eater's wife (or lover) caged (or dead) in his discarded pumpkin shell; Sleeping Beauty asleep—trapped in her own body—until that infamous and unsolicited kiss. Stories of catching girls and women have become a cultural norm, as have images of the objectified and sexualized female body. Right now, I want to write that Atwood's words were forebodingly prophetic, but I'd be overlooking the thousands of real-life examples she already had to draw from.

According to the National Missing and Unidentified Persons System, there are ten thousand Jane Does in the United States today. These are the unidentified bodies and remains of women and girls, discovered in creeks and lakes, in dumpsters, in the woods, in drainage ditches, near trailer parks, near campsites, near truck stops, along hiking trails, in ditches along highways and interstates, and many other places out of everyday eyesight. My daughter will learn someday about missing—and dead—girls because there will be more. Less than one month after Mollie's body was found, Wendy Karina Martinez was fatally stabbed in her neck, face, and head by a man she didn't know during her run through a trendy Washington DC neighborhood. Now, as I finish writing this essay, I read a new headline, this one about University of Utah student Mackenzie Lueck who's been kidnapped and murdered. No body yet. She's just burnt "female tissue" found in a "fresh dig site." The suspect in Lueck's case "recently expressed a desire to build a secret, soundproofed room with hooks on its walls in the basement of his home." *So it can never get away from you again.* Local reports of sexual assaults of runners occasionally land in my work inbox, delivered via a Timely Warning Bulletin. Recently, in Elmwood Park, within walking distance of my campus office: "An anonymous reporter indicated that they were sexually assaulted while running through the eastern portion of the park. At this time, the suspect has only been identified as a white male."

We must pay attention. A young man accosted Mollie Tibbetts during her evening jog, stabbed her multiple times, and stuffed her, bleeding, into his trunk. Drove her to a cornfield outside of Brooklyn. Then, dragged and carried her five hundred yards, dropping her face up. He buried her under corn stalks and left her for dead. I pay attention, but I don't always know what to do with what I've seen. Anger, like thorny vines, grows longer inside of me, attaching itself to organs and nerves, telling me something is not right here. I rage. I mourn. I fear. I write, and the writing rips out the anger, but during the healing that follows, raised, thick, uneven scars form. I read stories written by women who have grown their own scars and who talk unflinchingly about the female body and what it means to be a woman. I teach these stories to my college students, and one day I will teach them to my daughters. Together we will search out the right words for the places where there are none. Meanwhile, I work to keep my oldest daughter safe while loosening the emotional and physical tethers connecting us so she can grow up.

During field days at her elementary school, Lily already demonstrates a talent for track, finishing among the top three in her event. Family and friends have always observed that she has my build, and I can see she has my runner's legs. Colt-like and agile, she leaps and bounds and gallops everywhere we go. She will, in the near future, discover the pleasures of running through neighborhoods and on city streets. Perhaps she'll also discover a spot of Earth just for her, daydreaming herself the last woman on the planet, a feeling that both exhilarates and terrifies. I can see it now: her running alone on country roads surrounded by cornfields, the rustling leaves whispering their secrets from each narrow row, the stalks pulsing with green vibrant life.

GRATITUDE

I want to begin by thanking the writing community I met many years ago in Kalamazoo, those friends who now live scattered across the United States, and who read many of these chapters in their early forms. Thank you to Ann Przyzycki DeVita, a talented editor and beloved confidant. Anna Redsand, who shares the best kind of friendship and writing advice with me. And Kelly Daniels, whose honest critiques have challenged me to become a stronger writer. Many thanks to my writing professors at Western Michigan University: Richard Katrovas, Jaimy Gordon, Stuart Dybek, and especially Robert Eversz, who knows how to facilitate an amazing workshop.

Immense appreciation goes to my colleagues at the University of Nebraska Omaha and to my writing group: Annie Johnson, Aero Rogers, Kyle Simonsen, Joanie Latchaw, Anna Sims, and Tanushree Ghosh—I am grateful for your guidance, unwavering support, and companionship. Thank you to my students, who inspire me with their curiosity and creativity every day. And special thanks to John T. Price, my mentor and friend, who first introduced me to creative nonfiction and who has shared precious resources, encouragement, advice, and time.

Thank you to the writers I have met along the way: Cathryn Vogeley and Jenny Drai—you both offered crucial feedback. And love and gratitude to Jessie Carr, whose insights, baked goods, and droll sense of humor sustained me during the final steps of completing this manuscript.

I am profoundly grateful to the University of Nebraska Press, Courtney Ochsner, and Haley Mendlik for making this book possible. And thanks to Irina du Quenoy for your careful eye. Thank you

to the editors of the literary journals where some of these chapters first appeared and in slightly different form.

To my mother, father, and sister, who have supported my writing even when my words have been difficult for you to hear. Thank you.

And lastly, to my husband, Jon, and our two daughters, without whom these pages would be a lot less interesting—I love you. This story is yours, too. I am grateful.

I wish to thank the following publications for their support of my work:

"Under My Bed" appeared in *So to Speak*.

"The Secret of Water" appeared in *Hunger Mountain*.

"Firebreaks" appeared in *Cimarron Review*.

"The Maternal Lizard Brain" appeared in *Fourth Genre*.

"Neural Pathways to Love" appeared in *The Normal School*.

"Body Language" appeared in *Post Road*.

The opening paragraph of "Haunted" appeared in slightly different form in the *VIDA Review: Women in Literary Arts* in the essay "The Moon Does Not Fight."

SELECTED BIBLIOGRAPHY

Under My Bed

"Gender." The Bureau of Justice Statistics, Office of Justice Programs, U.S. Department of Justice. Accessed April 21, 2015. https://www.bjs.gov/.

Murder Accountability Project. Accessed April 21, 2015. http://www.murderdata .org/.

Murderpedia: The Encyclopedia of Murderers. Accessed April 21, 2015. https:// murderpedia.org/.

Rule, Ann. *The Stranger beside Me.* New York: W. W. Norton, 1980.

Smith, Kate. "Number of Women Killed by Homicide Grew by 21 Percent, Says New Study." *CBS News*, December 6, 2018. https://www.cbsnews.com /news/us-homicide-rate-female-victims-of-homicide-rose-by-21-percent -according-to-study-2018-12-6/.

"Violence against Women in the United States: Statistics." National Organization for Women. Accessed May 5, 2015. https://now.org/resource/violence -against-women-in-the-united-states-statistic/.

Recreationally Terrified

Canby, Vincent. "'The Thing,' Horror and Science Fiction." *New York Times*, June 25, 1982. https://www.nytimes.com/1982/06/25/movies/the-thing-horror -and-science-fiction.html.

Carpenter, John, dir. *The Thing.* Universal City: Universal Pictures, 1982.

Clover, Carol J. *Men, Women, and Chain Saws: Gender in the Modern Horror Film.* Princeton NJ: Princeton University Press, 1993.

Corrigan, Kalyn. "Every John Carpenter Movie Ranked from Worst to Best." *Collider*, October 16, 2018. https://collider.com/john-carpenter-movies -ranked/.

Edmundson, Mark. *Nightmare on Main Street: Angels, Sadomasochism, and the Culture of Gothic.* Cambridge MA: Harvard University Press, 1999.

Jennings, Bryant, and Dolf Zillmann, eds. *Media Effects: Advances in Theory and Research.* 2nd ed. New York: Routledge, 2002.

Lambie, Ryan. "John Carpenter's *The Thing* Had an Icy Critical Reception." *Den of Geek*, June 26, 2018. https://www.denofgeek.com/movies/john-carpenters -the-thing-had-an-icy-critical-reception/.

Menzies, James L. "13 Fascinating Facts about *The Thing*." *Mental Floss*, June 25, 2017. https://www.mentalfloss.com/article/68365/13-fascinating-facts-about -thing.

Outpost #31—The Ultimate *The Thing* Fan Site. https://www.outpost31.com/.

Pinedo, Isabel Cristina. *Recreational Terror: Women and the Pleasures of Horror Film Viewing*. Albany: State University of New York Press, 1997.

Tough, Paul. "How Kids Learn Resilience." *Atlantic*, June 2016. https://www .theatlantic.com/magazine/archive/2016/06/how-kids-really-succeed /480744/.

Haunted

Harrison, Hazel. "How to Teach Your Kids about the Brain." *ThinkAvellana* (blog), November 23, 2015. http://www.thinkavellana.com/new-blog/2015/11 /23/how-to-teach-your-kids-about-the-brain.

Johnson, Steven. "Emotions and the Brain: Fear." *Discover Magazine*, March 1, 2003. https://stevenberlinjohnson.com/emotions-and-the-brain-fear -5d71098b5ac9.

Krisch, Joshua A. "How Monsters under the Bed Became a Common Child-hood Fear." *Fatherly*, July 16, 2018. https://www.fatherly.com/health-science /monsters-under-the-bed-childhood-fears/.

Savini, Tom, dir. *Tales from the Darkside*. Season 1, episode 7, "Inside the Closet." Aired November 18, 1984, in broadcast syndication.

Sullivan, Regina, and Elizabeth Norton Lasley. "Fear and Love: Attachment, Abuse, and the Developing Brain." *Cerebrum*, September–October 2010, 17. https://www.ncbi.nlm.nih.gov/pmc/articles/PMC3574772/.

The Maternal Lizard Brain

Bhanoo, Sindya N. "Humans, like Animals, Behave Fearlessly without the Amygdala." *New York Times*, December 16, 2010. https://www.nytimes.com /2010/12/21/science/21obbrain.html.

Boddy, Amy M., Angelo Fortunato, Melissa Wilson Sayres, and Athena Aktipis. "Fetal Microchimerism and Maternal Health: A Review and Evolutionary Analysis of Cooperation and Conflict beyond the Womb." *BioEssays* 37, no. 10 (2015): 1106–18. https://doi.org/10.1002/bies.201500059.

Bryner, Jeanna. "Women with No Fear Intrigues Scientists." *Live Science*, December 16, 2010. https://www.livescience.com/9125-woman-fear-intrigues -scientists.html.

Evans, Paul C., Nathalie Lambert, Sean Maloney, Dan E. Furst, James M. Moore, and J. Lee Nelson. "Long-Term Fetal Microchimerism in Peripheral Blood Mononuclear Cell Subsets in Healthy Women and Women with Scleroderma." *Blood* 93, no. 6 (1999): 2033–37. https://doi.org/10.1182/blood .v93.6.2033.406k18_2033_2037.

Feinstein, Justin S., Ralph Adolphs, Antonio R. Damasio, and Daniel Tranel. "The Human Amygdala and Induction and Experience of Fear." *Current Biology* 21, no. 1 (2011): 34–8.

Hillerer, Katharina Maria, Volker Rudolf Jacobs, Thorsten Fischer, and Ludwig Aigner. "The Maternal Brain: An Organ with Peripartal Plasticity." *Neural Plasticity* 3, no. 58 (2014): 1–20. https://doi.org/10.1155/2014/574159.

LaFrance, Adrienne. "What Happens to a Woman's Brain When She Becomes a Mother." *Atlantic*, January 8, 2015. https://www.theatlantic.com/health/archive /2015/01/what-happens-to-a-womans-brain-when-she-becomes-a-mother /384179/.

Nowak, R., R. H. Porter, F. Levy, P. Orgeur, and B. Schaal. "Role of Mother-Young Interactions in the Survival of Offspring in Domestic Mammals." *Reviews of Reproduction* 5 (2000): 153–63. doi: 10.1530/ror.0.0050153.

Pappas, Stephanie. "Pregnancy May Change Mom's Brain for Good." *Live Science*, December 28, 2011. https://www.livescience.com/17655-pregnancy -change-moms-brains.html.

Steig, William. *Sylvester and the Magic Pebble*. London: Windmill Books, 1969.

Yong, Ed. "Meet the Woman without Fear." *Discover Magazine*, December 16, 2010. https://www.discovermagazine.com/mind/meet-the-woman-without-fear.

Neural Pathways to Love

Barker, Leslie. "When It Comes to Love, Just Follow Your . . . Brain? A Neu-rologist Explains Why." *Dallas Morning News*, February 9, 2017. https://www .dallasnews.com/news/healthy-living/2017/02/09/when-it-comes-to-love -just-follow-your-brain-a-neurologist-explains-why/.

Boutwell, Brian B., J. C. Barnes, and Kevin M. Beaver. "When Love Dies: Further Elucidating the Existence of a Mate Ejection Module." *Review of General Psychology* 19 (2015): 30–38. https://doi.org/10.1037/gpr0000022.

Martínez, Alonso. "What Happens to Your Brain When You Fall Out of Love with Your Soulmate?" *Cultura Colectiva*, December 1, 2016. https://culturacolectiva.com/lifestyle/what-happens-to-your-brain-when-you-fall-out-of-love-with-your-soulmate.

Smuts, Barbara. "The Brain in Love: Using Neurochemistry to Try to Unravel the Experience of Romantic Passion." *Scientific American*, April 2014. https://www.scientificamerican.com/article/the-brain-in-love/.

Zeki, S. "The Neurobiology of Love." *FEBS Letters* 581, no. 14 (2007): 2575–79. doi: 10.1016/j.febslet.2007.03.094.

Side Effects

Arthritis Foundation. Accessed September 3, 2018. https://www.arthritis.org/.

"Community Forums: Methotrexate." *Patient*. Accessed August 3, 2018. https://patient.info/forums/discuss/methotrexate-636258.

Hayden, Charlotte, Rebecca Neame, and Carolyn Tarrant. "Patients' Adherence-Related Beliefs about Methotrexate: A Qualitative Study of the Role of Written Patient Information." *BMJ Open* 5 (2015): e006918. doi: 10.1136/bmjopen-2014-006918.

Kremer, Joel. "Methotrexate: Where It All Began." *RheumNow*, February 10, 2016. https://rheumnow.com/blog/methotrexate-where-it-all-began.

My Grandmother

Cerminara, Gina. *Many Mansions: The Edgar Cayce Story on Reincarnation*. New York: Signet, 1950.

Colton, Michael. "The Prophet Center." *Washington Post*, December 31, 1997. https://www.washingtonpost.com/archive/lifestyle/1997/12/31/prophet-center/70c1857e-c1e1-4310-9236-d80ec62caf78/.

Edgar Cayce's Association of Research & Enlightenment. Accessed April 30, 2018. https://www.edgarcayce.org/.

Sugrue, Thomas. *Story of Edgar Cayce: There Is a River*. Virginia Beach VA: A.R.E. Press, 1997.

Woman Running Alone

Atwood, Margaret. "The Female Body." *Michigan Quarterly Review* 29 (1990): 490–93.

Benson, Thor. "What You Really Should Know about Child Kidnapping." *ATTN:*, April 2, 2016. https://archive.attn.com/stories/6974/odds-of-child-getting-kidnapped.

Bufkin, Ellie. "Remains of Missing Utah Student Mackenzie Lueck Found in Salt Lake City." *Washington Examiner*, June 28, 2019. https://www.washingtonexaminer.com/news/remains-of-missing-utah-student-mackenzie-lueck-found-in-salt-lake-city.

Cleary, Tom. "Mollie Tibbetts Missing: 5 Fast Facts You Need to Know." *Heavy*, August 7, 2018. https://heavy.com/news/2018/07/mollie-tibbetts/.

Ditum, Sarah. "I Don't Want to Hear How Sexy—or Not—I Look When I'm Running, Thanks." *Guardian*, May 2, 2013. https://www.theguardian.com/commentisfree/2013/may/02/dont-want-to-hear-sexy-running.

"Father of Missing College Student Mollie Tibbetts Believes She's with Someone She 'Trusted.'" *CBS News*, August 7, 2018. https://www.cbsnews.com/news/mollie-tibbetts-case-father-missing-college-student-believes-shes-with-someone-she-trusted/.

Harris, Paul, and Ed Pilkington, "Ohio Kidnappings: What Makes Men Take Women and Children Prisoner?" *Guardian*, May 11, 2013. https://www.theguardian.com/world/2013/may/11/ariel-castro-inside-mind-of-kidnappers.

"Man Convicted of Leaving the Scene after Death of Sadie Alvarado." *KWQC*, August 5, 2018. https://www.kwqc.com/content/news/Investigators-discover-dead-body-in-rural-Lee-County-490102831.html.

Nozicka, Luke. "Mollie Tibbetts Was Destined to 'Change Lives': 'You Couldn't Help but Just Love Her.'" *Des Moines Register*, August 22, 2018. https://www.wzzm13.com/amp/article/news/nation-world/mollie-tibbetts-was-destined-to-change-lives-you-couldnt-help-but-just-love-her/507-586451501 https://www.wzzm13.com/.

———. "She's Nurturing. She's a Harry Potter Fan. We All Know Mollie Tibbetts' Face, but Her Friends and Family Say She's So Much More." *Des Moines Register*, August 20, 2018. https://www.desmoinesregister.com/story/news/2018/08/20/mollie-tibbetts-missing-iowa-search-brooklyn-news-update-disappearance-latest-girl-facebook-reddit/1018226002/.

Shapiro, Emily. "Investigators Examine Missing Iowa Jogger's Fitbit Data as Search for 20-Year-Old Moves to 9th Day." *ABC News*, July 26, 2018. https://

abcnews.go.com/US/investigators-examine-missing-iowa-joggers-fitbit-data
-search/story?id=56834651.

"Statistics." National Sexual Violence Resource Center. Accessed October 13,
2021. https://www.nsvrc.org/statistics.

"Suspect in Mollie Tibbetts' Killing Tells Police about Her Final Moments."
Mercury News, August 22, 2018. https://www.mercurynews.com/2018/08/22
/suspect-in-tibbetts-killing-tells-police-about-her-final-moments/.

IN THE AMERICAN LIVES SERIES

CPSIA information can be obtained
at www.ICGtesting.com
Printed in the USA
LVHW042038190822
726382LV00001B/73